GOINGPRO

Published in the United States by Amphoto Books, an imprint of the Crown Publishing
Group, a division of Random House, Inc., New York
www.crownpublishing.com
www.amphotobooks.com

AMPHOTO BOOKS and the Amphoto Books logo are trademarks of Random House, Inc.

Library of Congress Cataloging-in-Publication Data is available upon request.
978-0-8174-3579-0

Cover and interior design by Kara Plikaitis
Cover photos by (left to right): Jim Garner, Scott Bourne,
Eddie Tapp, Stacy Pearsall, Eddie Tapp
Title page photo by David Ziser
Table of Contents photo by Chase Jarvis

Printed in China

10 9 8 7 6 5 4 3 2

First Edition

Scott Bourne and Skip Cohen

GOINGPRO

HOW TO MAKE THE LEAP FROM ASPIRING
TO PROFESSIONAL PHOTOGRAPHER

The Photographer's Complete Guide to Building
an Online Profile from the Ground Up

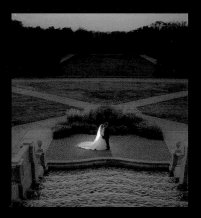

AMPHOTO BOOKS
an Imprint of the Crown Publishing Group
New York

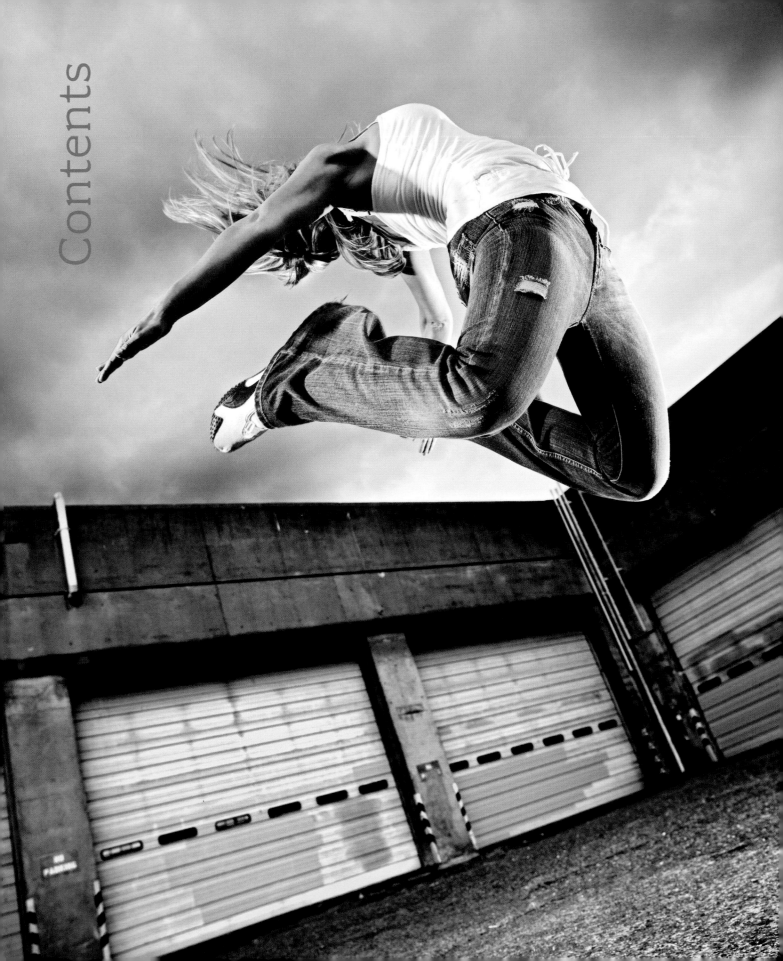

Contents

WE DEDICATE THIS BOOK TO THOSE WHO ARE WILLING TO RISK
EVERYTHING TO PROTECT OTHER PEOPLE'S MEMORIES.

ACKNOWLEDGMENTS

WE REALIZED A SHORT TIME AGO that between the two of us we have at least seventy years of combined experience in the photography industry. During all those years, the number of people who have come into our lives, influenced our styles, inspired and motivated us through a maze of life's paths has been incredible. So, where do we start when it comes to thanking so many wonderful friends and artists?

For the purpose of this book we have to start with all the photographers who contributed images to help demonstrate our message. All of you have been remarkable and your work represents some of the finest contemporary images in photography today. Next, we have to acknowledge those vendors who believed in our concept and are helping every day to raise the bar for new professional photographers, as well as those well established.

Lastly, it's our friends, families, and staff who have been there to watch our backs and help us stay focused, no pun intended. We consider ourselves two of the luckiest guys in photography and appreciate the incredible legacy left to us by so many wonderful photographers before us.

The poet Alfred, Lord Tennyson wrote, "I am a part of all that I have met!" All of you have in some way helped in writing *Going Pro*. It's your influence and passion for photography that continues to make imaging one of the most incredible career choices in the world today!

Good photographers allow us to see things we would never see otherwise. Here Vincent Laforet captures intriguing aerial views of surfers.
PHOTOS BY VINCENT LAFORET

AS MASTERS OF THE ART AND BUSINESS OF PHOTOGRAPHY, Scott Bourne and Skip Cohen are keenly aware that photography is just as much a business as it is an art—if not more so. In other words, being able to pick up a camera and push a button does not in itself make you a professional photographer.

Within the pages of this book you can expect to gain some invaluable advice on what it means to become a professional, and what you need to do to become a better one. Scott and Skip will guide you through some important choices, such as picking your niche and how to make your business grow. You'll be reminded that who you are and how you treat your clients and your subjects will define you as a photographer, perhaps more than your photographs will.

You'll be introduced to new ways of getting feedback on your work that will help you grow and market yourself. You'll gain a solid foundation in what it means to be a responsible professional who is aware of your market and how your actions affect that market.

As you approach the last pages of this book you will be better prepared to face the challenges of being a photographer in today's incredibly competitive market. You may find the ultimate reward in having a solid business foundation is that you get to focus on the most important part of photography: what is in your heart and in your mind. If you do, you will have come full circle and gotten back to what got you into photography in the first place—the passion, the fun, and the discovery that every single shutter click brings to all of us!

— Vincent Laforet

These aerial views of Manhattan are not just scenic. The scene at top documents traffic leading up to the George Washington Bridge as subways and buses were halted by a transit strike. PHOTOS BY VINCENT LAFORET

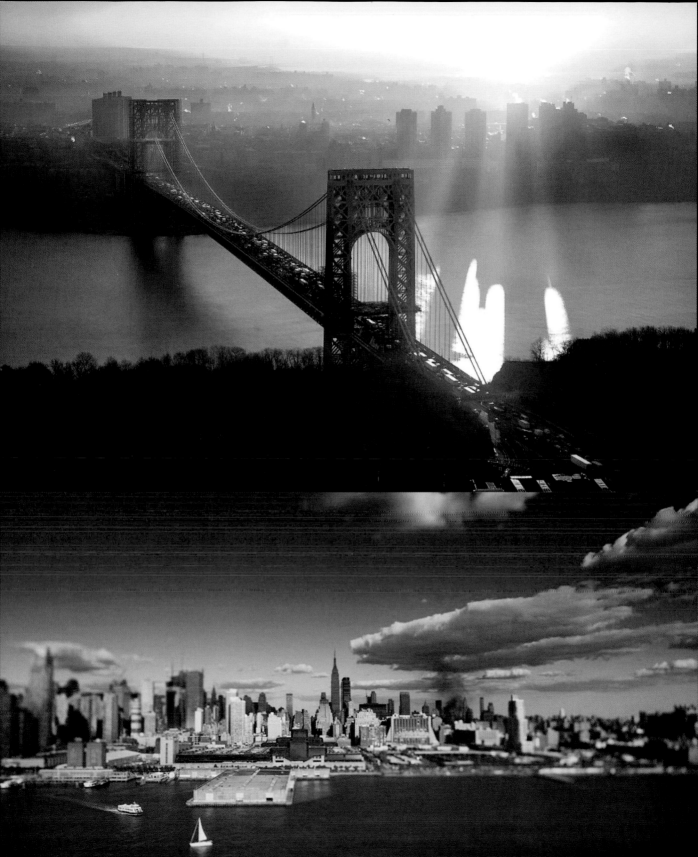

Introduction

As photographers, authors, bloggers, and members of this incredible industry for seven decades between us, we can say with some authority there's no industry like photography! All of you who read this book are committed to joining us in becoming magicians who capture moments out of time to be savored, cherished, and archived forever. Photographers have captured the tragedies of the world, the violation of human rights, and moments of celebration, joy, and love for almost two centuries.

Being a professional photographer carries with it a great deal of responsibility too, especially when working with clients. They're putting their trust in you to capture everything they're not going to have time to see, especially at an event like a wedding. A commercial client is looking for you to show the essence of a product in ways that can promote and grab the attention of the public. A photojournalist has a responsibility to freeze a moment to share with the rest of society with a full commitment to truth in imaging.

You've chosen a career path with a rich heritage of creativity, and nobody could be prouder to be a part of it than the two of us! The concept of *Going Pro* springs from our need to help new photographers focus on more than just their subjects. *Going Pro* is about developing a plan to start a business and following through on each component. It's about building a career, step by step, that not only gives you a reasonable income but builds your self-esteem and your role in the community.

Digital technology, Photoshop, and the Internet have all made it relatively easy for beginners to think they can get into the business. After all, it just takes some gear and an understanding of Photoshop, right? Nothing could be further from the truth—at least, not if you want to sell your services to a second customer. Anybody can get the first few customers, but will they ever come back to you? Will they be ecstatic enough to tell their friends about your work or will they become your worst nightmare?

We don't intend to teach you photography. Thousands of books, websites, webinars, blogs, schools, and workshops provide that kind of support. We're making the assumption that you understand exposure, composition, lighting, posing, Photoshop, printing, and other elements of creating great images (and you're dead meat if you can't make a picture!) and that you've developed a good workflow. We're also going to assume that you completely understand your gear, are comfortable with various lenses, and understand when a change in focal length is necessary.

We're going to launch our efforts by helping you identify the segment of the market that best fits your mind- and skill sets. Then we'll go to work on ways to help you achieve your goal of turning your passion for photography into a viable business. Just as there are no shortcuts to creating great images, there are no shortcuts to building your business. It's important to be eager to get started, but we want to help you build your business in the same way you'd build a house, starting with a solid foundation of understanding the craft, then adding in all the necessary components, brick by brick.

Not too long ago, a listing in the yellow pages was a huge asset to your business. We firmly believe that today your photography business will be most successful if you take advantage of social media. We're going to spend a lot of time helping you think through your social media strategy and identifying the different ways you can utilize this venue as a marketing and communication tool to expand your reach.

We're also here to remind you that great photography is also about your heart . . . shooting from the heart and creating images that grab people's emotions. *Going Pro* is all about having dreams and a vision, along with the patience and determination to stay focused on a plan.

In fact, just about all professional photographers started out with a dream or a vision. Something happened in their lives to trigger the love for photography, and over the years, a combination of creativity, understanding, awareness, and technology have pushed them to create better images. They've also experienced peaks and valleys and made mistakes and learned from those mistakes. We contacted some of the photographers we respect the most and asked them what advice they would give a photographer just starting out. Their wise suggestions appear throughout this book.

— Scott Bourne — Skip Cohen

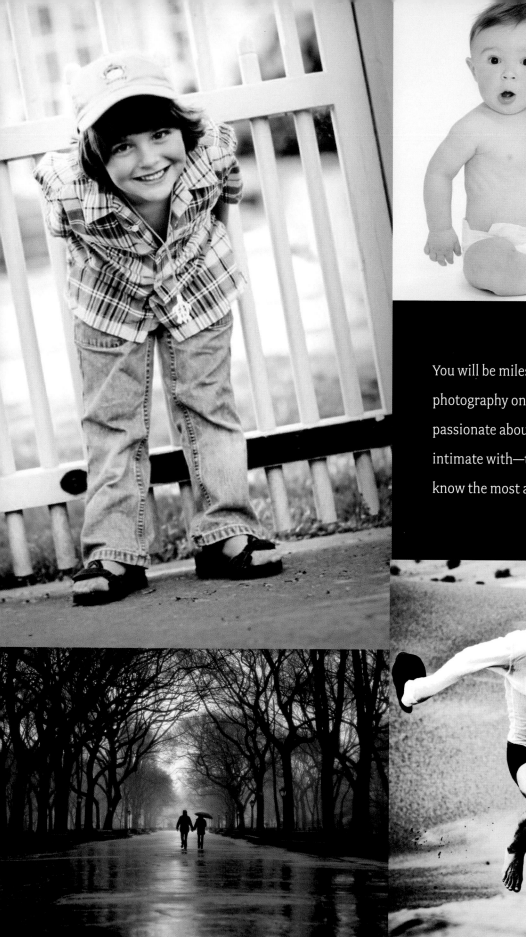

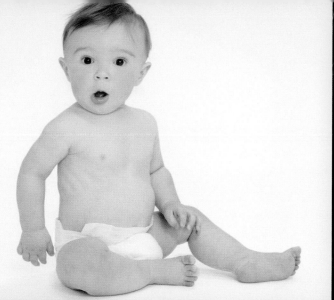

You will be miles ahead if you focus your photography on that which you are most passionate about and which you are most intimate with—that which you love and know the most about. –PHIL BORGES

Define Your Niche

SOMEWHERE ALONG LIFE'S path, somebody put a camera in your hand and you discovered that you love taking pictures. You may have been a child playing with an inexpensive point-and-shoot. Maybe you got caught up in the excitement of digital photography just a few years ago, capturing great moments on vacations. Whenever you got hooked, if you're reading this book, you're thinking about developing a business around selling your photographs. If you can sell someone a photo, you have communicated with that person. You have created a story that is compelling enough to cause others to feel, think, or react—you've established a dialogue. You have communicated so successfully that someone is willing to give up money for your image. In short, you have broken into the world of professional photography.

PHOTOS BY (CLOCKWISE FROM TOP CENTER): TAMARA LACKEY; BAMBI CANTRELL; SCOTT BOURNE; CHASE JARVIS; VINCENT LAFORET; TAMARA LACKEY

Find Your Passion

Where's the best place to start? Let's first figure out your niche. If you're going to sell photographs and do something beyond leasing a booth once a year at the local craft fair, you've got to define the various specialties and where your passion for creating images and starting a new business best fits. Simply put, you have to define your niche.

Professional photography is divided into different specialties. For the purposes of this book, they are: commercial, wedding, portraiture, nature/wildlife, photojournalism, fine art, and everything else. The "everything else" category includes scientific, medical, architectural, and forensic imagery, just to name a few.

Each category is further defined with a series of subgroups. For example, within the portrait category the subjects include babies, children, family, high school seniors, boudoir, business, and pets. Every subject has its own marketing vehicles, unique demographics, and in many cases might require different equipment—a variation of focal lengths in lenses, for example (a portrait of a baby will require a different focal length lens than a scenic landscape will). You will require different gear for on-location portraiture than you will for studio work.

Sometimes the most powerful images are those that comprise elements that our eyes take for granted.
LEFT: PHOTO BY EDDIE TAPP
RIGHT: PHOTO BY CHASE JARVIS

Your Personality Skill Set and Your Niche

The old expression "to thine own self be true" could not be more important than when you're working to define your niche. The big question arises: Does your personality match the niche in which you want to specialize?

Wedding photographers, for example, need to be sensitive, be understanding of the human spirit, and have excellent communication skills. They seem to rally with the stress of helping their clients meet the challenges of the wedding day. Remember, they have these qualities in addition to their unmatched knowledge of photography.

On the other hand, a photographer specializing in nature/wildlife photography is comfortable being alone and often will be described as having incredible patience, willing to sit in the duck blind for hours to capture that one unique image.

Whatever the niche you're about to choose, consider your personality. Think about what you enjoy photographing the most. If you like peace, solitude, and control then you're more likely to do well in commercial or nature/wildlife than you will as a wedding or portrait photographer. If you like the freedom to simply create and work by yourself, then fine art might be a stronger choice. If you're going to work to become one of the world's leading photojournalists, then you have to be comfortable being "on call," just like a doctor. You have to love spontaneity to the point of being ready to drop whatever you're doing at any time and picking up your camera.

Deciding on the niche that best suits your personality, passion, and skill set is the first step. From there it's a short jump to marketing, building your brand, and blogging and using other social media tools to create awareness for the purposes of building your business.

Wedding Photography

Wedding photography has become the single largest category for new professional photographers breaking into the business. The demand is steady: the website www.theweddingreport.com estimates the number of weddings at approximately 2.1 million per year for the past ten years, and the outlook is pretty much the same going forward. But the trends in wedding photography have changed dramatically.

Black-and-white images have come back with a popularity not seen since black and white was the only choice. Fusion technology, also referred to as mixed media, has brought still images together with video, and the technologies of photography and high-definition video have merged in new cameras. Presentations have expanded from traditional albums to coffee table–type books and slide shows. Some new albums even incorporate video technology, allowing you to create a traditional album with a small LCD in the back to provide up to 90 minutes of video.

However, documenting a wedding the right way and creating repeat business takes time and discipline. Anybody can shoot one wedding, get paid, and never see another ounce of business from the client. We want to help you develop a business model that makes sense, and the only feasible model is one that gives you an income and creates repeat business. Wedding photography, if done right, can be incredibly lucrative and rewarding—not just financially, but emotionally as well.

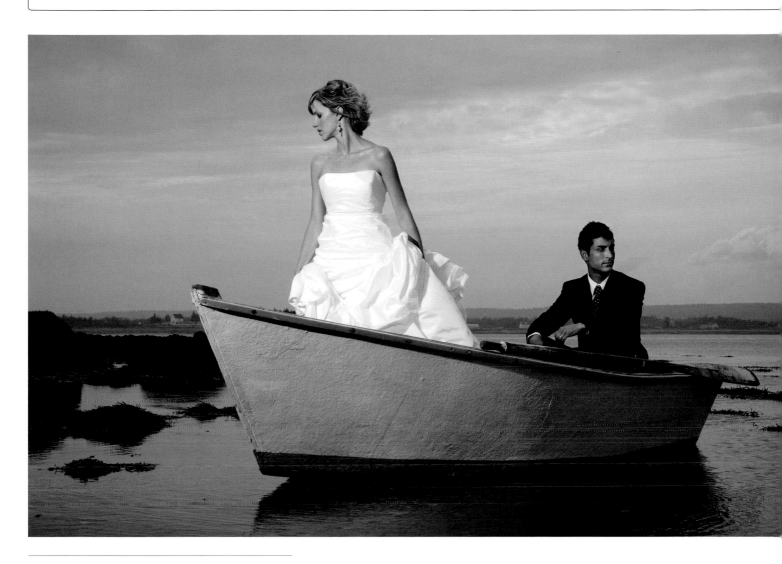

Wedding photography is anything but traditional these
days, posing new challenges and opportunities.
ABOVE: PHOTO BY NICOLE WOLF
LEFT: PHOTO BY JIM GARNER

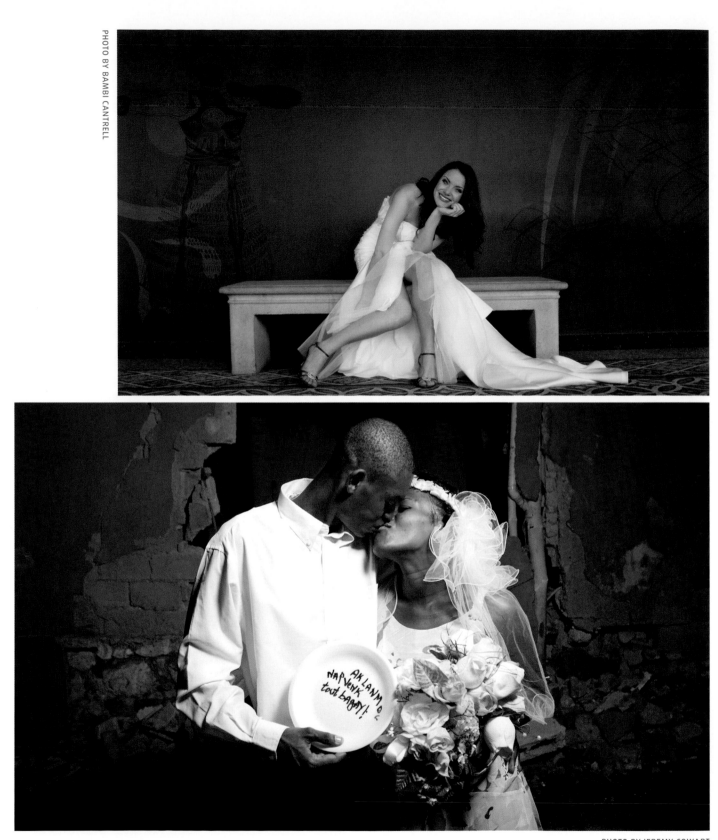

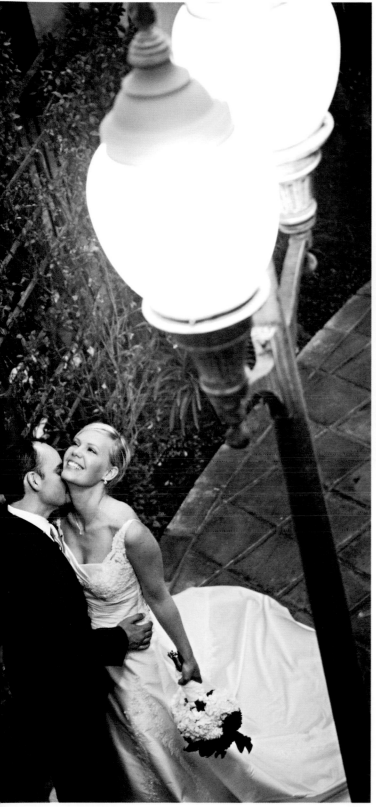

Portraiture

Portraiture, along with fine art, is probably the broadest of all the categories, and encompasses two broad subcategories: studio work and location shooting.

As the name implies, studio portraiture requires a studio, backdrops, studio lights, often some props, and an understanding of lighting and posing techniques. This is typically a more formal style of portraiture. Location portraiture allows you to photograph your subjects in their environment. You have less control over various aspects of the image, but by incorporating the environment, you can add more "personality" to the image and tell a story. This style is especially popular for photographing children, who reveal more of their personalities as they interact with their toys, pets, and siblings. It's no different with adults.

Depth of field plays a strong role in portraiture.
PHOTO BY MICHAEL CORSENTINO

Lighting determines the mood of any portrait.
PHOTO BY JEREMY COWART

A direct gaze, even when only implied behind dark sunglasses, can be a key element of a great portrait.

PHOTO BY MATTHEW JORDAN SMITH

PHOTO BY BAMBI CANTRELL

Portraiture Specialties

Within the category of portraiture are many subspecialties, from children to business executives to family pets. With such a wide range of subject matter, it's little wonder that portraiture is one of the most lucrative niches of photography. In fact, capturing images of brides, babies, and pets are the three most popular reasons people hire a professional photographer. Let's take a quick look at the many subcategories.

- **CHILDREN'S PHOTOGRAPHY** includes babies.

- **UNDERCLASS PHOTOGRAPHY** refers to your basic class photos of kids in school who are not seniors. This requires high-volume shooting, literally one portrait after another, usually under contract with a school system.

- **SENIOR PHOTOGRAPHY** may well be the fastest-growing specialty within professional portraiture and often the most fun. Senior shoots are often photography events that resemble fashion shoots, with props and several clothing changes.

- **FAMILY PORTRAITURE** today tends to be casual, revealing more personality.

- **BRIDAL PORTRAITURE** is not usually considered to be a separate specialty in the United States (as it is overseas), but virtually every wedding will require at least one traditional portrait of the bride by herself and one of the bride and groom together.

- **BUSINESS PORTRAITURE** still often implies a traditional headshot, but there's been a long-standing trend to bring the vocation of the subject into the image.

- **ENVIRONMENTAL BUSINESS PORTRAITURE** involves photographing subjects with a wider-angle lens and bringing their place of work or a vocation-related component into the background.

- **PET PHOTOGRAPHY** is popular and lucrative. People love their pets and consider them to be members of the family, but there aren't many photographers who specialize in pet portraiture.

On-location children's photography has become big business, but there's still nothing like a high-key portrait such as the one at bottom left.

PHOTO BY TAMARA LACKEY

PHOTO BY TAMARA LACKEY

PHOTO BY TAMARA LACKEY

PHOTO BY JULES BIANCHI

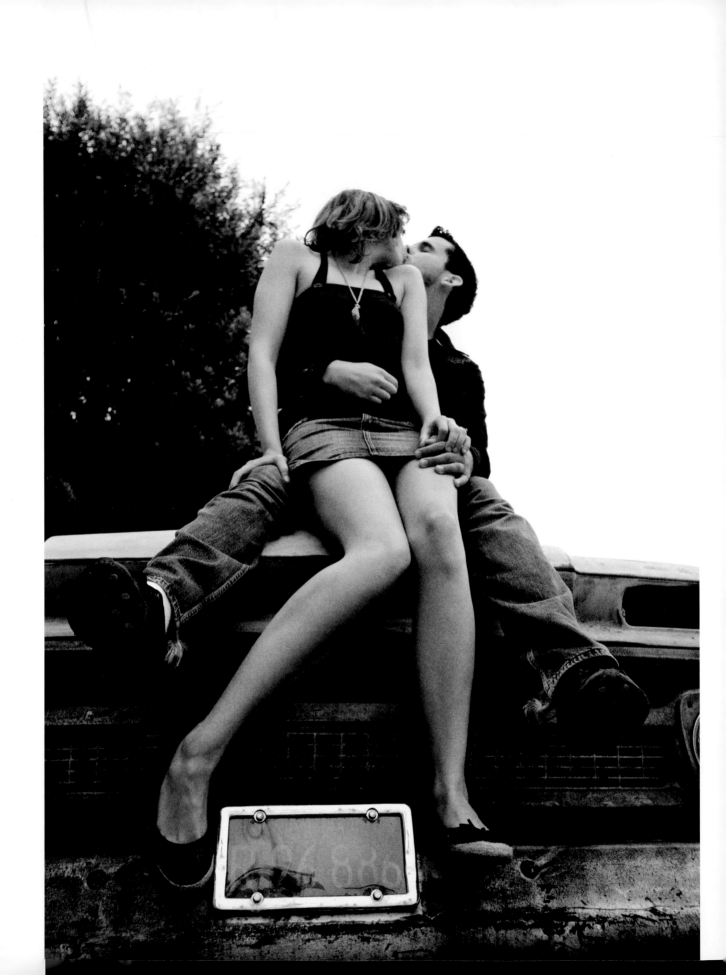

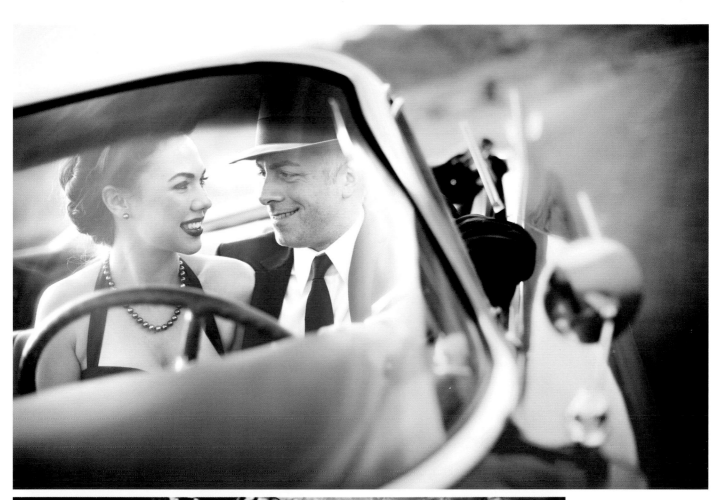

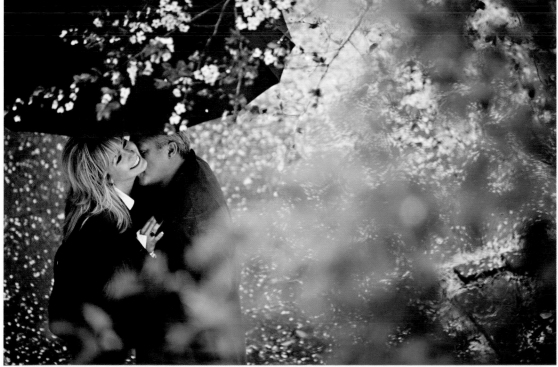

The most compelling portraits of couples often bring in elements of the location.

PHOTOS BY MICHAEL CORSENTINO

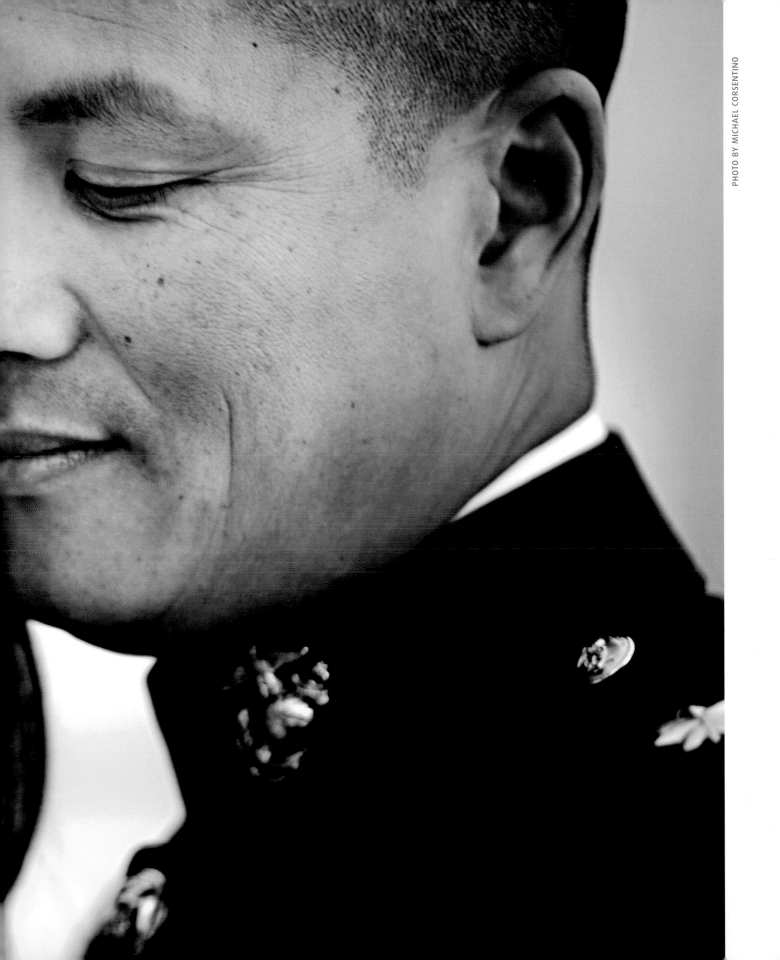

PHOTO BY MICHAEL CORSENTINO

Family portraiture is today anything but traditional. What makes work in this genre stand out is a unique style.

PHOTO BY BAMBI CANTRELL

PHOTO BY NICOLE WOLF

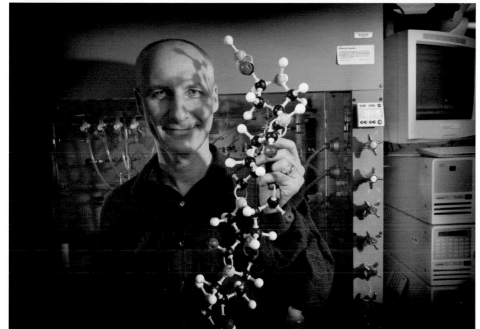

PHOTO BY ⌐ERRY CLARK

Environmental portraiture, sometimes with a little extra flair added, is especially effective in business images, but so is a strong, simple headshot.

PHOTO BY BAMBI CANTRELL

31

DEFINE YOUR NICHE

Commercial

Look at the images in *Graphis, Adweek,* and *Communication Arts.* If this is the kind of work you want to do and think you can do, commercial photography may be for you. With success in commercial photography, you'll have the satisfaction of seeing your work on national television and in major magazine ads.

Nick Vedros, often taking his inspiration from the cartoonist Gary Larson, brings humor into many of his images.
PHOTO BY NICK VEDROS

You can also reap considerable financial rewards, since commercial clients usually have big photography budgets. A few good jobs can make your year. The rewards of commercial photography don't necessarily come easily. This work is usually assigned by large advertising agencies, and to get it you have to have a spectacular portfolio, as well as a distinct style and usually a specialty. Emerging commercial shooters need to focus on getting their books seen. Competing in national contests, showing up on the appropriate forums, and doing lots of networking among marketing and communication professionals helps (we'll show you more ideas in chapter 4).

Pricing and bidding are probably more important in commercial photography than in just about any other photographic discipline. You'll need to be able to explain to clients why the job costs what it does, and what you're going to do with their money to justify their investment in you. Success in commercial photography will probably come slower than it might in wedding photography, but if it's your passion, you can get there.

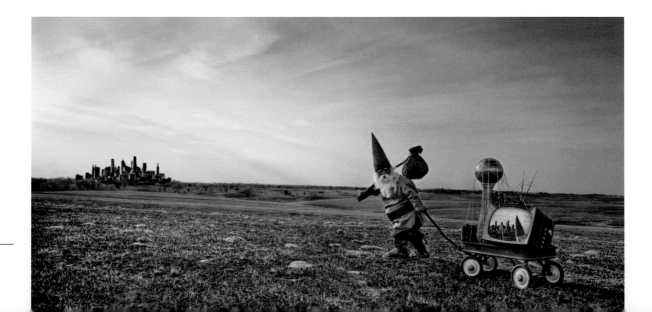

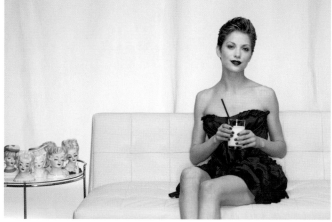

A strong image can tell an entire story
without a single word.

PHOTO BY CHASE JARVIS

Simplicity and sophistication—two
important elements of commercial work.

PHOTO BY NICK VEDROS

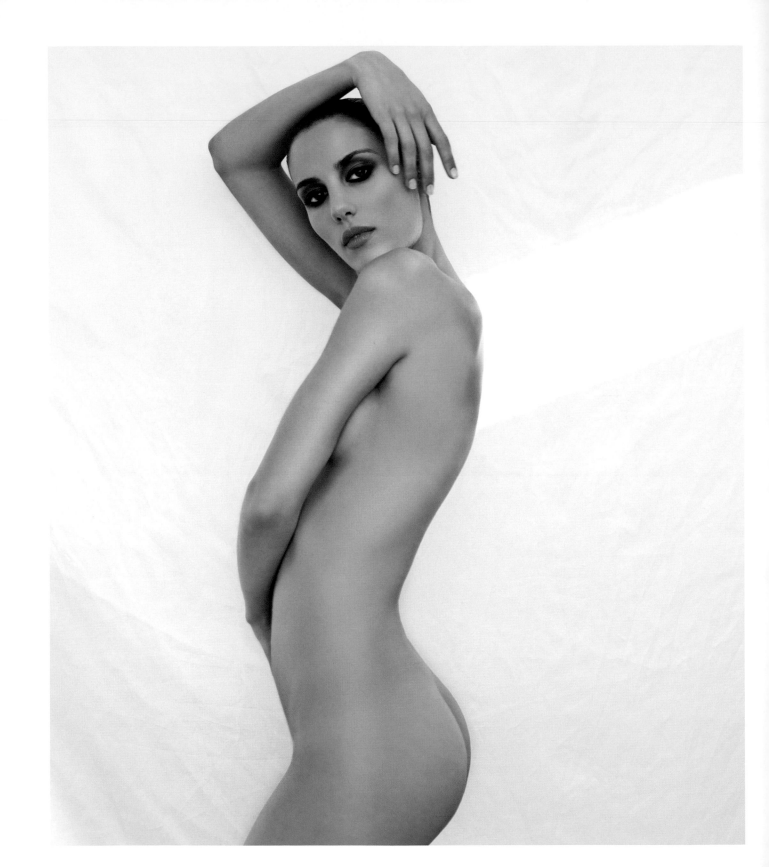

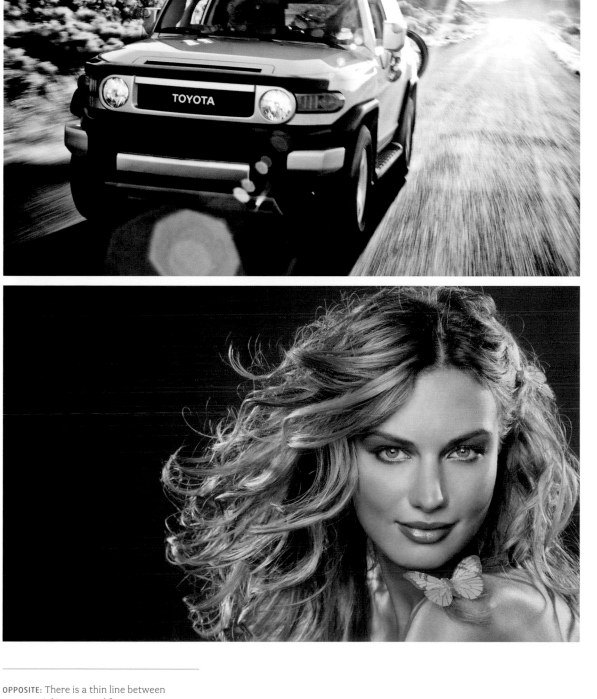

Lens flare isn't always a bad thing and can enhance even a straight-on image.

PHOTO BY CHASE JARVIS

Great lighting is a critical component of a commercial image.

PHOTO BY MATTHEW JORDAN SMITH

OPPOSITE: There is a thin line between commercial images and fine art.

PHOTO BY MATTHEW JORDAN SMITH

Fine Art

Galleries, poster shops, home-furnishing stores, crafts fairs, and other outlets around the world are filled with fine-art prints. Collectors buy work that ranges from photojournalism to landscape to the abstract—though finding buyers for your fine-art images is not easy, and this is probably the most difficult of the photographic disciplines in which to make a living.

The challenges are finding the audience to whom your work appeals, establishing the value of your work, and defining your niche in the art world. Many people consider the work of Ansel Adams to be fine art, while others consider his famous images to be nature photography—some of the finest work ever produced in the genre. As with any image, beauty is in the eye of the checkbook holder!

PHOTO BY EDDIE TAPP

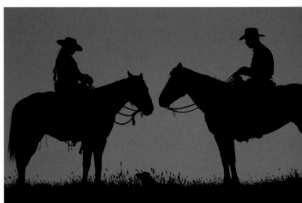

PHOTO BY SCOTT BOURNE

Is it fine art or simply a portrait, a nature shot, or something else? You be the judge, as will be the collectors who buy fine-art images.

PHOTO BY CHASE JARVIS

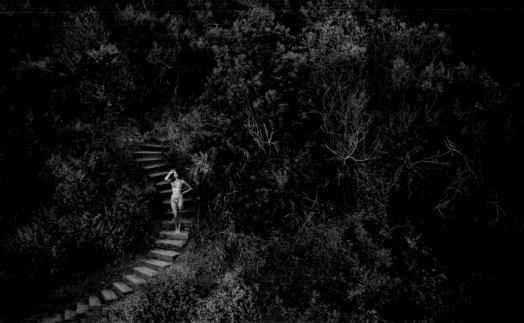

PHOTO BY JEREMY COWART

OVERLEAF: A wedding portrait
with a fantastical twist?
Whatever the intent, the
resulting image is an intriguing
piece of art.

PHOTO BY NICOLE WOLF

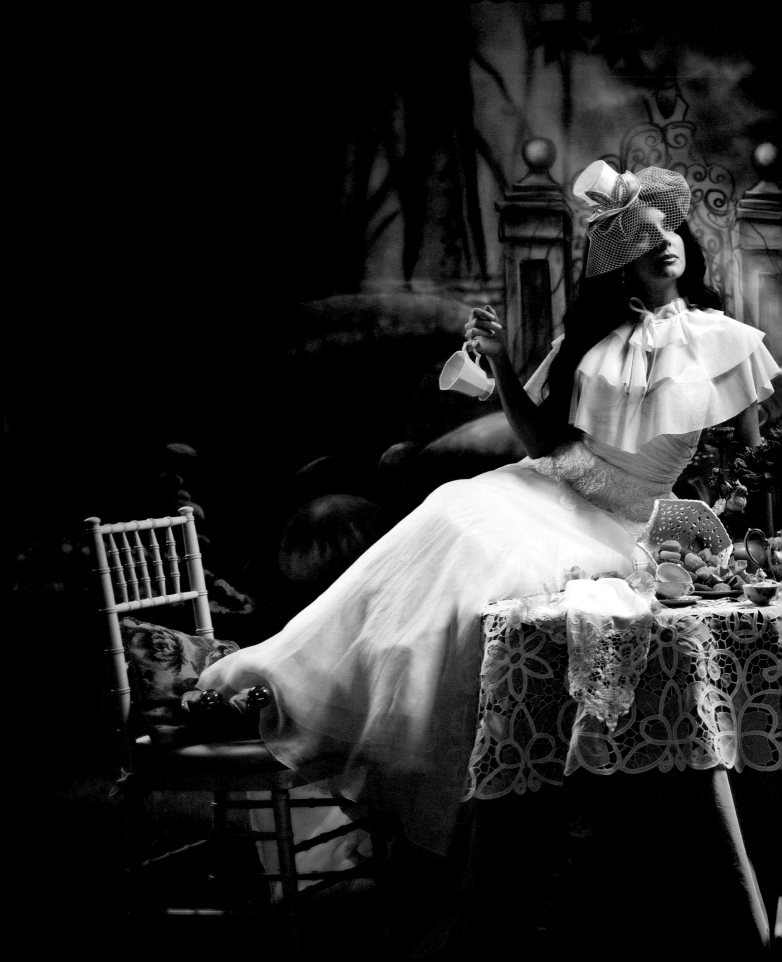

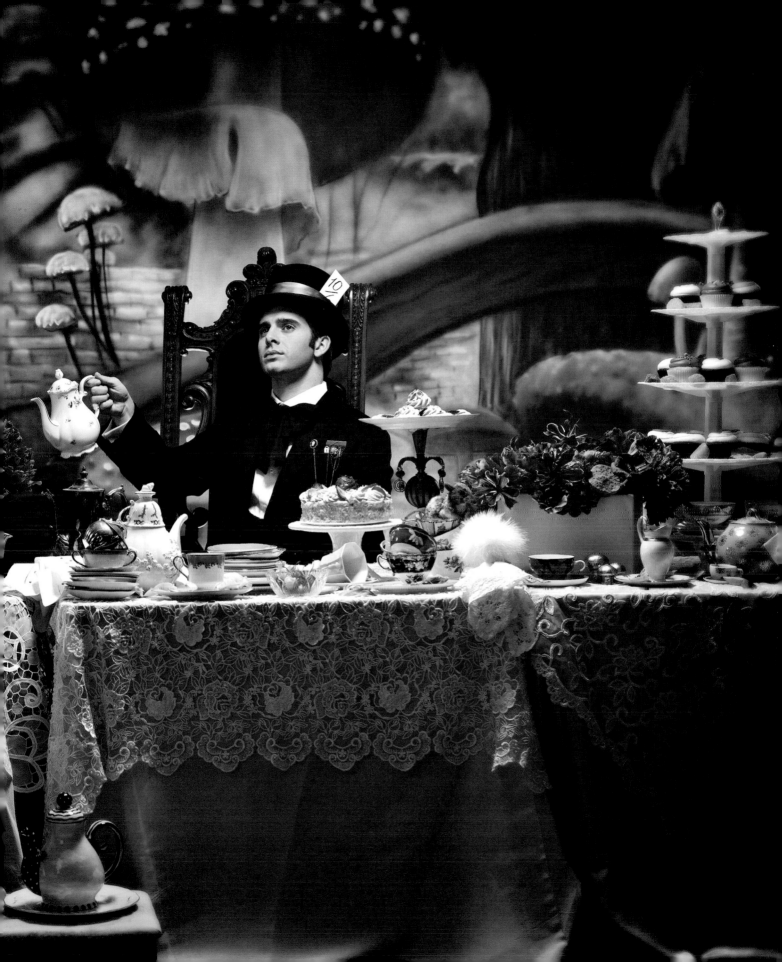

Nature / Wildlife

Just think: Who wouldn't want to get paid to go to national parks and lovely stretches of wilderness to take photographs? While the call of the wild is strong, the prospect of making a living as a nature and wildlife photographer is not. This is a highly competitive category, and for every nature photographer who succeeds, a thousand others do not.

Many amateurs like to dabble in nature photography, and this makes it even harder to succeed. Nature photography is also probably the lowest paying of all the photographic specialties, because there is so much competition. If someone has a picture of Old Faithful and is willing to license it for less than you are, you'll have a hard time convincing the buyer that your shot is better than his, or than the million other photos of Old Faithful out there. Don't be discouraged, however. Nature and wildlife photography will always be in demand. If you want to get paid in sunshine and are willing to specialize and market yourself, you can be happy in this category.

To stand out in this crowded field you need to devote most of your time to marketing, not to making photographs. Sales outlets include publishers of books, calendars, and postcards, producers of fine art nature/ wildlife prints, and stock and advertising agencies.

Concentrating on a niche is one way to make money in these markets, and innovators who find new ways to "productize" their work will find the most success. Scott Bourne created a successful stock agency selling his photographs of birds. For buyers who needed only bird images, this single source was much easier to use than stock agencies offering photographs of thousands of subjects.

Nature photography also provides rare opportunities to "speak for the animals." Wildlife photographers enter the world of photojournalism as they document the plight of so many incredible animals whose natural habitats are being destroyed daily.

I see wildlife photography as a responsibility and every image as an opportunity to speak for the animals.
PHOTOS BY SCOTT BOURNE

DEFINE YOUR NICHE

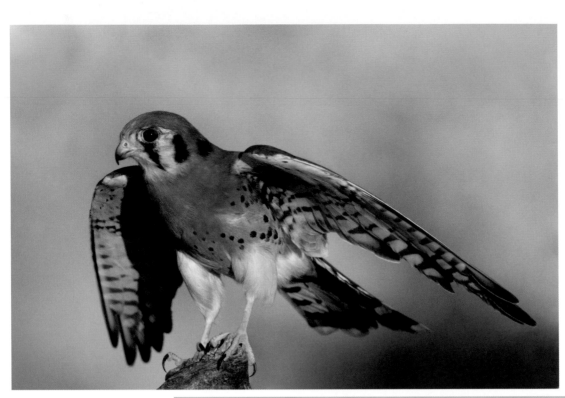

As with human portraiture, capture the eyes of your animal subjects to reveal their personality.

PHOTOS BY SCOTT BOURNE

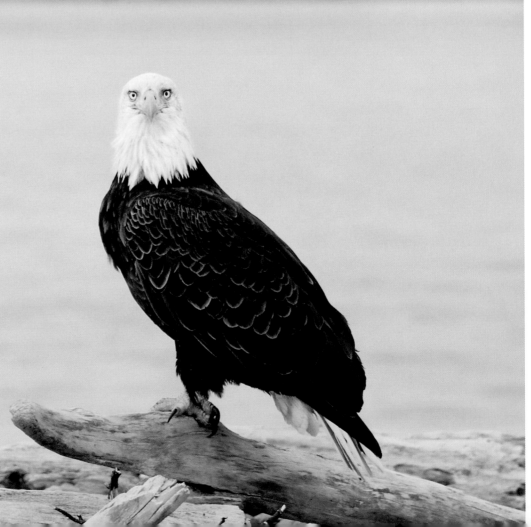

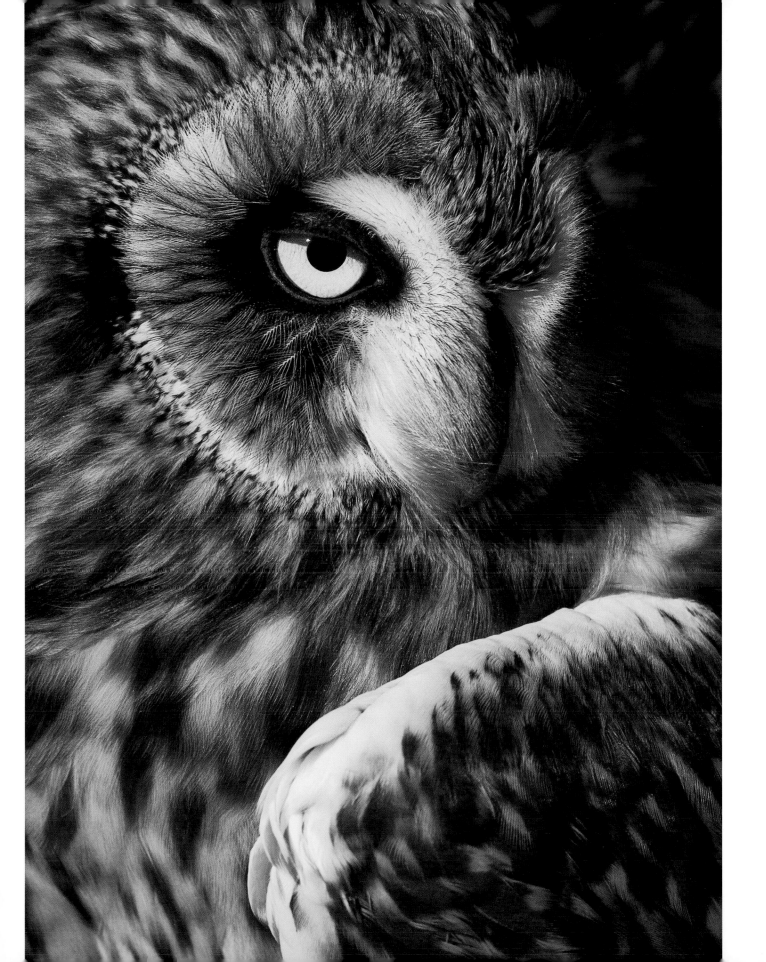

Photojournalism

Photojournalism, or news photography, is one of the most demanding photographic specialties. Getting the right shot depends on being in the right place at the right time to document a story unfolding. The reward is enjoying those incredible moments when an image captures the world's attention.

Steve McCurry was doing a story for *National Geographic* thirty years ago when he photographed "Afghan Girl." The image became iconic and is one of the most recognized portraits ever taken. "Afghan Girl" came into the news again, more than fifteen years after it was first published, when McCurry returned to Afghanistan in search of his subject.

Being a photojournalist takes time and dedication and a unique "always ready" mentality. Typically you start by submitting images to a local publication or newspaper until something is finally accepted. Think of yourself as a writer making countless submissions until one day a book offer turns up amid the rejections.

Being a photojournalist also requires strong skill sets. Would "Afghan Girl" be such a memorable image without Steve McCurry's complete understanding of photography? Look at the lighting and the way he created an outstanding portrait. Remember, too, this was taken back in the days of film photography. Steve didn't have the benefit of digital photography to check and touch up his work—and he didn't need to, because he understood the basic fundamentals of using film and his camera. A photojournalist also has to master the finely tuned skill of anticipation. Whether you want to capture a newsworthy event or the winning touchdown at a football game, as a photojournalist you must be able to anticipate the decisive moment and click the shutter. It's about patience, persistence, and an unwavering comfort level with your equipment—rarely will you get a second chance to get the shot!

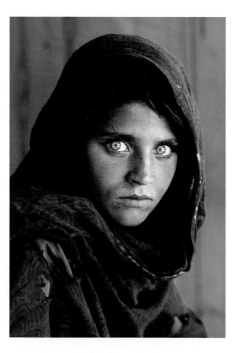

"Afghan Girl" is one of the great photojournalistic images that have become iconic.
PHOTO BY STEVE MCCURRY

44

GOING PRO

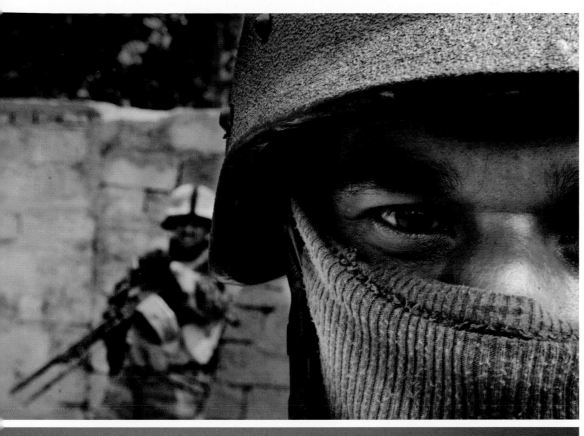

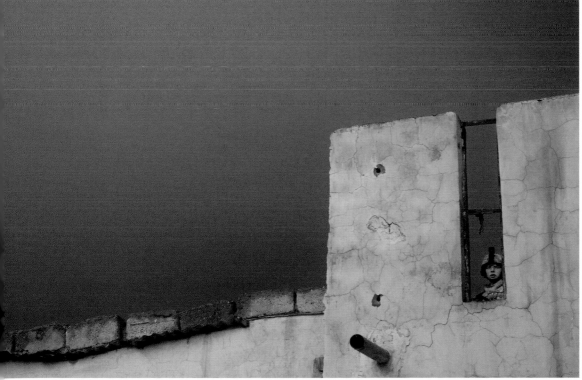

Being a photojournalist often requires being in the heart of the action. Stacy Pearsall was awarded the Bronze Star for her heroic actions under fire.
PHOTOS BY STACY PEARSALL

TWELVE HABITS OF HIGHLY EFFECTIVE PHOTOGRAPHERS

With a tip of the hat to Stephen R. Covey, here's a list of twelve habits we've noticed in effective photographers.

1. **THEY HOLD THEIR MUD.** That's an old-fashioned way of saying they stake out their ground and defend it. They own their opinions. They hold fast to their beliefs. They ignore the chattering class and look inward for their true selves. When you study the work of the truly great masters, you will notice that they generally ignored the opinion of critics and did what they thought was necessary to tell a story, the story the way they saw it. The greats don't fret. They don't sweat the small stuff. They are doers. They leave others to wonder why.

2. **THEY AVOID RELIGION.** We don't mean they aren't spiritual people or that they don't go to church. We mean that they don't get too wrapped up in PC versus Mac, Aperture versus Lightroom, film versus digital. Sure, the greats have opinions on these subjects, but all they really care about is creating the best photograph. To the greats, it has always been, and will always be, about the picture. Nothing else matters.

3. **THEY KNOW WHAT THEY WANT AND THEY GO FOR IT.** When you have the confidence to say, "This is the shot," then you are closer to greatness. When you feel the need to run that image by everyone from your priest to your camera club president for "feedback," then you're lacking what it takes to be really, insanely great. The greats don't wait for permission. Ever.

4. **THEY MOVE AHEAD.** The greats don't dwell on the past. Last year's photograph is last year's photograph. The greats are always thinking about the next great image. They don't worry about the image they missed. They enjoy the one they didn't miss. The greats don't let any excuse hold them back. They abandon past mistakes. They constantly seek the bleeding edge in their photography. The next image is the one they spend the most time thinking about.

5. **THEY KNOW WHAT NOT TO INCLUDE IN A PHOTOGRAPH** (as the great nature photographer John Shaw has so wisely pointed out). A great photographer knows that a photo is like an onion. You have to peel away the skin to get to the good stuff. Great photographers work by process of elimination. They refine rather than mine. They dig deeper than the rest of us. Where we see a complex scene involving many subjects, they see one simple subject in all its glory.

6. **THEY FIND A NICHE AND STICK WITH IT.** This doesn't mean you can't shoot more than one subject or style. It means you concentrate on one genre of photography.

7. **THEY KNOW THEIR AUDIENCE.** If you're a wedding photographer working in Southern California, you will have a different approach from a wedding photographer working in southern Mississippi. Knowing what your audience believes, feels, and desires is important.

8. **THEY WORK HARD AND OFTEN.** If you don't shoot every day, or at least work on showing, building, marketing, or selling your images every day, you're probably not as effective as someone who does. Photography isn't as easy as it looks. It takes dedication and hard work to succeed.

9. **THEY HAVE A PLAN.** Photographers who expect to get rich quick are almost always disappointed. Those who build a plan and work according to that plan have the best chance at not only being effective, but being successful and happy.

10. **THEY DON'T WAIT FOR PERMISSION.** Unless you work for "the man," you can't afford to stand around and wait for someone to tell you to go out and shoot. Pick up your camera, go out, make images, and show those images. It's up to you to make something happen. Don't wait for someone to tell you what to do. Do *something* and do it now.

11. **THEY NEVER STOP LEARNING.** If you really want to be effective as a photographer, you owe it to yourself to spend as much time reading photo books, magazines, and blogs as you can. You should be taking classes and attending conferences and workshops. No matter what stage of your career you're in, try to learn something new today, and every day.

12. **THEY MOVE FORWARD.** Photography is a lifelong pursuit that requires constant motion for success. You can only be moving in one of three directions: backward, side to side, or forward. If you aren't moving forward, you aren't making progress. Ignore the negative. Embrace the positive. Move forward and leave the doubt, fear, bitterness, anger, and jealousy that plague much of our world behind. You'll be a better shooter for it.

VINCENT LAFORET

Many photographers strive to create images that say something about them as well as their subjects. It's not uncommon, for example, for portrait photographers to be as well known as the celebrities they photograph.

A photojournalist, however, goes out into the world and tries to tell other people's stories. If you want to be a good documentary photographer, you need to make sure you can check your ego at the door and dedicate yourself to photographing other people's lives: their triumphs, their tragedies, and, more often than not, their everyday lives that we and they all too often take for granted.

A good photojournalist learns that his or her mission is to go out there and make photographs of the ordinary and to make those photographs extraordinary. I often say that my job is to make "something out of nothing," or, in other words, to see the beauty that most others miss. One of your primary functions is to listen, to learn, to study your subjects, to become informed, and to document them and what they do as objectively as possible. You are not going out there as a columnist to show people what your opinion is or what your bias is. You are not there to interfere with the news or event, nor to become a part of it. Your goal is to remove all of your own biases (we all have them) and to try to document what is happening in front of you.

At the end of the day, your measure of success should not be how "beautiful" or "well composed" your image is. What matters is whether or not you were able to document what or whom you witnessed that day faithfully—and to make sure that you were able to share that with the rest of the world (in other words, that you made your deadline!). Photojournalism is not about you or your pictures; it's about the people in your photographs and their stories.

Vincent Laforet captured Londoners Ben and Becky Smith on the Mall in Central Park, unfazed by the soggy weather as they were beginning a trip around the world.
PHOTO BY VINCENT LAFORET /
THE NEW YORK TIMES

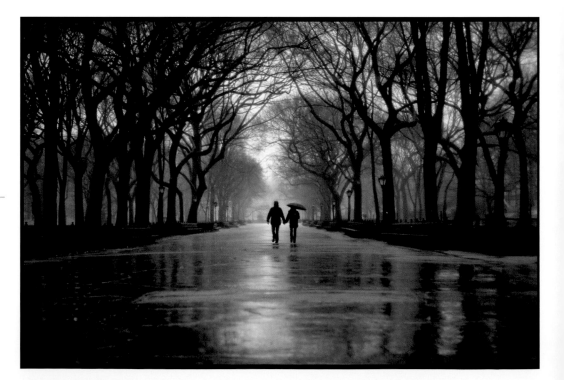

BAMBI CANTRELL

I've known almost my whole life I wanted to be a photographer. I can remember posing my little (monster) brother and threatening his life if he didn't behave, while at the same time telling him he had better smile his guts out. I found out pretty quickly that my "no nonsense" approach was probably not going to make me popular with my subjects if they were children. So I decided to photograph weddings. Little did I know how much the two have in common. I learned quickly I had to change my tactics if I was to be successful. Not to mention that if I didn't change or adapt, I would have a bride or a baby throwing a major tantrum.

Those early experiences with my little brother taught me a great deal about the three P's: patience, perseverance, and passion. Patience helped me to learn the craft. (Even in high school I found it difficult to learn any kind of technique from a book, but give me a visual lesson and immediately I was able to move forward.) It took perseverance to ignore that little voice in my head that would scream and tell me I should not pursue my dream, because I would never be good enough, smart enough, or perfect. And pure unadulterated passion has kept me in the game, continuously pursuing and learning the craft of photography.

Two things sum up my advice: Expression is more important than perfection, and humility always trumps ability.

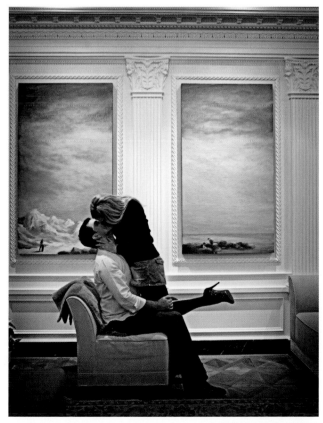

PHOTO BY BAMBI CANTRELL

PHIL BORGES

Once you decide to be a photographer, your job is visual communication. You need to be conscious of what you want to communicate, of what you want your work to say or accomplish. You will be miles ahead if you focus your photography on that which you are most passionate about and which you are most intimate with—that which you love and know the most about. Once you know your focus and what you want to say, play, experiment, and have fun.

A perpetual observer of humanity, Phil Borges lends a signature look and feel to his images.
PHOTO BY PHIL BORGES

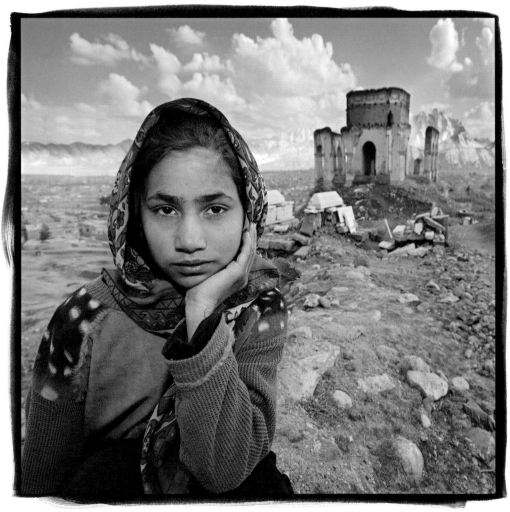

Kabul, Afghanistan Humaria 11

TONY CORBELL

Of all the elements necessary to succeed as a professional photographer, perhaps no single one is more important than quality. You simply must possess the drive and ambition to present to your clients a quality product. You must be a quality person. You must be a quality employer of others. Quality has to permeate everything you stand for.

Quality doesn't come easily. There are no shortcuts and it often requires great sacrifice. But if you deliver quality appropriately in every dealing you have, with everything you touch, success will surely follow. And it will sustain a great career.

As a leading specialist in lighting, Tony Corbell never compromises on the quality of an image.
PHOTO BY TONY CORBELL

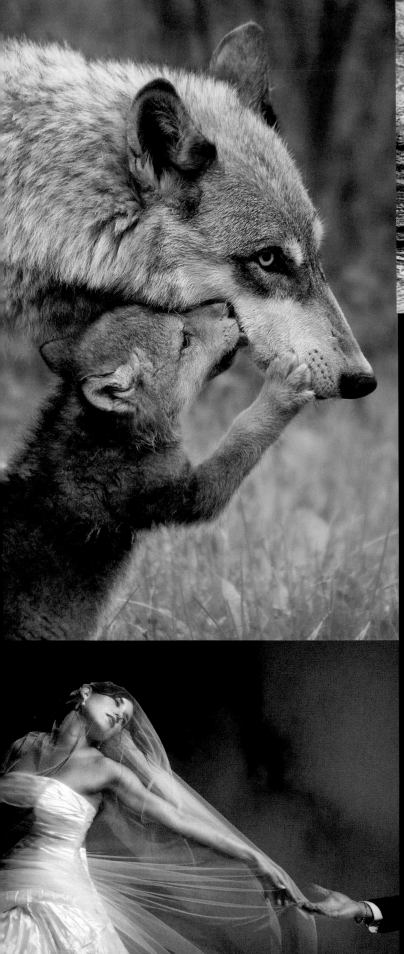

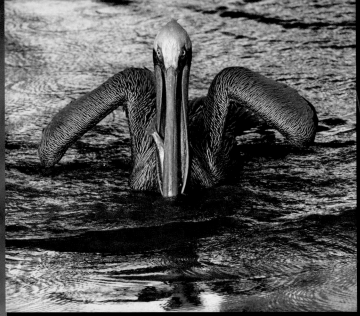

Don't fall in love with being a photographer without learning to be a great photographer. You can make a dream come true only if it's based on a solid foundation. —HELEN YANCY

Be the Best Photographer You Can Be

ROBERTO VALENZUELA ONCE told a group of students, "Practice doesn't make perfect. Only perfect practice makes perfect. If you're practicing it wrong, over and over again, it won't make you a better photographer!" If you're a golfer you completely understand the implications of that statement. No matter how many times you hit the driving range, if your swing is wrong, you're only reinforcing bad habits. Photography is no different. You have to practice the right techniques and stay focused on the final results.

We're not going to teach you the nuts and bolts of photography in this book. But here are some things you can practice to help you become a better photographer and make sure you're practicing your way into good habits and techniques.

PHOTOS BY (CLOCKWISE FROM TOP CENTER): SCOTT BOURNE; TERRY CLARK; BRIAN PALMER; NICOLE WOLF; JERRY GHIONIS; SCOTT BOURNE

Know Your Camera and Your Lenses

You need to know every feature of your camera and all of its capabilities and limitations. If you're going to be a professional photographer you have to understand every feature so well that you can utilize it without hesitation. You never want to risk missing the shot because you forgot how to switch to a different application mode on your camera.

Don't just read the instruction manual. Invest in some of the dozens of books about the operation of your gear. Check out the in-depth material that manufacturers offer on their websites. Webinars are often available, as are traveling workshop series presented in major markets around the United States. Many photographic retailers offer camera clinics to help you realize the full potential of your equipment.

Having a lens of the right focal length will make or break an image. Most photographers should have at least three lenses in their bag: a wide-angle lens, a standard lens, and a longer telephoto lens. The challenge is to make sure you have the finest optics you can afford, in terms of sharpness and speed.

Different lenses are going to have different applications, and as you get to know your gear better and better you'll also become more creative in how you use them.

In wildlife photography, a long lens allows you to be invisible and observe animals without disturbing them. In wedding photography, a wide-angle lens helps turn that little church into a cathedral. And in environmental portraiture, a wide-angle lens brings the subject's environment into the image, so the surroundings say something about who the person is. When you switch lenses you need to know the exact area of coverage every focal length is going to give you.

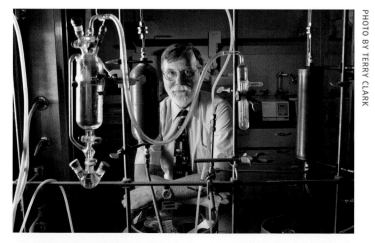

PHOTO BY TERRY CLARK

The challenge of environmental portraiture is using the right lens to bring the subject's occupation into the image.

The only way you're going to get to know your lenses and the benefits of each focal length is to practice in dozens of different situations. This is where practice *will* make perfect.

Practice Wherever You Can

- ¤ Photograph indoors in your home first to start recognizing the limitations of each lens in a confined space.

- ¤ Take your gear to a local church or synagogue and photograph with each lens. Imagine you're photographing a bride and groom during the ceremony from the first row, but off to the side, where a photographer might actually be allowed to stand. Notice the difference in the way each lens captures the scene.

- ¤ Attend a community event and photograph from a fixed position, again varying the lenses you use and paying attention to the differences in the coverage.

- ¤ Interested in outdoor/wildlife? If you live in an area conducive to finding birds and animals, terrific. If not, spend the day at the local zoo with your camera and experiment with different lenses and distances.

A longer lens allows you to be invisible—essential for a wildlife photographer.
PHOTOS BY SCOTT BOURNE

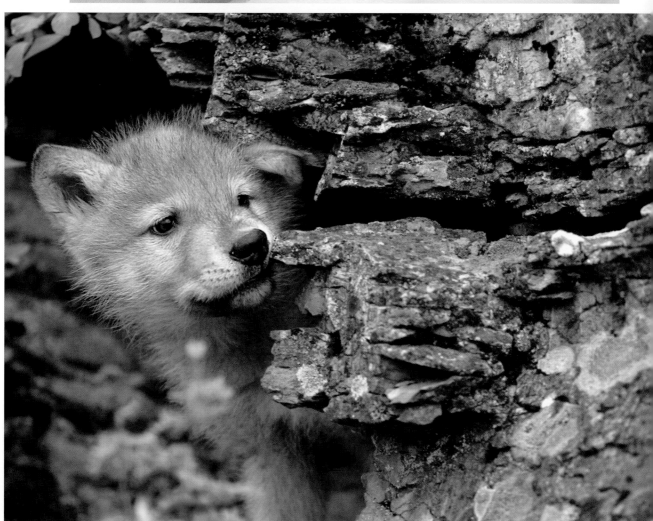

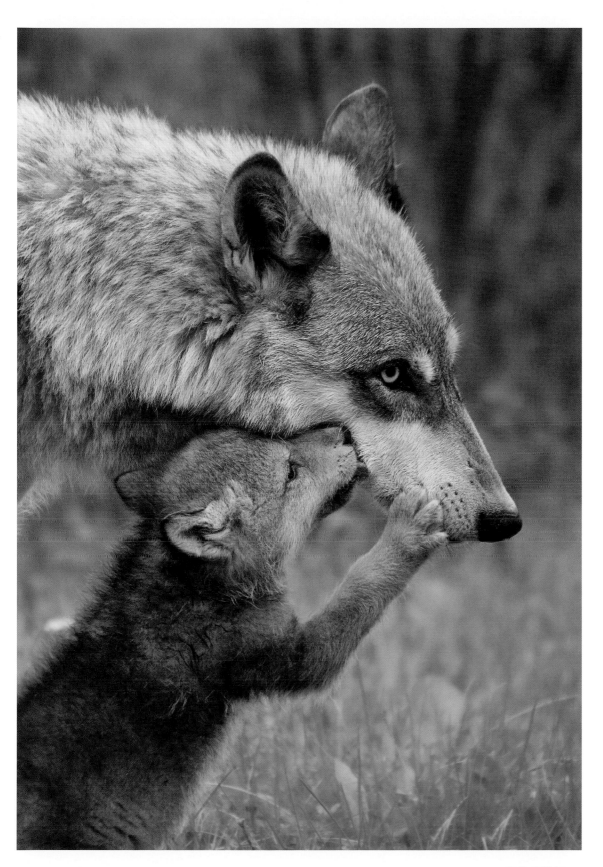

BE THE BEST PHOTOGRAPHER YOU CAN BE

A Pro's Take on Focal Length

For years David Ziser, noted wedding/portrait photographer and instructor, has been demonstrating the importance of lens selection and focal lengths. Here's what he has to say:

A lot of photographers don't realize the powerful compositional tool they have right in their gear bags. Camera manufacturers show their full arsenal of lenses on their websites and brochures. We lust for the widest and the longest lenses, don't we? We think we need a wide-angle lens to take it all in. We think we need a long telephoto lens to bring it in close. Sure, that's all well and good, but there is much more potential and creativity your lenses' focal lengths can achieve for you than just capturing a wide view or an up-close, tight view.

Look at the two images below. Both could have been made with the same zoom lens; for example, Canon's 24—105mm IS lens. The first image, shown at left, was made with my lens at 28mm focal length on my Canon 5D Mark II. Notice the bride in relationship to the cross behind her. Now look at the second image, shown at right. The cross appears to be twice the bride's size, even though she didn't move at all!

What's different between the two images? The answer is simple: Only the focal length changed in taking the second shot. I racked the lens out to 70mm, backed away from the bride until she was the same height as she was in the first image, and captured the second photograph.

Here is where the compositional magic of "focal length" comes into play: Shorter focal lengths make objects in the background appear smaller when compared to subjects in the foreground. Longer focal lengths make background objects appear larger relative to the subject in the foreground. Just remember to back away from the subject, keeping him or her the approximate same height in both photographs. Understanding this concept now gives you an easy, fast way to create a wide range of compositional diversity in your images, and it's kind of fun to see the difference.

Remember: It's not always about having the fastest, most expensive glass in your gear bag. Most of the time, it's about understanding how to use the gear you already own!

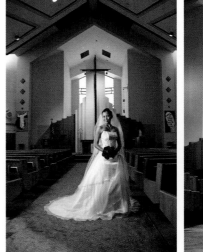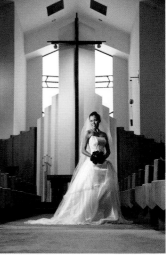

Working with longer and shorter focal lengths can add compositional diversity to images.
PHOTOS BY DAVID ZISER

SEVEN THINGS YOU CAN DO TO BECOME A BETTER PHOTOGRAPHER

Being a good photo-grapher requires vision and talent, but here's some practical advice as well.

1. **ALWAYS HAVE A CAMERA IN YOUR HAND** . . . your pocket, your purse, your car, or all of the above. Always. No exceptions.

2. **READ YOUR MANUALS, PLEASE.** At least 90 percent of the camera-related questions you might have are probably answered in the manual. Download a PDF of the manual, search for the answer, and read.

3. **PHOTOGRAPH SOMETHING EVERY SINGLE DAY.** No exceptions. No excuses. Don't just take a snapshot—make a picture. Think about what you're doing. Focus (pun intended).

4. **LOOK AT LOTS AND LOTS OF PHOTOGRAPHS EVERY DAY.** Look at published photographs in books and magazines, on billboards, in advertisements, and on the web. Ask yourself: "Why did they light it like that?" or "Why did she put the subject on that side of the photo?" or "What made the editor select this shot over another?" Asking questions about the photos you look at will make you think.

5. **EXPERIMENT.** Don't be afraid to make mistakes. Try different angles. Shoot at different times of day. Get outside your comfort zone.

6. **READ SOMETHING ABOUT PHOTOGRAPHY EVERY SINGLE DAY.** Take five, ten, or fifteen minutes to read photography blogs. Buy a book. Go to the library and ask for photography books. Read, study, learn, apply.

7. **SHARE.** Show your work to others. Ask them how it stacks up to the work they see in newspapers, books, and magazines. Be willing to experience some criticism and see if you can use that information to get better.

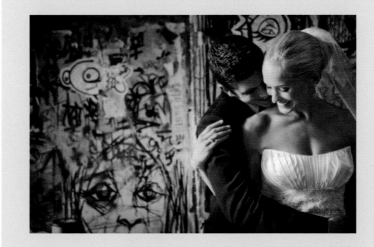

Look at photographs and see what makes them work. Here, a graffiti-covered wall adds a powerful design element to a bridal portrait.
PHOTO BY JIM GARNER

Understand Depth of Field and Other Techniques

It's one thing to know your camera gear and the impact a change in focal length will have on an image, but it's another to master photographic techniques. One of the most effective is depth of field—the relationship between aperture and shutter speed. A narrow depth of field will add significant impact in the right situation. What better way to demonstrate than to utilize an image created by Gregory Heisler, one of America's leading editorial photographers who has had seventy-two *Time* magazine covers in his career?

Heisler decided to capture a new portrait of one of *Going Pro*'s co-authors, Skip Cohen, for his birthday. He photographed wide open with a Hasselblad H1 with the 100mm f2.2 lens. A narrow vertical softbox with just the modeling light turned on was six inches from Skip's face and the camera was approximately eighteen inches away. An assistant held a black piece of card stock between the camera and the softbox, to keep the flare off the lens.

Here's where you really start to understand why Gregory Heisler is the "master." As he does here, he often concentrates on the eyes of his subjects and uses a narrow depth of field, with just the plane of the face in focus. This is a trademark of a Gregory Heisler image. While he toned the original print and used a little Photoshop to lightly clean up some of the subject's "personal challenges," in terms of exposure and lighting the image looked this good right out of the can. Greg understood exactly the look he wanted and didn't have to spend time cleaning up the image in post-production.

Gregory Heisler's portrait of *Going Pro* co-author Skip Cohen utilizes depth of field for maximum impact.
PHOTO BY GREGORY HEISLER

JUST IN CASE YOU DON'T THINK PHOTOGRAPHY IS IMPORTANT

No matter what you're photographing, whether it's a bird or a bridge or a building or an old man, your photograph could create a lasting impression of that subject.

Care about your subjects and tell their stories as if you are going to be the last person to ever get that chance. Put effort into the image. Don't cut corners. Don't go halfway. Spend some time thinking about what you're doing. Learn your gear and your craft. Execute as flawlessly as you can. And remember—it's a privilege to speak for your subjects.

A great image is not just about a great subject: As a photographer creating a lasting impression, you must master composition and depth of field as key tools in the creative process.
PHOTO BY JEREMY COWART

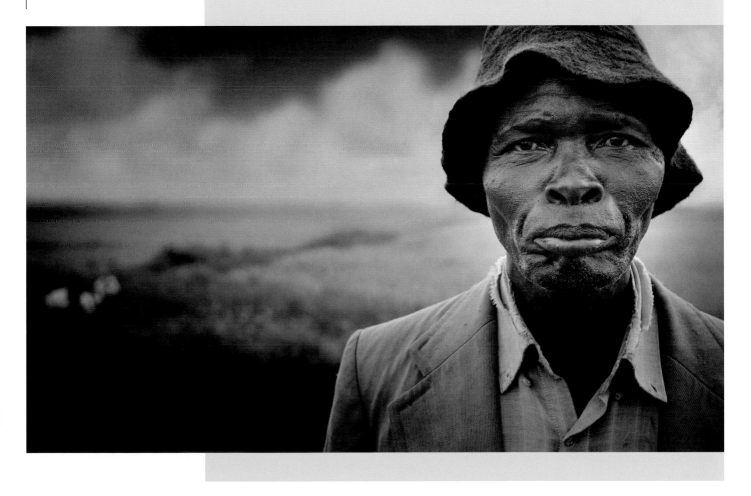

SEVEN WAYS TO IMPROVE YOUR IMAGES WITHOUT BUYING NEW GEAR

Gear alone won't make you a great photographer. It's also about learning technique and developing good habits.

1. **AIM FOR QUALITY OVER QUANTITY.** What if you limited yourself on your next outing to just one photograph? Think about it. Plan it. Work hard to research where and when you'll make that image. Get to know your subject.

2. **KEEP A NOTEBOOK HANDY AT ALL TIMES.** Write notes about things that visually inspire you. When you get into a rut, page through the notes to see if you can find something that shakes some fruit out of the tree. A modern-day equivalent would be the voice recorder on an iPhone. However, there's some additional value to being forced to write something down. It sticks better.

3. **START TEACHING.** No matter where you are in your photographic journey, you know at least one more thing than someone else does about photography. Find someone you can help and go do it.

4. **SHOOT FOR YOURSELF.** Think of a photo project you've always wanted to do. You are the audience. Make a pact with yourself: You will never, ever show the images from this project to anyone. In fact, you will delete the images once the project is over—except the one you'll keep as a reminder that shooting from the heart makes the best photography.

5. **AVOID CLICHÉS.** Find your true self in your next big image. You don't have to concentrate on breaking the rules or being gaudy for shock value. Focus on what you really want to say with your camera. Do you want to make images that last? Do you want to make images that really stand the test of time? Then be yourself. Shoot what your heart wants you to shoot. Make a decision on what's important to you, not to your editors, or your partner/spouse, or your teacher. You are the person behind the image. Don't be afraid to let that infect your work. Don't try to be cool for the sake of being cool. Be true.

6. **THINK BEFORE YOU SHOOT.** In fact, spend more time thinking about a shot than you take to actually make the shot. If you don't spend time applying some critical thinking skills to your work, you're probably not even coming close to your potential. Thinking through and working through problems makes you stronger.

Being the best means mastering technique: lighting, camera angle, depth of field, and exposure all play a role along with a creative vision.
PHOTO BY CHASE JARVIS

7. **PERSEVERE! HALF OF PHOTOGRAPHY IS PATIENCE.** It's not easy to set a goal and stick to it. But it sure is rewarding. Gut it out. When it gets hard, dig in your heels and work harder. Stay on each location an extra ten minutes. Spend an extra fifteen minutes a day looking at published photos (and studying the work of successful photographers whom you admire should be part of your routine). Handle your camera. The more effort you apply, the better the result. Work hard, then work harder. Back in high school we used to say, "Everybody wants to be a rock star without having to learn the chords." There's no getting around the fact that getting good at photography involves dedication and hard work. Buying the best camera in the world won't do a thing for you if you don't get off the couch and go shoot.

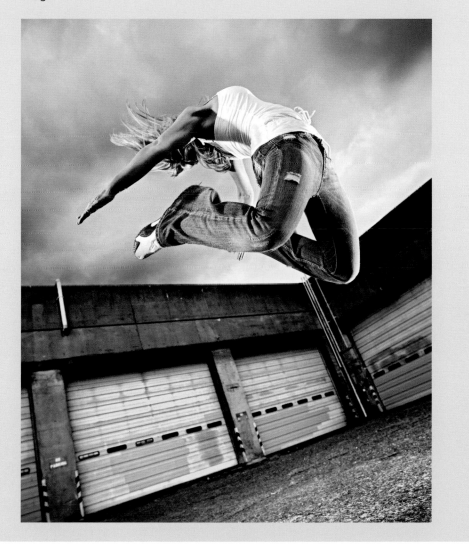

Keep on Learning

Many times throughout this book we'll talk about the importance of continuing your education. Being a great photographer isn't just about capturing great images; it's about staying on top of new techniques, listening, observing, and appreciating the latest in trends. You're literally about to embark on a career that demands you keep learning in order to be the very best. Here are some ways to make that happen.

Use Your Friends as Models to Build Your Portfolio

Remember, you've got to practice, practice, practice, and do it right! So when you don't have real assignments coming in you need to create your own—and that might mean talking friends and family into spending a day being your subjects. Interested in children's photography? You probably won't have trouble finding friends or neighbors with kids. Interested in outdoor/wildlife photography? Get yourself to a zoo and use a long lens and narrow depth of field to create images that demonstrate your skill set. Want to break into wedding photography? Hit a rental shop and deck your friends out in gowns and tuxedos.

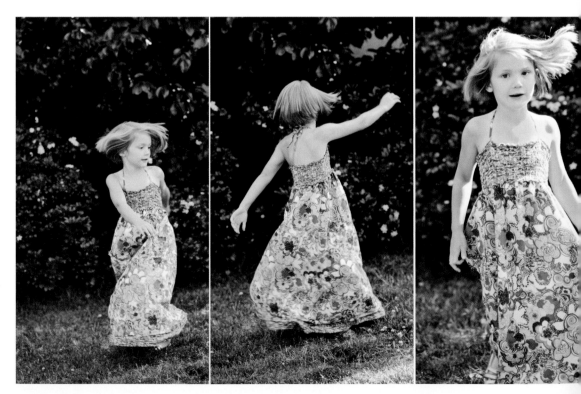

Experiment with shooting in sequence—kids can be great subjects when learning new techniques.

PHOTO BY TAMARA LACKEY

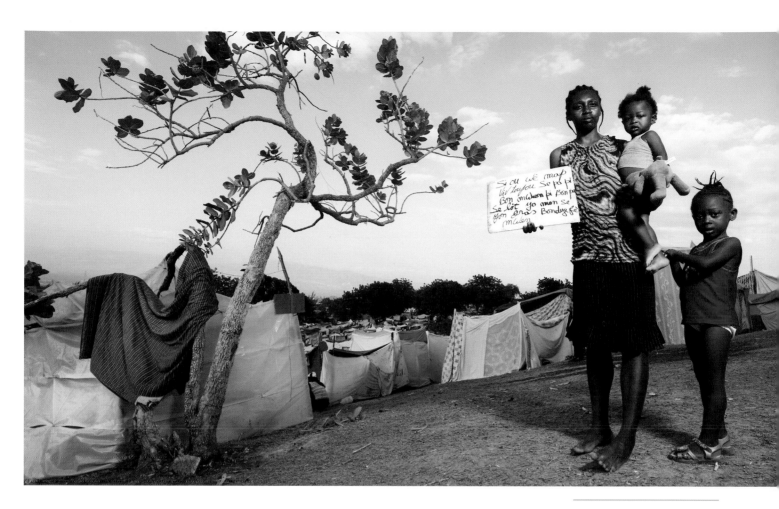

Let your images tell a story.
PHOTO BY JEREMY COWART

A PICTURE REALLY IS WORTH A THOUSAND WORDS

The old saying goes "a picture is worth a thousand words." If that's true, what words are *your* pictures saying?

If you think of your picture as a "story," it might help to construct the story before you get the picture.

Let's start at the beginning. What is your story's headline? What message does it scream? We like to think of this as caption or title first, shot second. It's a technique we've used for years to great effect.

Next, what is the idea or the purpose of your story? Is it to impart wisdom, evoke emotion, share beauty, preserve for posterity? The main idea should be simple and easy to grasp. You should also think of your audience. Is this story for the mother of the bride? Is it for the history museum or the textbooks?

When you're stuck trying to figure out the next great photograph, send these ideas flashing through your mind before you press the shutter. Maybe then people really will be talking about your image long after you're gone.

Consider Internships and Being a Second Shooter

It may seem odd, but a strong network is one of the key ingredients to help you refine your skills. It's the "yellow brick road," and the relationships you establish along the way are critical to helping you find opportunities to work with established professional photographers. Building the right relationships can help you land a full internship for several months or longer or a onetime event second-shooter gig.

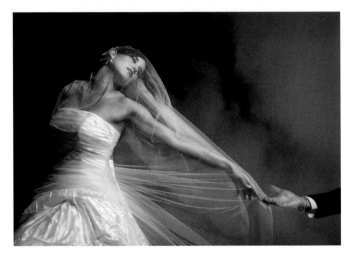

See a hint of Michelangelo here? Being an outstanding photographer is about being an artist and learning a thing or two from the great masters.
PHOTO BY JERRY GHIONIS

Internships pay little, if anything at all, but the experience is invaluable. One of Gregory Heisler's first internships was with the legendary Arnold Newman. The experience Heisler gained during those early years helped him build an incredible foundation to draw from in later years. Your challenge as an intern is to watch, listen, and make yourself useful. You'll also want to form habits. You're going to be a sponge, observing how images are created. You'll practice on your own, drawing on what you see, hear, and learn.

This is an industry built on relationships, and photographers will often help out other photographers who are just starting out by taking them on as second shooters. Being a second shooter (assisting another photographer) is far less of a commitment and more convenient than an internship if you're working in another career. A second-shooter experience gives you the chance to observe the techniques of an established photographer. Even so, a second shooter still has the responsibility to deliver great images, so it's imperative that you know your gear and have the skill set to capture a decent image. Many photographers continue to work as second shooters long after they establish themselves as professionals. It's all about the creative juices that another photographer's way of shooting might enhance.

BEING A SECOND SHOOTER

Jerry Ghionis, one of the most recognized wedding photographers in the world, made the following comment about being a second shooter:

I believe that assisting at weddings is the best training for any photographer. At the very first wedding I assisted, I probably learned more than in all of the time I spent in school. And that was because I was getting on-the-job, real-world training. At that first wedding I was taught about the direction of light, how to use flash, interacting with clients, working under pressure, and working under time constraints. I literally just carried bags and assisted a photographer for a year and half with no pay while I was working at a camera store. I did all of that just so I could be involved in the industry. And that's because when you're photographing a wedding, you're actually shooting much more than that. You're shooting a wedding, portraits, and fashion; you're shooting as a photojournalist; you're shooting product (all the details that you need to document); you're shooting the landscape, etc. So you're photographing in all these different genres and under time constraints, weather constraints, different cultures, and you're dealing with different personalities, so I truly believe that a really good wedding photographer can pretty much shoot in any genre. Artistically, don't be safe or stay in your comfort zone by going to "pose number 23 in location number 37." Comfort zones have never been synonymous with artistic expression.

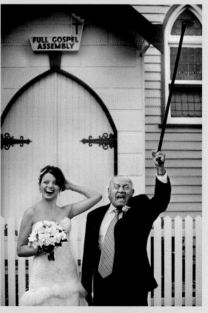

Having a second shooter allows a photographer to capture images that might have been missed otherwise.
LEFT: PHOTO BY JULES BIANCHI
RIGHT: PHOTO BY JERRY GHIONIS

Use Photo Blogs to Develop Discipline

In chapter 7 we're going to discuss ways to maximize your blog as a marketing tool, but now let's look at your blog as a tool for refining your skill set. Brian Palmer, a young photographer in Ohio, gave himself a challenge—to add one new image every day to his blog. The end result was a better-developed sense of discipline and a collection of terrific images.

Think about what it takes to find something interesting in your everyday environment. Creating an image a day, even if it's not posted on a blog, is an opportunity to experiment with every aspect of your skill set.

Attend Conventions and Workshops

You have your choice of literally hundreds of conventions and workshops to attend throughout the year. See page 200 for a list of some of the biggest. At each one you'll have the opportunity to learn a new technique or simply fine-tune your photographic, marketing, or business skills. It's important to choose wisely—attend only those programs that cover topics you need help with the most. Many will offer a lineup of photographers who can help you hone your skills. In fact, virtually all of the major icons in professional photography teach throughout the year, both on their own and as parts of various programs independent of any association or affiliation.

Check Out Webinars and Podcasts

Just about every professional photographer whom you may consider iconic has his or her own DVDs and books and is often a presence on the Internet in podcasts and webinars. At the top of the list are our own *Going Pro* podcasts and webinars, available on iTunes. Another way to stay on top of what's out there is to stay tuned to www.goingpro2011. com, where we announce new podcasts and webinars, along with various programs we think you should know about to improve your photographic, business, and marketing skills. We also have two other blogs that may help you stay on top of what's going on: www. photofocus.com and www.skipsphotonetwork. com. Remember, too, that every manufacturer of every piece of gear you own has a website. Many have blogs and offer online support on how to best use all their products and understand the various features.

LEFT: Brian Palmer makes it a point to capture a new image for his blog every day, mastering new techniques as he does so.
PHOTO BY BRIAN PALMER

RIGHT: Photography is a career in which you never stop learning. Attend every workshop, webinar, and convention you can.
PHOTO BY KENNY KIM

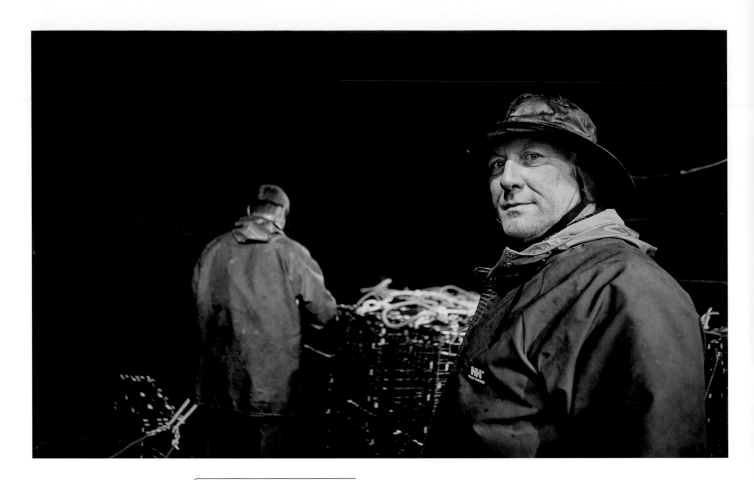

SPECIAL PROJECTS

There's been a lot of discussion recently from a number of well-respected photographers about "special projects"—that is, photographing the things they most enjoy. Nicole Wolf grew up in Maine and has spent several years photographing lobster fishermen. Here's what she has to say about building her personal body of work.

Ever since grad school I have also understood the importance of a personal body of work. This is not a paid gig. There are no clients involved. You may or may not ever show it to anybody else, but it is yours! It allows you to take your work to a place that is vulnerable, where you are not being judged on whether you got the right shot or produced the perfect photograph. It is raw, organic, and real. Figure out what you want to say. Tell a story or discover a new way of seeing. Allow yourself to make mistakes so that you can in turn create something inspired.

The list of photographers who maintain files of images with a specific theme and interest is extensive, but in every situation special projects help to keep you focused on the passion you have for imaging, regardless of what kind of photography pays the bills. Special projects give you a chance to constantly fine-tune your skill set and experiment in shooting in ways different from what your normal work requires.

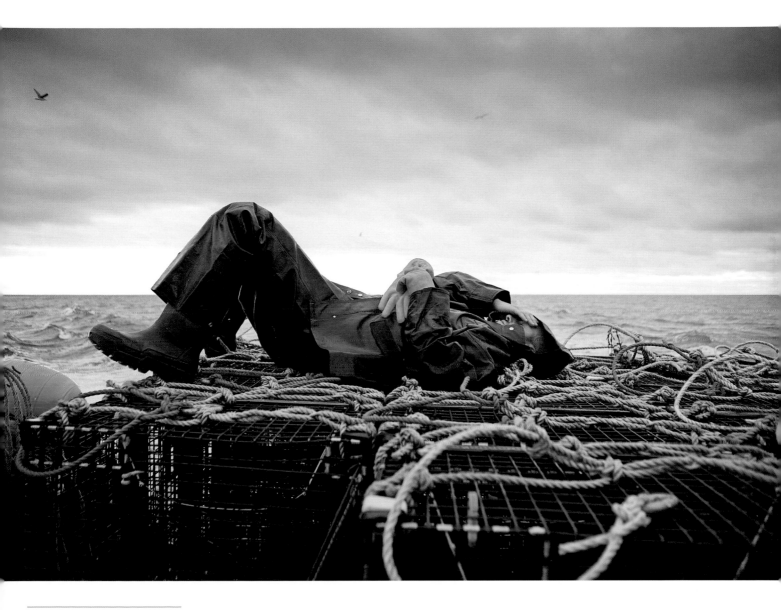

Pick a special project to indulge
your passions and utilize your
skills. The purpose is to nurture
your soul, not your wallet.

PHOTOS BY NICOLE WOLF

GREAT PHOTOS DON'T JUST HAPPEN

These photos reveal traits with which every photographer should be born, or at least be willing to develop over time. What they have in common is that with each, a single image tells a story, reinforcing the idea that storytelling is at the heart of good photography.

Photos like these don't just happen. Capturing images like these requires a certain amount of obsession with getting the right shot—doing so becomes almost the fulfillment of a dream. With this comes wonderment and imagination, being sympathetic toward a subject and playing with that sympathy to see what you can come up with. It is also necessary to get to know your subjects, whether a bird, a person, or a waterfall. Doing so will help you know exactly how to make the best images of those subjects. Finally, all good photographers must have patience, and lots of it. For some images you need to be willing to sit in a blind waiting for a bird to float by or until mist or another natural phenomenon finally decides to cooperate.

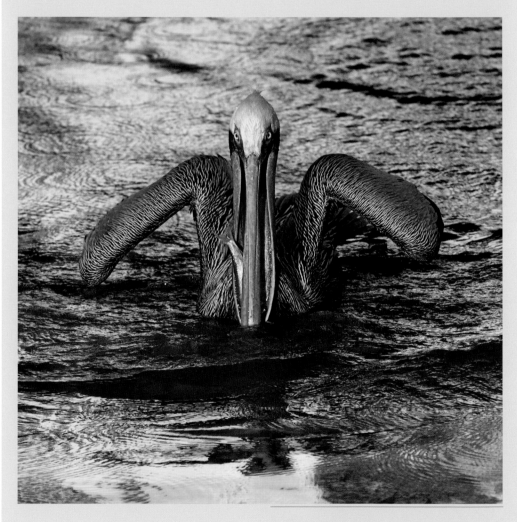

Single images of an oil-covered pelican or a gravely ill young person tell entire stories.
LEFT: PHOTO BY SCOTT BOURNE
RIGHT: PHOTO BY NICOLE WOLF

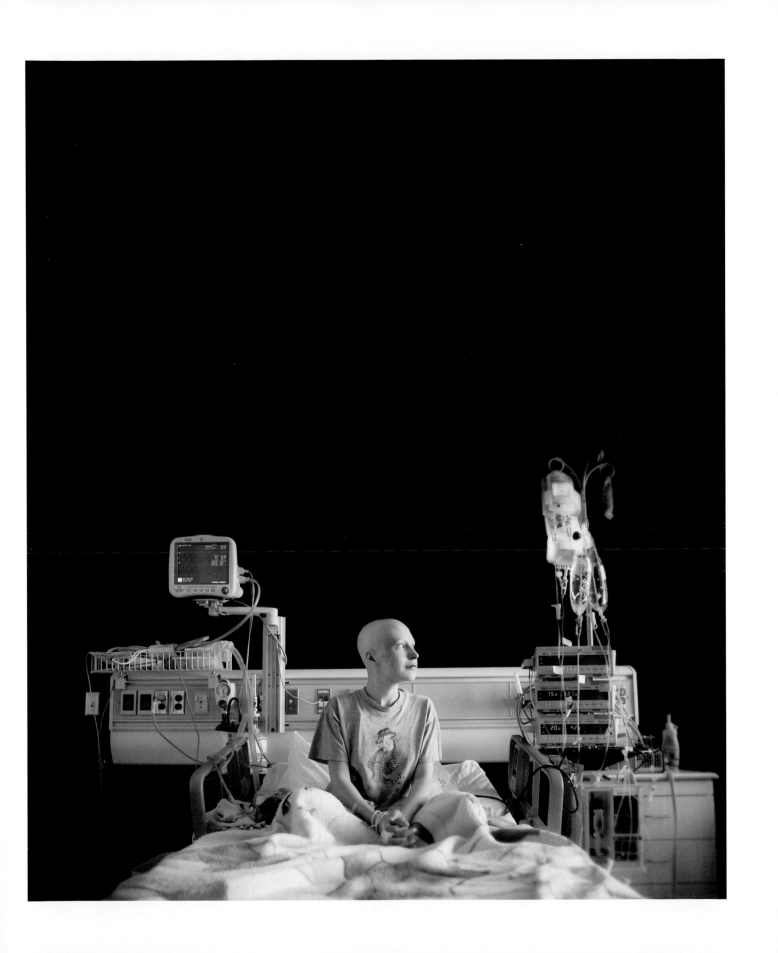

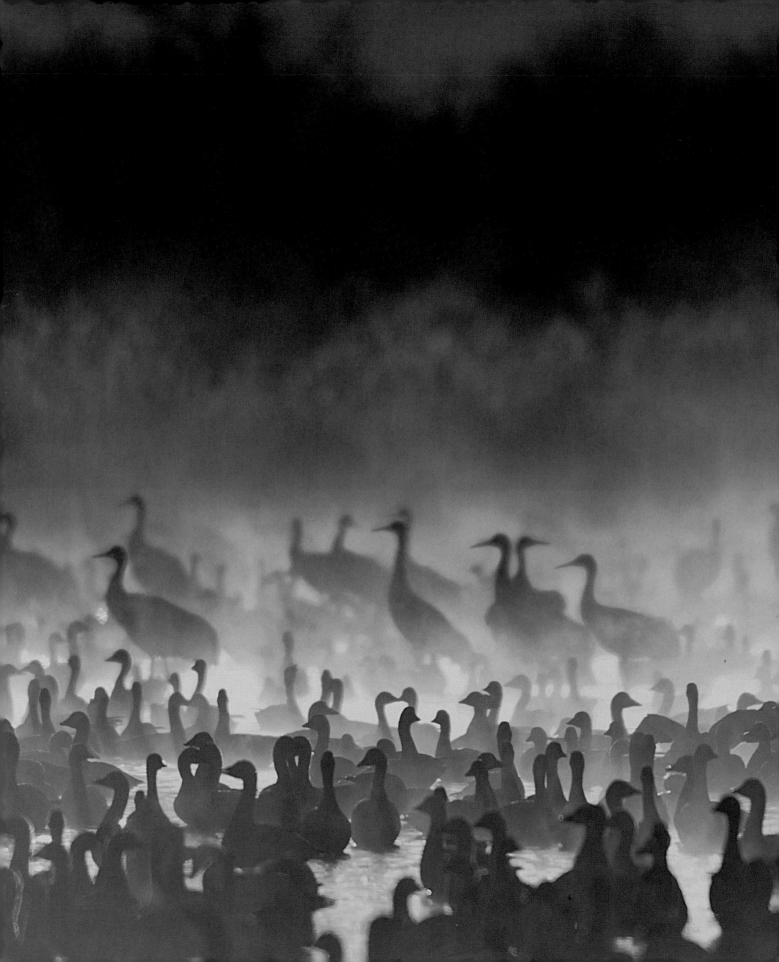

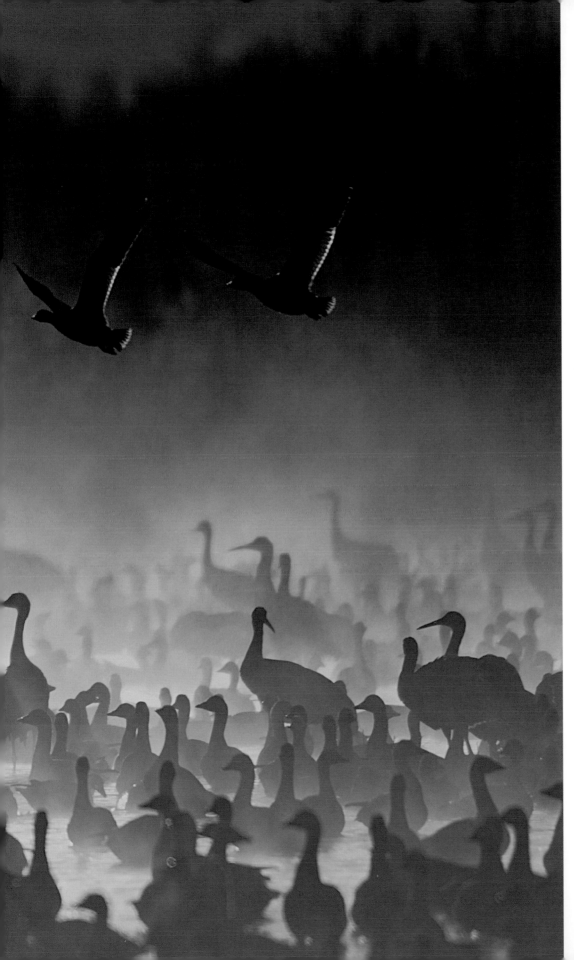

I worked at capturing this image every year for thirteen years. While that's an extreme, no one can question the passion it took to get the shot!
PHOTO BY SCOTT BOURNE

Bring a sense of passion to what you want to do and accomplish. Never say you are doing your best. You have no clue what your best is, and you never will as long as passion is your friend. And lastly, resolve that there will be no excuses in your life. Excuses only lead you down the slippery slope of failure.

DAVID ZISER

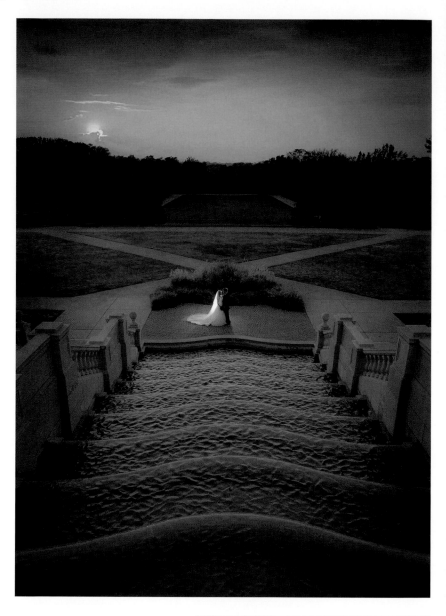

No two weddings are alike and each presents a photographer with an opportunity to strive for stunning creativity.
PHOTO BY DAVID ZISER

The most important thing you can be is educated, educated, educated. Don't be a casual shooter. Learn your craft; learn marketing; learn business. Don't fall in love with being a photographer without learning to be a great photographer. You can make a dream come true only if it's based on a solid foundation. Your dreams have to have a solid footing, with the right skill sets. Build your vision from both your world and the art world. Pay attention to the great artists. Study the art world in addition to the photography world and put them together to develop your own vision.

HELEN YANCY

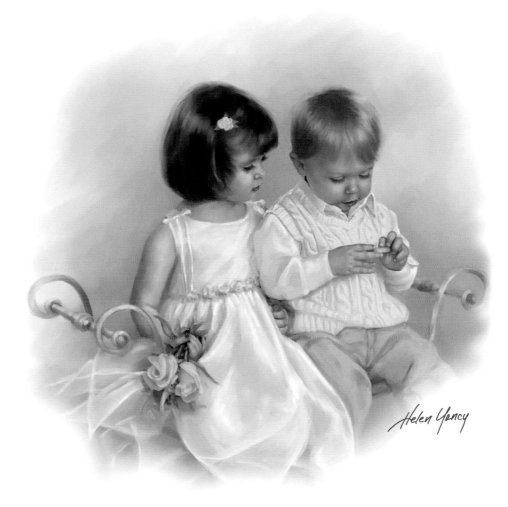

Special moments deserve special effects—in this case, converting a photograph to a watercolor was the ideal way for the artist to capture the softness and innocence of childhood.
PHOTOGRAPHIC WATERCOLOR PORTRAIT BY HELEN YANCY

RALPH ROMAGUERA

So you want to go pro in the world's greatest profession. First go to a baseball game, then go to a symphony! What happened before the big game? What happened before the concert? They practiced infield, and batting basics; they played scales—the same thing they did the first day they picked up a bat or that French horn!

I've made it for forty-two years as a photographer because of one daily routine—practice the basics.

Use images in your promotional materials that highlight your skills, style, and techniques.
PHOTO BY RALPH ROMAGUERA

MATTHEW JORDAN SMITH

Most photographers are busy in the beginning trying to find somebody's style to "almost copy." Learn to be comfortable in your own skin, with your own work. When I started I was always asking for advice; then a photographer I was working for told me, "Stop looking for advice from everyone else. Learn to see the value in your own work and be comfortable putting your work out there."

Don't try to anticipate what people will love and use that to determine what you're going to show. Show your work through your heart. It's the only way you'll ever be completely fulfilled.

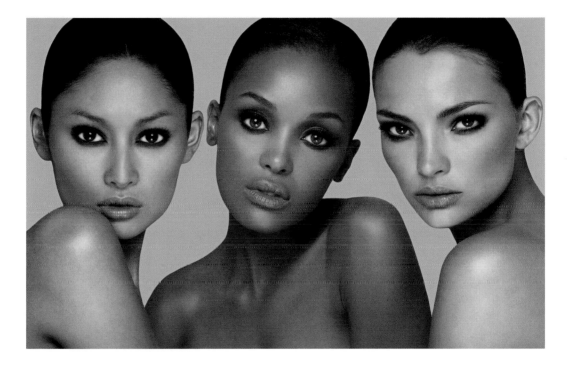

Never, never compromise on the creativity or quality of an image.
PHOTO BY MATTHEW JORDAN SMITH

Show the work every single chance you can get . . . Show the work—sell the work.

—SCOTT BOURNE

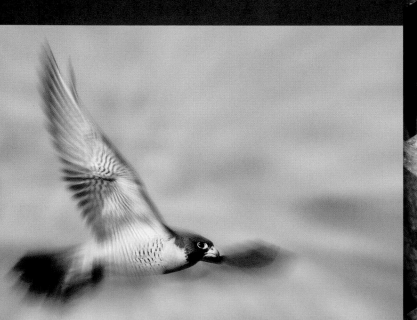

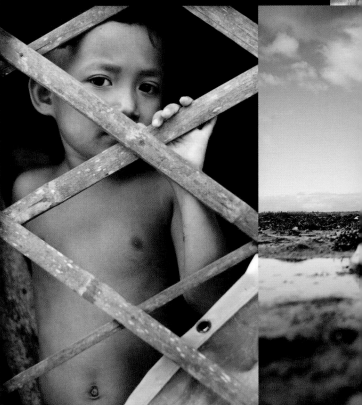

Test the Water and Show Your Work

PEOPLE CAN'T BUY what they don't see, and you need to commit to showing the work you do best every chance you get. The more frequently you show your work, the more of it you will sell. Enter art fairs and contests, create an outstanding website, publish articles on your blog, and hang your images in coffee shops, offices, and galleries. Offer to illustrate books in return for photo credits and send copies of your portfolio to professional designers and decorators and ask them to use your photographs when they create displays. Barter for wall space in local banks and restaurants where the public will see your images. Get the point? The more frequently you show your photography, the more of it you will sell.

PHOTOS BY (CLOCKWISE FROM TOP RIGHT): CHASE JARVIS; CHASE JARVIS; NICOLE WOLF; KEVIN KUBOTA; SCOTT BOURNE; CHASE JARVIS

Make an Impression with Your Website

Your website is essentially the equivalent of your storefront. You want people to take a look and like what you have to offer. That's why you want your website to show your very best work. It's a lot harder to undo a bad impression with a potential client than it is to just make the best impression in the first place! For more on creating effective websites, see Chapter 7. But, in brief:

- Never compromise on quality. Love every image you put up on the site.

- Let your images say who you are. It takes at least twenty images to tell a client who you are. That's the barebones minimum.

- If you're multifocused, be careful to not confuse your target audience. A wedding photographer who also does family and children's portraiture won't run the risk of confusion. Both niches are about people and there's a logical connection. But if this same photographer also loves to do tabletop commercial work and shows images from both niches, the audience may well become confused. In this case our vote would be to have separate websites aimed at different audiences, one for wedding work and one to show commercial work.

- Make your portfolio attractive.

- Don't bore viewers with lots of copy about who you are, your philosophy, and your goals. Just give them images to look at and a bit of text that is as dazzling as your images. Once someone hires you, they'll have lots of time to get to know about you and your background. Hook them with your skills first!

- About that dazzling text: Whatever you write needs to be from the heart. So often photographers spend too much time talking about their past awards and forget to simply tell their clients why they love what they do. Write a simple mission statement of three to four paragraphs in which you make it clear why you love photography and working with your clients.

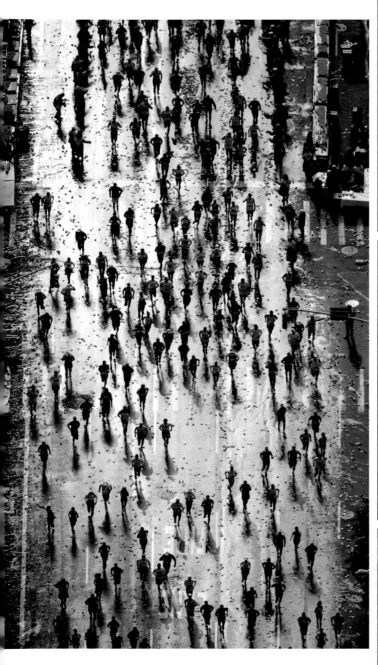

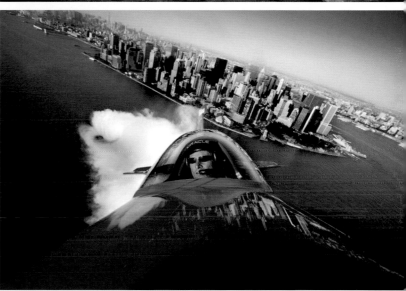

Every image on your website should be stunning—you should love every one of them, but even more important is having impact with your viewers.

PHOTOS BY VINCENT LAFORET

Take Advantage of Portfolio Reviews

New photographers often tend to lug around monster portfolio cases. You don't need hundreds of images in your portfolio, just a few dozen of your very best. You also don't need to print them at 16 x 20"—they don't need to be any larger than 5 x 7". We really believe that, even in our digital age, you should still have prints in your portfolio, because they demonstrate the printing and the presentation side of your skill set.

If you're showing several different types of photography, organize them by specialty. There's nothing wrong in having variety in your portfolio but keep each category separate, as it makes the demonstration of your skills that much stronger.

You can show your portfolio at two types of formal portfolio reviews. Portfolio review events are held throughout the country and expose emerging photographers to photo buyers, museum and gallery curators, book publishers, and photo editors. These events are job fairs for photographers and are usually packed with aspiring shooters. Bring business cards and be prepared to discuss your images in depth. Reviewers attending the event will select only the very best images and photographers (see page 200 for a list of some of the best-known review events around the country).

Portfolio reviews are also provided as an added benefit at many workshops and conventions, where you bring your portfolio and sit down with a working professional photographer, who reviews your images and gives you feedback. These critique sessions are not intended to introduce you to buyers but to help you improve your presentation. Whether you agree with the photographers looking at your portfolio or not, listen to what they're saying and how they look at your images. They have nothing at stake and are there to give you objective feedback.

For both types of review, show only your best work and display your images in the most flattering way.

Who are the people in these photos? Where are they and where are they going? Every image in your portfolio should suggest a story that engages the viewer.
TOP: PHOTO BY NICOLE WOLF
BOTTOM: PHOTO BY CHASE JARVIS

Contests and Competitions

Don't underestimate what you can learn by entering a contest or print competition. Many organizers will provide feedback on the images submitted, and some, such as Wedding and Portrait Photographers International, offer two days of open-to-the-public judging where you can sit and listen to the comments of the judges about each image.

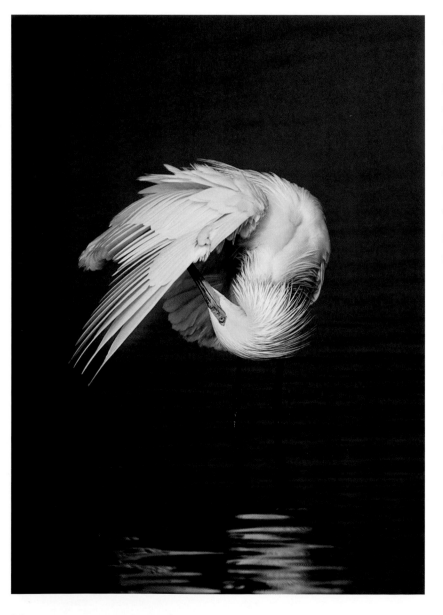

Even though an image may not win the competition, it may still garner attention. For instance, in contests sponsored by photographic magazines, often images are chosen as covers and for use in editorial. You never know who's going to see your images when you submit them in a contest. This is about building brand recognition for your name. It's also about building your network as you expand recognition of your work to other photographers, editors, and professionals who support photography.

Subject matter alone does not account for a competition standout. Keep in mind that camera angle, tilt, and depth of field all contribute to making an image unique.
LEFT: PHOTO BY SCOTT BOURNE
RIGHT: PHOTO BY BAMBI CANTRELL

OVERLEAF: All of the elements come together here for an image that would grab the attention of any judge.
PHOTO BY CHASE JARVIS

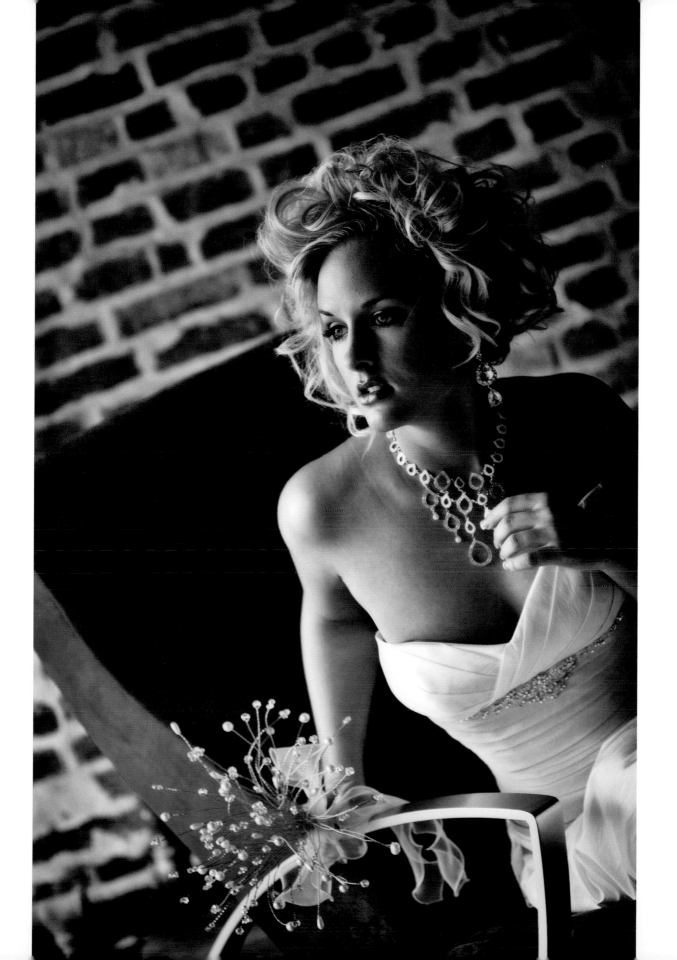

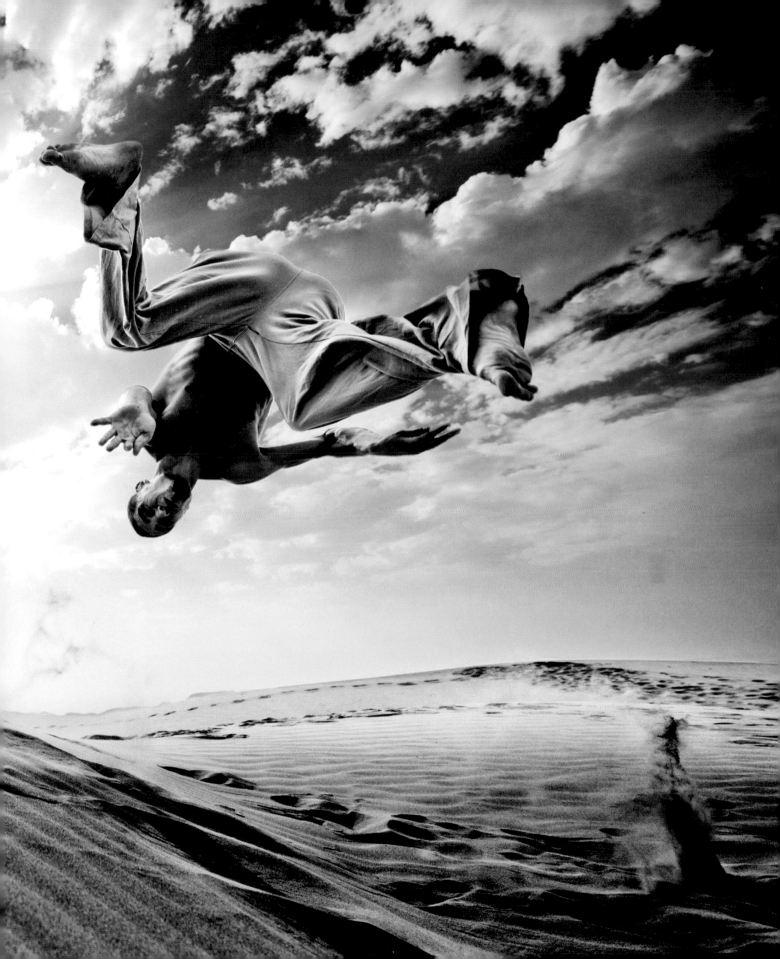

Share with Manufacturers and Possible Sponsors

Stop and think about how many different manufacturers or vendors support your role as a photographer. You've got cameras, lenses, printers, camera bags, tripods, on-camera strobes, and maybe even studio lights. You work with a lab, album companies, framers, slide show software providers, and the list goes on. Every one of these companies has a potential interest in your work, especially if it's creative and exciting. You never know when a company is going to need images for its website, newsletter, blog, or printed brochures. Maybe the way you're using a product is unique and might be something a company would like to share with more photographers.

Start by getting to know the players. This is as simple as going up to a vendor at a trade show and introducing yourself. Talk with the vendor about how you're using a company's products or services. Or, if you're not using these yet, ask pointed questions to show your interest as it relates to your business and your images. Leave a small postcard or an accordion-style foldout business card with multiple images so your new contact has something to remember you by. This way you open the door for a follow-up letter or e-mail a few weeks later. With either, explain how the company's products or services are helping you produce better images and attach examples.

How to Get Sponsorship

The manufacturers, labs, and service providers in our industry are buried in requests for sponsorship. So what are you going to do to make yourself stand out? There's a unique method to sharing images with potential sponsors, especially when you're just starting out.

What do you have to offer? Companies are interested in your helping them sell their products and increase awareness for their brand. The big question they'll be asking when they look at your images is, "How can this photographer help us sell more products?"

How's your reputation? Especially because you're a new professional photographer, be appreciative of whatever time you get from a manufacturer. If a company is not interested in your work, play it cool, listen to any advice, and stop by and say hello at the next trade show or convention. The more professionally you handle yourself the more likely you're going to stay in focus for future projects. **We're a small industry.** Virtually every

manufacturer has staffers who have worked at other companies. So be careful what you say and who you say it to. Bad news travels a lot faster than good news, and the manager you're talking to at one company may be incredibly close to the company or manager whose product you just bashed. On the positive side, don't assume that just because one company wasn't that excited about your images, your name isn't going to stay out there for a little while. Outstanding images are outstanding, and word gets around.

Stay in contact, but don't make a pest of yourself. Projects are limited and staff at any company today is limited. You're sending in work to a totally overworked, spread-too-thin manager to ask for support. Give him time to review your project. Don't get in his face. If you send in images to a company and don't hear back after a few weeks, no news simply means no news. Just be patient. If you're a class act and your work is good, everyone you approach will love to get involved with you at some point.

Be sincere. Make it a point to only approach companies whose products and services you really use and believe in. If they're not interested in seeing more of your work,

give it a little time before you jump ship. **Most important of all, be patient and don't give up.** Many of today's sponsored photographers never approached most of their sponsors—their sponsors approached them. The key to having a company like your work so much that they want to sponsor you comes down to building your brand—getting people to know you, your work, and what you represent. Never compromise on quality and always create the very best images you can.

Clay Blackmore has been sponsored by Canon for many years. The power of Clay's images is about his creativity, lighting, composition, and the way he brings out the best in every subject.
PHOTO BY CLAY BLACKMORE

Get Published

Let's start with publishing images on the local level. You might have images in your "stash" that you took at a specific event that might be of interest to the local paper, the chamber of commerce, or businesses that were involved in the event you photographed.

If you're just starting out, we suggest you share a few of these images at absolutely no charge with some of the local businesses and the chamber of commerce, just to let them know you're there. Make up a few prints and drop them off personally to the entity you're trying to reach. Remember, you're also networking and getting to know all the players in town. You never know when somebody is going to find your images useful in brochures, a web page, or promotional opportunities. If you have a child on the local high school football team, consider getting permission from the coach to photograph the game from the sidelines. Then contact the local sports editor at the weekly paper and look for an opportunity to show your images.

As you start trying to break into paid work, search for less competitive publications. These may not have the curb appeal that major national magazines do, but they don't receive as many submissions and are more likely to hire beginners. While you're at it, don't overlook the value of local weekly newspapers. Small town weeklies usually cannot afford to hire a full-time staff photojournalist, providing freelancers with a tremendous opportunity to break into print.

Every industry has trade publications that you've probably never seen unless you're a member of an association or deeply involved in a particular industry. These publications often pay for editorial content, giving photographers the ability to demonstrate not only their ability to capture an image but to write about it as well. Small presses and publishing companies often look for images to use in calendars, brochures, hard-copy newsletters, and small-run magazines they print for a variety of clients.

Your greatest reward and toughest challenge will be breaking into photographic magazines. You never know when an editor at any of these magazines might just find something interesting in your work and want to use your images in support of editorial content. It's not easy to get an editor's attention, but it's not impossible. Most magazines publish their editorial calendars a year in advance. You'll find calendars on magazine websites, usually under a category targeting advertisers. *Rangefinder* magazine, for example, lists the editorial calendar with the media kit under "Advertising." The calendar shows each month's theme, covering such topics as portraiture, children, lighting, and fine art.

Let's start with how to get your images in front of a staff member:

Do your homework and get to know who the players are, their responsibilities, e-mail addresses, mailing addresses, and all other contact information. This information is usually listed on the masthead of the magazine or in the "about us" or "contact us" sections off the website.

Check to see if your contacts are going to be at upcoming conventions or events that the magazine might be sponsoring. *Rangefinder* owns the Wedding and Portrait Photographers International (WPPI) Convention (February or March); *Photo District News* (PDN) owns PhotoPlus Expo (October); and Professional Photographers of America (PPA), which publishes *Professional Photographer*, owns Imaging USA (January). The magazines' entire staffs usually attend these conventions, and they exhibit at their

Use depth of field to bring power to your images.
PHOTO BY MICHAEL CORSENTINO

own shows, at one another's shows, and at a number of regional and road show programs. You want to meet some of the staff directly—not to be in their faces pitching them the first time out but to start to network and get to know them. You'll always do better making contact in the future if you've actually met somebody in person. These organizations are in constant need of help for their trade shows and conventions and volunteering gives you a chance to meet the staff as well as expand your network.

Check out some issues of the magazines to see who the big advertisers are and whether you use their products or services. Reaching an overworked editor is always easier if you've got a relationship with a potential sponsor or vendor who might put in a good word for you and help open the door.

Last but not least: Do you have incredible work to share with the magazine you're interested in? When we say "incredible," make no mistake about it—the images have got to be outstanding. Remember what you're after here: the golden chalice of exposure—getting your work published! You're competing with thousands of photographers who might be more established and have more depth in their skill sets, but that doesn't mean you can't break through and get your work published.

Submit Your Work the Right Way

The submission is the first real impression an editor will have of you so it is important to make a professional presentation. First, try to

obtain and follow all the submission guidelines that most publications list on their websites.

Next, pay attention to detail. Don't be sloppy. Use new, clean, and appropriate packaging for the submission. Put your photos between two clean pieces of cardboard with rubber bands around them. Use professional-looking packaging for your CD.

You'll make more of an impact with overnight shipping than you will with normal mail, and never send anything to arrive on a Monday or a Friday. On Mondays, editors are catching up with all the mail that came in over the weekend. On Fridays, they are usually trying to meet a deadline and want to leave for the weekend.

A well-composed letter with actual images is far more effective than an e-mail, unless you've actually gotten to know the editor or staff member you're writing to. It's just too easy to delete an e-mail and not take the time to look at the attached images.

Your query needs to be brief—a picture really is worth a thousand words—so show your work instead of spending too much time talking about it. The first paragraph should immediately hook the editor and answer two questions: What does this information mean to the readers? and Why will readers care about your images? The rest of the letter should briefly outline your credentials as a writer and photographer and detail the photos you will provide to illustrate the story.

Consider E-Books

If you are having trouble getting your photos published by a traditional publisher, consider producing an e-book. An e-book is a digital

file that readers can purchase and download or receive on a CD.

If you have a particular photographic area of expertise and can write about it, you can write an e-book and sell it. Photography e-books are most popular when they are written with a how-to, travel, or adventure approach—it will be easier to sell an e-book that features pictures of Yellowstone National Park if it is written as a travelogue rather than an attractive Yellowstone picture book.

You Never Know!

While being a legend obviously gets you more exposure faster, don't be intimidated by your lack of experience. The keys to success are having great images, a unique approach to a photographic challenge, and a great story behind your love for photography. Over the years *Rangefinder* magazine has featured hundreds of photographers who were virtually unknown but showed all or some of these qualities.

The impact of an image and the story it tells can get your work published.
PHOTO BY KEVIN KUBOTA

OWN YOUR OWN ZIP CODE

Don't spend another second worrying about becoming a nationally known photo rock star. It doesn't matter where you live, you should be the photographer that everyone knows and talks about in your own zip code. It's feasible, even in large cities, to knock on every single door within one zip code. It's possible to phone or meet everyone who lives near you. So do it. If you're like most people, you shop and spend your time and money on basic entertainment and services in your own zip code. Make sure each of the places you patronize knows you're a professional photographer. Get that business first. Then expand to the next zip code, and the next, and the next. Most famous rock bands didn't start playing in a stadium. They started playing in the local bar.

For example, *Rangefinder* was searching for a cover image for a lighting issue a few years ago and just couldn't find a great shot. Then a press release arrived from Adobe announcing the winners of a recent contest. Third place had gone to a student from Savannah Arts College who took an outstanding image of a boxer with incredible lighting. The image wound up as the cover shot. Carl Nunn, a photographer from New York, called *Rangefinder* to ask about submitting images for consideration. Several months later his work appeared as a feature story. A new feature in PDN's *Focus on Wedding* supplement in December 2009 called "Waiting in the Wings" showed the work of Brian Palmer. Brian was unknown in the professional photographic community outside Akron, Ohio, until he submitted his work and it was included because it was terrific.

Stories like this get repeated every day in publishing. So don't let yourself get caught in the cycle of thinking, "There are so many people as good as or better than I am. I don't have a chance!" This is all under the heading "You Never Know!" for a reason. You just need to be patient and remain optimistic. In the words of the legendary Vince Lombardi, "We would accomplish many more things if we did not think of them as impossible!"

A good image should compel the viewer to know more about the subject.
PHOTO BY NICOLE WOLF

BILL HURTER

I recall one spring, when I was working for Petersen's PhotoGraphic, *I got a call from the Dodgers' press office. They had seen some of my sports photography and wanted me to come down for an interview with the general manager, Fred Claire. Elated, I went to the interview and found Claire friendly and enthusiastic. One thing he told me stuck with me throughout my entire career. He said, "Everyone in the Dodgers family knows how things work—from Ron Cey (then the Dodgers' third baseman) to the guy selling beer." He continued, "For as long as you can do the job you were hired to do well, you'll be part of the Dodgers family." He went on to say that once you can't or don't perform up to those standards, your days with the organization are over. Seems like a simple formula, and at the time I thought maybe it was a little harsh. But those words have rung true over the years and I've never forgotten them.*

Bill Hurter is one of the finest photo editors in the business. For his own photography, Bill has a favorite application or two—in this case, fine art.

PHOTO BY BILL HURTER

SCOTT BOURNE

Here are three things I wish I'd known about professional photography before I got started:

1. Your ability to interact and get along well with people is way more important than your ability to make a photograph. People hire professional photographers they like being around and working with over and above professional photographers with just amazing skill sets.

2. Always chase the good light. Don't take jobs that require you to work in horrible light unless you can bring your own light. Avoid any situation where the light is still terrible, even after you've done what you can do with artificial lighting. Without great light, you cannot have a great photograph. It pays to get along with people, but if you know how to find sweet light and you can get along with people, you'll be successful.

3. Show your work every single chance you can get. When you're starting out, show it to anyone and everyone who will look at it. Show it often. Show it again and again. Show the work—sell the work.

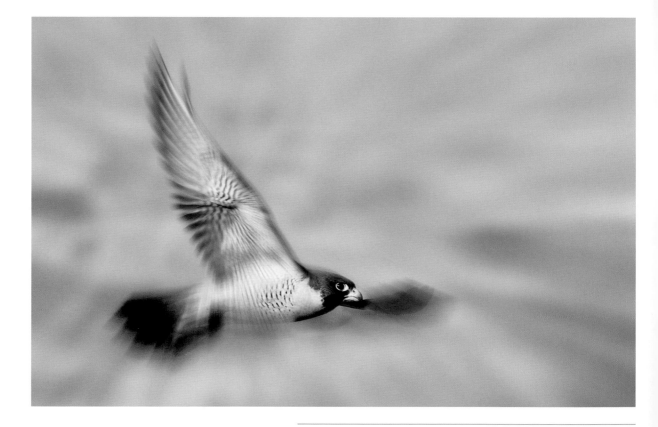

As a professional nature photographer I have learned the importance of knowing my gear so well there's never a doubt I'll get my shot.
PHOTO BY SCOTT BOURNE

EDDIE TAPP

1. Get an accountant—this is number one!

2. Establish a business plan. This can be on a napkin, or as a comprehensive three-, five-, or ten-year plan of how you want to shape your business. Consider your target market; the services you will offer; the cost of equipment over the next three years; monthly operating costs (marketing, utilities, supplies, salaries); how much money you want to make, and a plan for how to make this money; a mission statement; and a branding directive.

3. Select two mentors you want to study with, but learn from everyone.

4. Befriend your competition.

5. Give in order to receive . . . learn what part of that is for you.

6. Take a leap of faith.

7. Satisfy one client at a time.

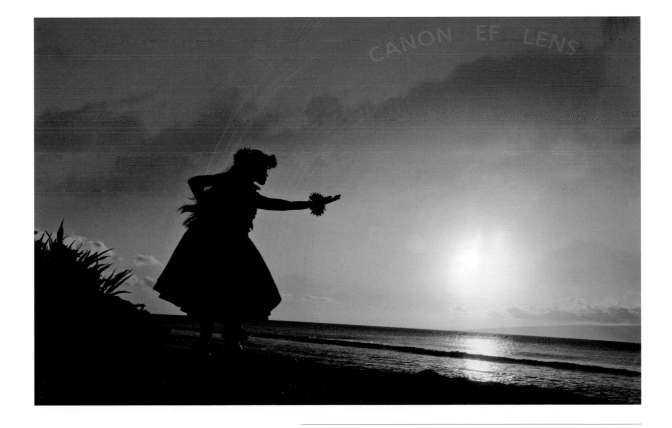

Truly great photographers help us see what we never see otherwise.
PHOTO BY EDDIE TAPP

> The new generation of
> photographers needs to
> successfully pair passion for
> the craft with an acute sense of
> business and marketing.
>
> —CLAY BLACKMORE

Marketing

WHAT GOOD IS creating the finest images of your life if nobody knows who you are? Getting your name out there when you're just starting out and funding is limited can be frustrating. While it takes time to develop a reputation in the photo world, take heart: You have a lot of resources for advertising and publicity. How you use them is going to be the foundation of your marketing plan. You must be patient and persistent, and you must plan to spend time each day doing something to let people know you're here.

PHOTOS BY (CLOCKWISE FROM TOP CENTER): NICOLE WOLF; NICOLE WOLF; CHASE JARVIS; EDDIE TAPP; EDDIE TAPP

LEARN TO OFFER YOUR ENTIRE PRODUCT LINE

Marketing king Doug Box does a great demonstration about making sure you offer your customers all your products and services. If a customer calls you and asks, "How much are your 8 x 10s?" what will you answer? Most photographers just put a price out there.

Now, pretend you're a baker and somebody calls and asks, "How much are your cakes?" Your answer is going to be preceded by a series of qualifiers: "How many people do you want it to serve? What flavors do you want? Do you want anything written on top of the cake? Do you want it delivered or are you going to pick it up? Does anybody have a peanut allergy? Do you want an ice cream cake or. . . ." And the list continues.

Doug reminds us that none of us are bakers, but we know what to ask the person buying a cake. Sadly, we sell short the customer we know best who's calling for pricing on prints. Why isn't everybody asking all those same types of qualifiers? "Do you want just an 8 x 10, or did you know we have a special that includes other sizes? How many 8 x 10s would you like? Does the image require any touch-up? We have a terrific reputation for custom work—would you like a portrait sitting as well? Would you like the image framed? Is the image black-and-white or color?" The list of potential questions is extensive, but over and over again we too often fail to qualify customers fully and pull them into our entire product line.

In fact, very few photographers take the time to think about their product lines. With your skill set—along with techniques available through Photoshop and other software and hundreds of vendors offering you lab services, albums, frames, canvas prints, paper prints, slide shows, mixed media and hosting services—you have an inventory that beats Sam's Club and Costco combined! But odds are you've never thought of yourself as offering a product line.

Start thinking about the diversity of the products and services you offer. Before your next round of workshops and programs, take the time to visit the speakers' websites and look at the way they position their products and services. Look at what they offer their clients. They're on the podium because they're successful, and as trite and simplistic as it sounds, most of them take a cue from McDonald's: "You want fries with that?"

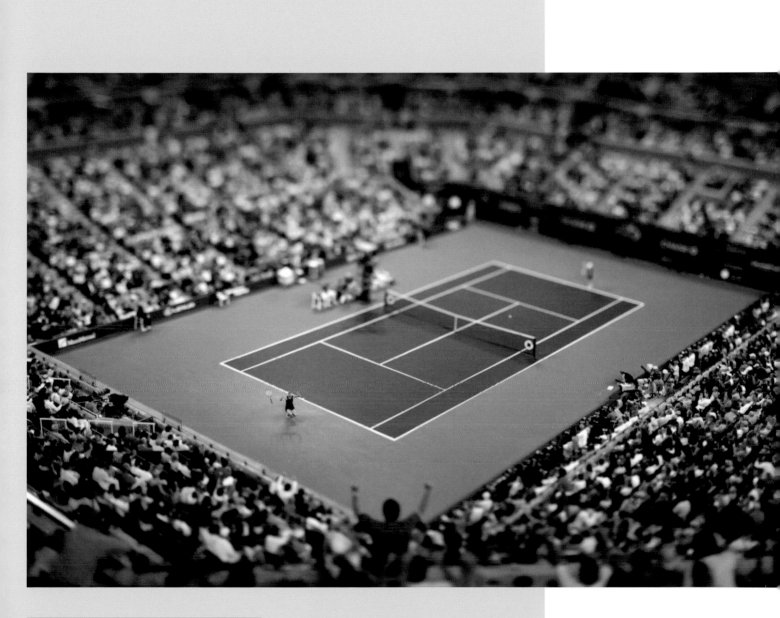

Top professionals succeed because they bring
unique skills and a singular vision to market.
ABOVE: PHOTO BY VINCENT LAFORET
LEFT: PHOTO BY SCOTT BOURNE

Social Media and Your Website

We're going to go into far more detail in chapters 5–8, but for now, even though "social media" covers a wide variety of Internet vehicles, think of it mainly as Twitter, Facebook, and your blog. Each is very different in functionality, but we believe they're vital to a solid investment in marketing and developing your business model.

You can't be in business today without a good website. We're sure you've heard the expression "You never get a second chance to make a first impression." Well, nothing could be more true when it comes to your site. You've got to present your very best images in a way that's easy to view and doesn't require a lot of navigation. Don't make people mine for the data you feel is most important.

Use images on your website that stir curiosity and draw the reader in.
PHOTO BY EDDIE TAPP

Some tips to remember:

¤ Your site should load quickly.

¤ Make sure your site is easy to navigate.

¤ Use easy-to-read fonts and keep the text to a minimum.

¤ Show people whatever is most important first. In most cases that means leading them to your galleries right from the home page.

¤ Show work that's diverse. You never know who's going to be looking at your website and what other photographic needs they might have beyond the obvious.

¤ When showing diversity in your work, keep the galleries separate and don't let your diversity stray too far from your main specialty. For example, being a wedding photographer and including family and children's portraiture has an obvious link, but showing outdoor/landscape photography or a commercial table top is a stretch. To showcase a completely different discipline we suggest you establish a separate website.

Lighting and
composition direct the
viewer's focus.
PHOTO BY VINCENT LAFORET

Advertising

Advertising goes well beyond print media in a magazine or newspaper to include direct mail (ideally with a well-designed postcard), e-mail, banner advertising on other websites linking back to yours, business cards, stationery, and even holiday cards.

Direct mail is back with a vengeance. There was a short time when e-mail was the only advertising tool anyone was using, but think about how much e-mail you trash today. An effective postcard when combined with a strong e-mail blast gives you the best of both worlds.

You need to choose your most compelling images when printing a postcard. Different photographic specialties will have a different target audience. If your specialty is outdoor/ wildlife, one spectacular image might get the attention of an editor. On the other hand, if your target is a bride, you might want to have several images demonstrating your ability as a storyteller, capturing different aspects of the wedding.

Many successful photographers send out a new postcard each quarter to their database or a purchased list. Each postcard should have different images but should always include a snappy headline or caption on the back along with your name, address, phone number, e-mail address, and website.

The old rule of thumb that you should run a print ad at least three times in the same location within a publication still holds true. Grab your audience with your images, some sort of call to action, and then the contact information they need to acquire whatever it is you're promoting. Print advertising is still effective but can be costly. If you're considering print media, look at bringing in some partners to help share the cost.

Producing effective e-mail is a science all its own and there are dozens of companies available to help you. Constant Contact seems to be one of the companies most often talked about and it offers a full range of support in effective e-mail campaigns.

Banner advertising can be very effective, but only if you're being exposed to the right audience. Placing a banner ad for children's photography on the Home Depot site, because you want to be out there in time for Father's Day, will be as effective as advertising in *Guns & Ammo* magazine! Why? Because an industry study showed, in reference to the portrait and wedding categories, that 98 percent of the purchasing decisions to hire a professional photographer are made by women! It's also important that the link you place in your banner ad takes people right to your strongest images.

Business cards, stationery, and holiday cards all need to be professional, show your best work, and have a consistent look and feel that present you in the way you want to

be seen. Use a quality, heavy-stock paper for business cards and stationery, and give relevant information, including phone numbers, e-mail address, and postal address. It's fine to use a photograph on your business card, but be sure the subject can be seen at such a small size.

Holiday cards and notes provide the easiest and least expensive way to advertise.

Use your own images on your cards. Preprint a message on the inside, and on the back, where you'd normally expect to see a commercial brand logo, put your logo, along with contact information. This is a subliminal message at its very best and effective when you're trying to remind people you're a professional photographer.

People love having their pets photographed, so a note card featuring a furry companion is bound to be noticed.
PHOTO BY BAMBI CANTRELL

Two Dog Night

Put a Plan in Action

Now that we've covered the basics of advertising, let's look at how to launch an effective campaign to build your photography business.

Build a Database

There are two kinds of databases: those built out of your own contacts and those you acquire to meet your target demographics. For your own contacts, start with everybody you've met in your area, including previous clients, neighboring businesses, and anybody who's in your network. Don't be afraid to go outside your geographical area as well, including friends from your hometown and associates you've met at various conventions. Put everybody you know into this database and build it both as an e-mail base and for postal addresses.

The second database is one you'll develop through a combination of purchasing lists and finding business entities you believe might need your services. For example, let's assume you want to purchase a list of potential clients interested in hiring a children's photographer. Looking at a list of available categories from a list company, you might consider "new births," "summer camp prospects," and "affluent retirees." Lists are normally available for purchase in quantities as small as 200 names and sorted by zip code. One trip to Google, searching by "mailing lists," will provide you with a wealth of resources for building a database.

And don't forget those affluent retirees. There isn't a grandmother on the planet who doesn't complain about not having up-to-date images of her grandchildren and family. Yet so many photographers never consider this consumer category.

Make a Mailing Strategy

Once your database is developed it's time to consider your message and the design for your mailings. These should include both e-mail blasts and direct mail, which work most effectively together.

While e-mail was considered the marketing cure-all of the late twentieth century, think about its effectiveness. How much e-mail do you trash before you even turn on your computer, iPhone, or Blackberry? The challenge is to develop an effective e-mail style that works together with a direct-mail piece—for example, a great postcard.

Google the words "effective e-mail" and you'll find dozens of companies offering support in developing e-mail campaigns. Freelance writer Susan Johnston lists six basic rules for developing more effective e-mail:

- ¤ Use a descriptive subject line.

- ¤ Add the recipients last to avoid accidentally sending before you're ready.

- ¤ Keep it simple.

- ¤ Make recommendations.

- ¤ Avoid snappy comebacks.

- ¤ Avoid words and phrases that appear to be spam.

It's all about common sense. On the direct-mail side, we still love a well-designed postcard, which is inexpensive to produce and mail and easy to update. But it has to be great. It's critical that the images all be "wow" prints! They need to be spectacular in quality, and they need to provoke thought and tug at the heartstrings of your target audience. Your images should both draw people in and make them want a similar look in the portraiture for their own family, company, or products.

When it comes to the size of the card, consider one that's slightly oversized. Remember, you have to get through all that noise stacked in the mailbox along with your mailing. It just might be worth spending a little more in printing and at the post office to make your card stand out when the mailbox is opened. Remember to check with your local post office before you approve anything for printing. The last thing you want is to be caught off guard with an outrageous postage bill!

A powerful image, spectacularly executed, should move your target audience to ask you to produce similarly fine work for them.
PHOTO BY EDDIE TAPP

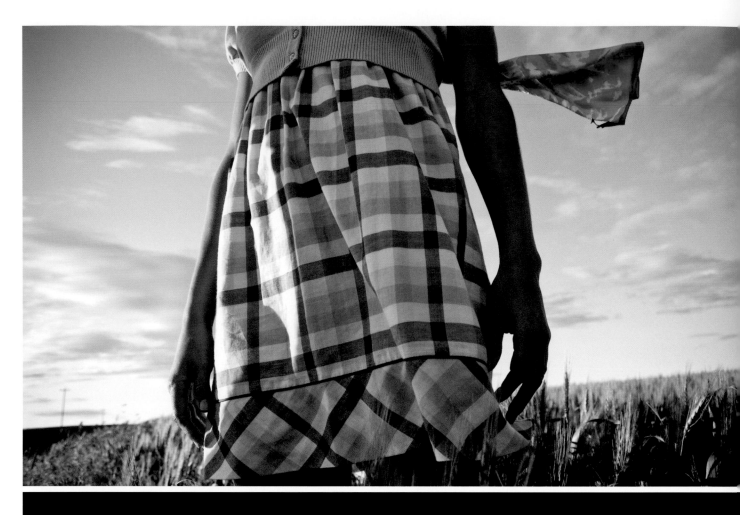

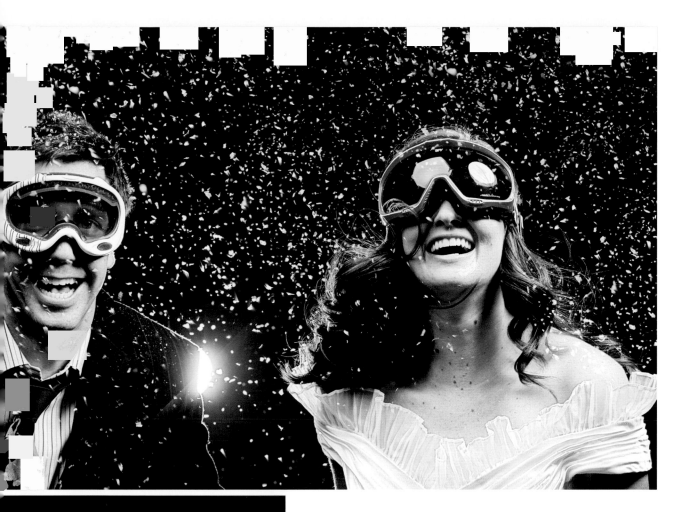

When promoting your photography business make sure that each image you send out is unique, powerful, and has that "wow" factor.

TOP LEFT: PHOTO BY CHASE JARVIS
TOP RIGHT: PHOTO BY NICOLE WOLF
LEFT: PHOTO BY EDDIE TAPP

Issue a Press Release

While effective e-mailings and direct mailings are helping you spread the word about your diversity, don't forget to develop a strong publicity campaign. So many exciting things can happen to a photographer every day, but nobody ever talks about them! Some events are more newsworthy than others, but the real issue is thinking about publicity as another component of your marketing campaign.

Just as in advertising, social media, direct mail, and editorial, for example, developing a constant flow of publicity is a key component to your success. This may be the most difficult component of your marketing efforts to consider because in your mind, nothing worth talking about may have actually happened yet. But that's where you're so wrong. With the right spin the most routine events can be newsworthy for the right audience. Did you attend a workshop or convention? Are you working with a new lab? Are you involved in a new charity? Are you helping in any community event? Are you a volunteer for any programs in the school system? Got the picture? The list goes on.

Each topic has the potential to help you become a publicity machine, but you have

MAKE NEWS!

Here's a template you can use to do it.

FOR IMMEDIATE RELEASE

Your city, Today's date

Area Photographer Attends International Photographic Event

In (his/her) continued efforts to expand the broad selection of cutting-edge photographic services, (your name) recently attended the _____ Convention in _____ a three-day professional photographic workshop and convention.

"There's never been a more exciting time to be a professional photographer or to have images created by a professional. Digital technology is changing all the time, and I want to make sure I'm offering my clients the very best!" said (Your Name).

(Your name) is the founder of (your studio) which is located at (address). The studio offers a full range of (commercial, portrait, wedding, children, etc.) services. [Or] (your name) plans on continuing as a freelance photographer...etc.

For more information contact: (Your name, phone number, and e-mail address)

to take the time to write a press release, or find somebody who will write it for you. Let's assume you're going to a national, regional, or state convention involving professional photography in the next few months.

The template at left only applies to attending a convention or workshop, but the elements of any press release are usually the same:

- ¤ A headline and an opening paragraph that describe what the event is.

- ¤ A quote that explains your position as it relates to your customers.

- ¤ A paragraph describing your business and who and where you are.

- ¤ A contact line so people know where to find you.

Always include a photograph of you at the event interacting with other attendees, a speaker, or a vendor. The more people in the image, the more likely it will be published.

Now, what are you going to do with the press release? You're going to print a hard copy and make a print of yourself at the event. You're also going to put the press release and the image on a disk. Following all the previous guidelines about submitting work to editors (see page 96), send press releases to any organization with a publication that reaches your target audience: the local newspaper, chamber of commerce, organizations you belong to (they all have newsletters), blogs within the community, your own blog, bridal magazines, and so on.

Start by sending out at least one release twice a month for the first three months and then reduce to one per month. As with other components in your marketing plan, you have to be consistent and continue the effort, even when nothing seems to be happening. You never know when an overworked editor is going to be short on time and/or stories and have a gaping hole to fill—that might be your lucky day!

No marketing tool is more effective than being able to refer to images or a story about you that has been published. Editorial involvement gives your advertising and publicity efforts credibility, so getting published should remain your overarching goal (see page 94).

Attend Events

This is about being involved in your community and getting out and meeting people, using your skill set as a photographer as the door opener.

One way to get to know the key players in your community is to design a program for others who share your interests. Dawn Shields, a Missouri wedding photographer, contacted everyone in her community who had anything thing to do with weddings: florists, travel agents, limo companies, venues, wedding planners, bakeries, music agents, and more. Now they all get together once a month for a networking lunch and exchange information and ideas.

You may also want to consider cause-related marketing, which involves volunteering your services at such events as a fundraiser shoot for a local charity, for example. The payoff is often twofold: You'll meet people in the community with whom you might be able to do business and you'll create a sense of goodwill; people like to buy products from companies that they perceive as giving something back.

CUSTOMER SERVICE: WHO SAYS YOU CAN NEVER GO BACK?

Today's social media structure gives an unhappy customer incredible reach and has the potential to severely damage your reputation in the community.

Wedding photographer David Ziser once commented that the younger the bride, the more friends she has who will be getting married. He works hard to maintain great relationships with all of his clients, but his younger brides are the most important to building his reputation and business.

Now, think about the reverse of David's comment and how many friends that same bride can influence if she's unhappy. You may not be able to do anything about some of your old problem customers, but that doesn't mean you can't work to keep building better relationships with everyone going forward. Most important, consider that many complaints arise because the photographer doesn't conform to the customer's mindset.

There's an easy solution for that in the future: Listen more, talk less. Repeat to your client what you believe you heard them ask for. At the very first sign of disappointment from a client, take a deep breath and go to work neutralizing the challenge. Digging your heels in and taking a stand is rarely going to be the right answer, from a customer service perspective.

TWELVE WAYS TO BUILD BRAND AWARENESS

We all know the lizard from the Geico Insurance commercials and the golden arches of McDonald's, and you can probably sing the jingles of half a dozen local merchants and recognize the theme music from your favorite shows. So, how are you going to get your target audience to remember your name just as well? You need to be in front of your target audience at every opportunity.

1. Direct mail puts you in their mailbox.

2. Advertising gets you into the local papers and magazines.

3. E-mail blasts and newsletters get you into their computers.

4. Links from other sites bring them to your website.

5. Community involvement gets you next to them on various projects. This is about your getting to know the people in your community and your neighbors getting to know you.

6. Publicity releases get you into the local paper.

7. A great image on a holiday card brings you into their homes.

8. Your business card and stationery remind them you're a photographer.

9. Cross-promoting with other non-competing vendors gets you into their heads via association with other businesses in the community.

10. Being active on Facebook and Twitter gets you into their world of social media and makes you more accessible.

11. Writing your own blog and keeping it fresh with a consistent presence gives you an opportunity to show off your work and your personality.

12. Getting published gives you an incredible level of exposure and gives your publicity and advertising credibility.

That's it: twelve ways to reach your targets and build your brand. It also takes patience, consistency, and an unwavering dedication to delivering a quality product. Even more important is your passion for the craft. If you love photography and always shoot from your heart, then you can create images that reach a chord, and word-of-mouth advertising becomes the mortar between these twelve bricks.

CLAY BLACKMORE

With today's changing photographic climate, the new generation of photographers needs to successfully pair passion for the craft with an acute sense of business and marketing. You have to develop yourself commercially while you grow artistically, and the only way to do that is to keep at it. Twenty-five years ago, Phillip Charis told me that the key to success is perseverance. That's even truer today.

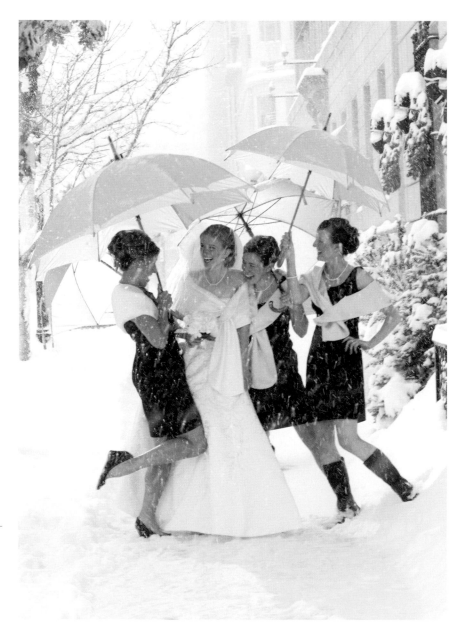

Seasoned pros know that bad weather need not get in their way—in fact, with a little creativity, it can become an asset.

PHOTO BY CLAY BLACKMORE

TAMARA LACKEY

If you are just now deciding to become a professional photographer, my first piece of advice would be to solidify your business structure as soon as possible. It's not uncommon for artists to find the business side of their work dry, uninteresting, or even intimidating. Creating a full-scale business plan would be wonderful, but if you find that it's taking you some time to put one together, try at least to focus on documenting your basic business processes, locking down your overall workflow, and setting up some sort of client management system.

It's a thrill to suddenly become a "working photographer." But without a solid business base, you'll inevitably find yourself beating back fires in every direction and working very long hours—photographing and then editing and delivering (in all possible ways) your images. What's happening is, you're working very hard, but not very efficiently.

There's a certain finesse to business strategy that can allow you to work less and enjoy photography more. Smart business process flow can revolutionize a scattered business; when implemented upfront, before a business gets going, it sets you up for a best-case scenario, enabling you to save time, avoid expensive mistakes, and recognize smart business decisions. Take the time to build your structure and, trust me, Fabulously Successful Future You will thank you for creating a base of order from which to flourish so creatively!

Let your subjects interact and wait for the image to happen.
PHOTO BY TAMARA LACKEY

You've got to have the skill set to create outstanding images, but being a professional photographer is also about relationship building. —SKIP COHEN

Social Media Marketing for Photographers

SOCIAL MEDIA ARE probably the best way to market your photography business. We will cover Twitter in the next chapter, and so in this chapter we'll talk about Flickr, Facebook, and YouTube. While it's beyond the purview of this book to give you a master class in social media, you should know the basics. Social media marketing relies on connections, and these simple connections create meaningful relationships between marketer and consumer. And these days, sales and marketing are really all about managing relationships. To make successful use of social media, you have to be real; that is, you have to show some aspect of your true self, and you have to be authentic.

PHOTOS BY (CLOCKWISE FROM TOP CENTER): KEVIN KUBOTA; CHASE JARVIS; SKIP COHEN; SCOTT BOURNE; SCOTT BOURNE

Use Flickr to Grow Your Photo Business

Flickr is a photo-sharing site owned by Yahoo. While Flickr has a strict policy against selling images on the site, you can still show and share your best work. The more you show your photos, the more chances you will get to build a fan base and eventually find paying clients.

You can set up a free account at Flickr, but we suggest that you pay for what Flickr calls a "Pro" account. Buying the Pro account shows that you are serious about using Flickr to show your work, and it comes with a few extra privileges that include unlimited uploads and file storage.

Pick a professional name for your Flickr account, preferably one that matches the other social media accounts you have set up. In your profile you can edit the URL so that it directs people to your photos on Flickr; use a URL that matches your business name. Also be sure to completely fill out your Flickr profile, as this is where people will find out who you are and what you're all about. Use a photo of yourself or your company logo as your Flickr Buddy Icon and include all of your contact information. While Flickr policies don't allow for you to sell images on the site, someone who wants to buy one of your photos should be able to check your profile and find out how to get in touch with you.

When you post images on Flickr, you can choose between making them available via a Creative Commons (CC) license or as copyrighted property. (You can read more about the Creative Commons license at www.creativecommons.org.) According to Flickr, a Creative Commons license allows more liberal use and sharing of your photos or video while still maintaining "reasonable copyright protection." This is actually only half true. The "reasonable copyright protection" is only available if you also register your images with the Library of Congress. Professional photographers and emerging professionals have to walk a tightrope here because, on the one hand, using a Creative Commons license will get your work out there to a broader audience. But, on the other hand, it will also absolutely lead to unauthorized use of your images. If you don't mind that, then select a Creative Commons as your default license. But beware: Once you have licensed an image through Creative Commons, you can never again license it exclusively to someone else. We generally believe that protecting your images as "All Rights Reserved" is the safest choice for emerging professionals until you know more about this subject. This protects all future rights and can be changed at any time or even on an image-by-image basis.

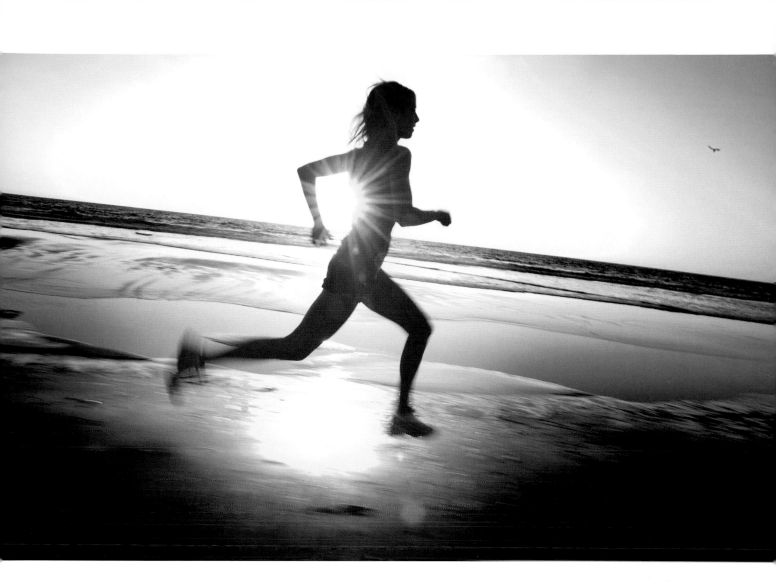

Flickr is another venue for showing your work. As elsewhere, post only your best images that will encourage viewers to seek you out.

PHOTO BY CHASE JARVIS

YOUR GOOGLE PROFILE

The first thing you need to do if you want to become a successful social media marketer is to create a Google Public Profile (this is available for free at www.google.com/accounts/). The Google Profile actually enables you to decide how you come across in a Google search instead of leaving the search results up to chance, so it's basically the linchpin for pretty much everything you will do in this Google-driven world. Be sure to fill out the information as completely and succinctly as possible and add links to all of your blogs, social media accounts, and portfolio sites. Also make sure to add links to your Google Profile URL (assigned once you create the profile) from these sites.

FLICKR DOS AND DON'TS

Using Flickr in just the right way can draw attention to your work.

Do

- ¤ *Post only your best images.*

- ¤ *Create groupings—a scenic group, a wildlife group, a wedding group—that make it easier to sort your content.*

- ¤ *Post every week, the more often the better.*

- ¤ *Post photos from live events in real time, as these are likely to get attention and capture a new audience for your work.*

- ¤ *Review other photographers' work that you find interesting.*

- ¤ *Join photo groups that match your interests—the B&W group, the Canon DSLR User Group, etc. Posting pictures in these groups and actively participating in the group critiques will draw attention to you and your images and is a surefire way to get yourself known quickly.*

- ¤ *Promote your Flickr stream on your blog, website, and other social media accounts; also include the URL for your Flickr stream in your e-mail signature and on your business cards or stationery.*

- ¤ *Give careful thought to the title, caption, keywords, and the detailed descriptions you write for each photo.*

- ¤ *Use Flickr Stats to determine how many people are viewing your images, which images are most popular, and where people are finding out about your Flickr photos (go to www.flickr.com/photos/YOURFLICKRNAME/stats/ or click on the stats button on any of your photo or video pages).*

Don't

- ¤ *Spam.*

- ¤ *Be pedantic or argumentative when commenting on photos.*

- ¤ *Ever engage a troll (someone who deliberately posts provocative comments).*

- ¤ *Post advertising messages in discussion groups.*

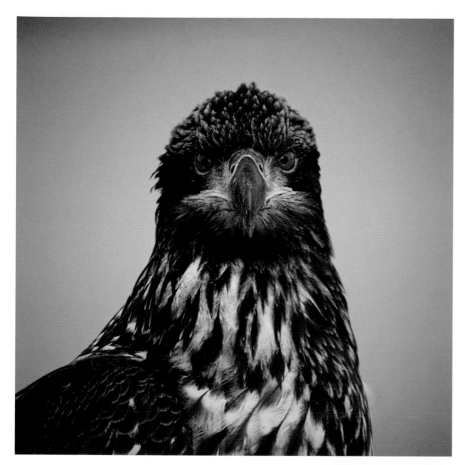

By grouping your Flickr images you'll make it easier for viewers to go through your work. The site also has photo groups that match users' interests.
PHOTOS BY SCOTT BOURNE

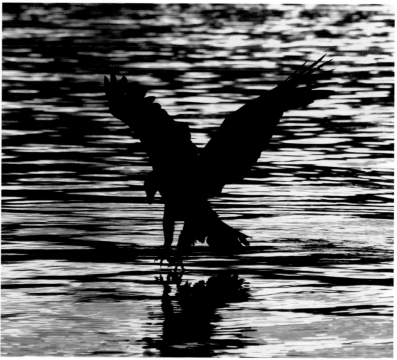

Work with Facebook

For us, Twitter is a more powerful tool, but Facebook is the most popular social media site. We would be remiss if we didn't pay some attention to Facebook as a marketing tool for photographers.

If you market to teenagers or college students (i.e., if you have a strong local or regional focus), are shooting high-school senior portraits, or are working with engaged couples, you'll almost certainly need to have a Facebook presence. Facebook is superior to Twitter when it comes to networking with existing clients or potential clients who know your work.

Be forewarned, however, that Facebook's privacy and photography policies should be of real concern for photographers. If you read the Terms of Service carefully, you will notice that any photograph you post on Facebook is essentially theirs to do with what they will. Facebook will argue that you don't have to worry, that the service doesn't intend to do anything illegal or inappropriate with your photos. Maybe that's true, but your use of Facebook constitutes your agreement with the terms nonetheless. Since you can control the experience and the terms of service better on your own site than you can on Facebook, keep the images you post on Facebook small—no more than 500 pixels—watermark them clearly, and invite viewers to visit your website or blog to see higher-resolution versions.

FACEBOOK TOOLS

Facebook can be powerful and helpful. But to get the most out of it you have to be very active. Don't bother to set up a Facebook page unless you plan to spend a great deal of time tending to it. The following list of tools may help you get more out of your Facebook experience.

- ¤ **Twitter App** *(http://bit.ly/FB_twitter_app) automatically pulls your tweets into your Facebook status.*

- ¤ **Static FBML** *(http://bit.ly/FBML_static) allows you to add advanced functionality to Facebook using HTML (HyperText Markup Language) or FBML (Facebook Markup Language).*

- ¤ **Flash Player** *(http://bit.ly/FB_flash) adds a box to your Facebook page where you can upload Flash files to play any kind of Flash video, widget, etc.*

- ¤ **Blog RSS Feed Reader** *(http://bit.ly/FB_blog_rSA) allows you to add a personal blog, corporate blog, or RSS feed to your Facebook profile.*

Four Ways to Use Facebook to Your Advantage

To get the most out of this platform, you'll need to understand the four facets of Facebook: Profiles, Pages, Groups, and Networks. All of these elements present ways for you to show yourself in a favorable light.

1. *The profile is the most important content you'll create on Facebook. Spend time working on this. Use a photo of yourself, not a logo representing your company, and let your personality shine through. Since you're a photographer it only makes sense to use a decent photograph of yourself. Even worse than using an unprofessional image on your Facebook page is not using a head shot at all! Your profile is where you share all the personal information that you're comfortable sharing about yourself. You'll want to make your profile at least somewhat personal. This requires a delicate balancing act, because you don't want to share so much that the average stalker can use it against you. On the other hand, if you don't share enough information, people may not want to engage with you. Nobody cares about your romantic status, so save that for Match.com or the other popular dating sites. The context we're focusing on is one related to business, not dating and personal relationships. Be real, be genuine, be transparent, but don't be inappropriate.*

2. *Your Facebook profile page (a.k.a. fan page) is where you'll build a community around your business. You can and should use this spot to promote yourself and what you do. Be sure you also use this space to cross-promote the other social media content you use, such as your Twitter feeds, Flickr accounts, etc. This is also a great place to promote the RSS feed from your blog or website. If you have more than one business or specialty you can create multiple Facebook fan pages.*

3. *Facebook users form groups around common interests, including photography. Building and joining groups is a powerful and quick way to gain traction on Facebook. You can start a group simply by going to the Groups application and clicking on the "Create a Group" in the upper right hand corner of the page.*

4. *Facebook "networks" can help promote your business. Join as many networks as you can, since these will make you more visible. List your city, industry, neighborhood, and any other relevant information to let potential customers and business partners know where they can find you.*

Post on YouTube

YouTube is a website on which to show videos. Whether or not you're a cinematographer or a filmmaker, you should post videos on YouTube, even if all you do is create a slide show based on your portfolio. The more creative, adventurous, and, dare we say, brave among you will use YouTube for much more.

You might want to post training videos, day-in-the-life videos, or behind-the-scenes videos. Whatever you post, don't fall into the trap of thinking that just because you posted a video on YouTube it's going to go viral. That's rare. Promote what you post on YouTube on your blog, website, Facebook, and other social media accounts. Even without viral video success, you can get a great deal of traction out of posting on YouTube.

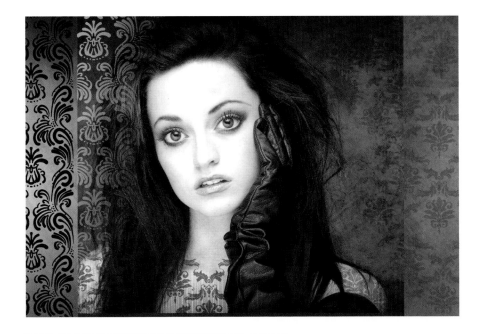

Even if you're not a filmmaker, you can use YouTube to post slideshows to get your best work out there.
PHOTO BY JUDY HOST

YouTube Dos and Don'ts

Even if you're not a videographer, a few well-conceived posts on YouTube can create a market for your photographs.

Do

- *Go for the highest-resolution you can. YouTube heavily compresses videos posted to its site, so it's worthwhile to go big to begin with.*

- *Keyword and appropriately title your video; this will increase the audience size dramatically.*

- *Think about your audience and not yourself. You're not making this content for you—you're making it for them.*

- *Give your audience a really good reason to consume the content.*

- *Make your content accessible. Passwords, sign-up firewalls, or any other hoops will cost you a large portion of your audience.*

- *Spend time and resources to achieve the highest production values. People have very high expectations.*

Don't

- *Make your videos any longer than three minutes, unless they're purely educational.*

- *Waste time getting your audience's attention. You have thirty seconds to convince them that your content is worth their time. After that, they're gone.*

- *Rely on user-generated content. Create your own content and bring the audience to your door. Don't rely on someone else to do that for you.*

HOW PHOTOGRAPHY HELPED ME LEARN TO LIVE FOR AMAZING MOMENTS

It was in large part my photography that taught me to live for amazing moments. Henri-Cartier Bresson, the great French photographer, once said, "There is a creative fraction of a second when you are taking a picture. Your eye must see a composition or an expression that life itself offers you, and you must know with intuition when to click the camera. That is the moment the photographer is creative."

So what makes a moment amazing? That depends. Sometimes moments borne out of tragedy or simple mistakes are amazing because of what you learn from them. Sometimes the chance to simply create is amazing. So many of us walk through life going from task to task as if that is our only choice, until our time runs out. Being able to recognize our inner need to make a difference, to matter, to make something that lasts, to contribute—that is amazing.

Then there is the simple realization that not all amazing moments come when there is a camera in hand, or at least the camera doesn't matter. I don't think you can separate your photo life from your real life. They fuel each other. It's impossible to be the best photographer you can be without pouring the real you into each image. So it follows that the real you is something you should develop as fervently as you study your craft of photography. On occasion, I have been somewhere, or seen something, that was simply so beautiful and yes, amazing, that I didn't make a photograph. I got caught up in the moment, and merely forgot to press the shutter or just lost interest in making a picture. I decide to live that moment instead of photograph it.

My first trip to Bosque del Apache was just such a moment. I went there to photograph what we call the "blast off." This is the moment when the tens of thousands of geese take off and make their way north each morning looking for food. They take off all at once. Sometimes, if you're lucky, and the wind's right and the conditions warrant it, they take off against a brilliant sunrise. On my first trip there, I'd been briefed on what to expect. But nothing I read or heard about the experience was able to really prepare me for its amazingness. The birds took off and, like a statue, I stood there in awe. It was amazing in every way. I merely forgot to press the shutter. And guess what—that's okay if it happens to you, too. Nobody has to know unless you're a fool like me, and you pour your heart out to thousands of people every day on a photography website!

We're offered thousands of moments each day. When I look at my favorite photographs (both mine and yours), I see lots of special and amazing moments. In my own work, I am rewarded not only with the visual reminder but with an emotional reminder, since every photo I make is also part of my life's experience.

I've been very, very fortunate to go places and see things most never see. Some of these moments were truly amazing—like walking into the Lower Antelope Corkscrew Canyon for the first time, or cresting a ridge near Paradise on Mt. Rainier for my first full look at the mountain in all its glory. Or the time when I stood a few yards from the big coastal brown bear in Kennack Bay, or shot my first nude study outdoors in the desert with a beautiful woman posing freely.

If we live and photograph with purpose, if we participate in these amazing moments, then we are not only better photographers, we're better humans. Oh, and we're likely to find more amazing moments as a reward.

I am spending what time I have left on this planet in hot pursuit of amazing moments, both those I can photograph and those that I can simply be a part of, no matter how small. I want to take big bites out of life. I'm not wasting any of my time and hope you aren't either.

—Scott Bourne

Photographs can be visual and emotional reminders of life's memorable moments.

PHOTOS BY SCOTT BOURNE

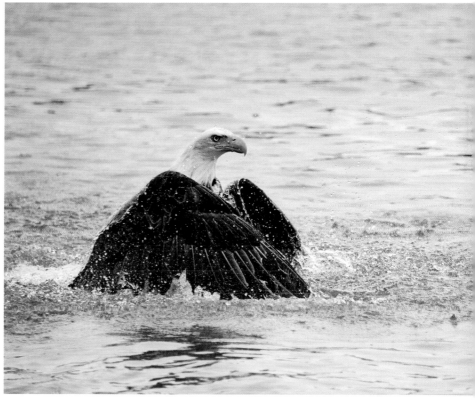

The pursuit of amazing moments can lead to amazing photographs.
PHOTOS BY SCOTT BOURNE

You've got to have the skill set to create outstanding images, but being a professional photographer is about relationship building and, in turn, trust, integrity, and communication. It's important to get that first sale, but it's more important when that first client comes back to you a second time! Always remember that your clients—and, as your business grows, your employees—are your greatest resource. Treat them with respect and enthusiasm, and deliver beyond expectations.

Last but not least, never sacrifice the quality of your work for anything else. There are no shortcuts to building your integrity and reputation, but there are shortcuts to damaging it!

SKIP COHEN

One of my favorite images started out as just another flower shot from a trip to Tokyo.
PHOTO BY SKIP COHEN

I believe in my heart that we get so caught up in backgrounds, cameras, new toys, business models, and sales techniques, to name a few, that we forget to just be nice. Today, it's so easy to communicate with each other in impersonal ways, but remember, a handwritten note goes a long way.

The best advice I can give someone getting ready to begin a career in photography is a simple concept we all know, but one I think we tend to forget: Be kind. Be a good person. Treat your customers with respect and understanding. Go the extra mile to make sure your clients are happy. Remember that it truly is the little things that mean the most. A happy client is a loyal client. Make customer care your number one goal, and you will create clients for life. If you can remember this simple concept you'll find yourself twenty-five years later with a successful and rewarding career—and clients who have been with you through the entire process.

KAY ESKRIDGE

When a picture tells a story, your subjects don't have to be looking directly at the lens.
PHOTO BY KAY ESKRIDGE

It's easier than ever to tell people about good work through social media. People are always looking for the next cool video on YouTube or the next cool image to tweet about or blog about. —JEREMY COWART

Use Twitter to Grow Your Photo Business

MANY PHOTOGRAPHERS ASK us why we place such a high emphasis on Twitter. While not everyone agrees, we find Twitter to be a valuable business tool, especially for photographers. As a marketing tool, it has several advantages (in most cases) over Facebook: Twitter reaches more people at work. It goes viral faster since it has better Search Engine Optimization (SEO) hooks to Google. And we believe it's easier to gain a large following more quickly on Twitter than on Facebook. Twitter provides a chance to establish a real "tribe," as marketing expert Seth Godin would say. You don't need an Oprah-sized following to be effective, although there are certainly benefits to having a large Twitter audience.

PHOTOS BY (CLOCKWISE FROM TOP RIGHT): NICOLE WOLF; MICHAEL CORSENTINO; MATTHEW JORDAN SMITH; SKIP COHEN; VINCENT LAFORET; NICOLE WOLF

Start Using Twitter

Before you start using your Twitter account to grow your photo business, consider the following: What are your goals and objectives? Who is your audience? What sort of content can you regularly provide? What sort of brand will you represent? How often will you use Twitter to market yourself? Can you be a part of a community, and if so, which one? What style and voice will you bring to the table? Make a list of these questions and answer them honestly and to the best of your ability. Consider the outcome of your Twitter marketing plan. Use this as a roadmap to success.

When choosing a name for your Twitter account, use one that is professional: for example, "George Jones Photographers," not "BabyGotBack199." Your Twitter name is the first contact potential clients have with you. Make it count. Once you've come up with a name, go to www.namechk.com to see if it is available for use on other social media sites. If you plan to expand beyond Twitter, it's helpful to use the same name in all places. It might be the right move to use your business name as your Twitter name, but never forget that people are hoping to interact with you as a person, not just a business.

Now you are ready to go to www.twitter.com and set up your free account. Fill out your Twitter profile and include your contact info. Make sure you use the word "photo" or "photography" or "photographer" in your profile and include a picture of yourself. From our unofficial Twitter tests, we've found that a photo on your homepage is very effective; in most cases, a photo of you is much better than one of your logo, for example. If you really want to stand out, create a custom Twitter background that offers even more information about yourself. (Search "custom twitter background" on Google for more information.) Be sure to revisit your Twitter profile every three to six months to make sure it is up to date.

We recommend that when you start using Twitter for business, you remove most of your personal opinions about controversial subjects from your profile. People who follow you for photography advice don't really care about your politics. If you talk about religion or politics, you will lose some portion of your audience, no matter how valuable your photo-related content might be.

Set up Twitter so you can monitor it on the go. Visit http://m.twitter.com to set up mobile Twitter access. If you have an iPhone, Twitter has an iPhone-specific application you can use.

Now, take the following steps in the following order:

- Follow. Find photographers you admire, industry leaders, well-known instructors, and photo vendors to see how they use Twitter. Go to www.wefollow.com and search the categories "photography," "photographer," and "photo." While you're at it, add yourself to the WeFollow directory in the same categories. Follow your clients if they are on Twitter. You may also want to follow your friends and family, although using a Twitter account for business and to interact with friends and family may become awkward. Follow only people you know or know of. This advice goes counter to what some of the so-called "social media experts" will tell you, but we've seen the negative results that can result from following the wrong people on Twitter. It's all about association. With whom do you want to be seen associating?

- Listen. Just listen. See what other photographers are saying. Search photo-related tweets using Twitter's search function (http://search. twitter.com). Make sure you're also monitoring corresponding Google alerts (www.google.com/alerts).

- Set goals. After you listen and get the basic idea of how Twitter can work, decide what goals you want to pursue. Do you want to find new prospects, sell photos, offer customer support, find new clients, or gain new sponsors?

- Establish credibility. Start by re-tweeting authoritative content. Be a part of the conversation. When someone has a question you can answer, answer it. If you see a cool photo blog or product or photo, tweet about it and link to it.

- Tweet daily. If you've followed the aforementioned steps, you probably have a pretty good idea of how you can use Twitter to send out your own messages. Send one tweet a day for the first week and see how that's received. Judge the reaction, adjust as necessary, and tweet once per day for a second week. Repeat the cycle until you're comfortable with the results, and then cut loose. But always remember to think before you tweet. Once you press the ENTER key, the words you just wrote will live forever in the Internet universe.

- Engage. Answer questions, offer links, and be responsive and helpful.

Tweet Now

Before you get overwhelmed, we want to remind you that Twitter can be useful to you right now. We're going to give you additional Twitter knowledge in the next few pages, but first, here are five things you can do immediately to grow your budding photography business:

- ¤ *Tweet a link to your portfolio and ask for feedback.*

- ¤ *Tweet a link to a recent photo shoot or event or image that you were paid for.*

- ¤ *Tweet a link to a contest offering a free print or session in your studio.*

- ¤ *Use search.twitter.com to find prospects by searching for related topics, such as weddings for wedding photographers.*

- ¤ *Send a tweet answering someone's photography questions.*

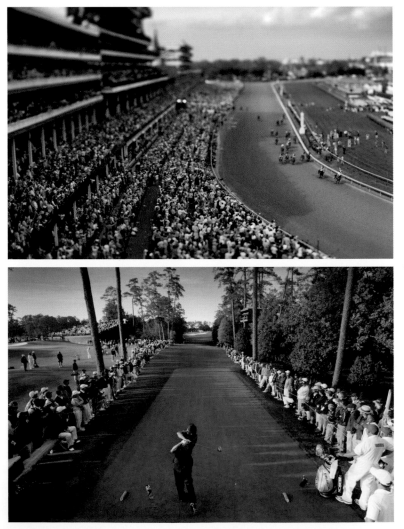

You can follow photographers you admire online and, in many cases, follow links to the work they are producing.
PHOTOS BY VINCENT LAFORET

Free Online Tweet Scheduling Services

If you tweet at the same time of day, every day, and don't consider the live-stream impact of Twitter, you will miss some of your potential audience.

For instance, if you have an international audience, you may want to send the same tweet twice in a day about twelve hours apart so that your followers in different time zones see it when they are online. Here are several automated services that can help you schedule tweets throughout the day. Most work the same way: You type in the message you want to tweet along with the date and the time you want the tweet to go live and the software does the rest. This way you aren't tied to your computer or your mobile device all day long. Go online to check the particular merits of each service.

CoTweet (http://cotweet.com)

Dynamic Tweets (www.dynamictweets.com)

FutureTweets (http://futuretweets.com)

HootSuite (http://hootsuite.com)

SocialOomph (www.socialoomph.com), previously called TweetLater

Taweet (http://taweet.com)

Twaitter (www.twaitter.com)

Tweet-U-Later (www.tweet-u-later.com)

TweetFunnel (http://www.tweetfunnel.com)

Twittontime (http://twittontime.com)

Twuffer (http://twuffer.com)

PHOTOGRAPHERS ON TWITTER

Here's what the pros have to say about the ways Twitter is helping their businesses.

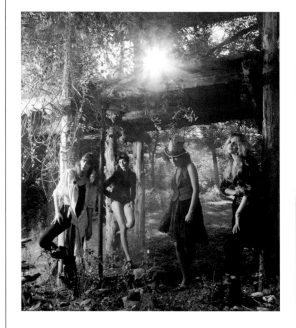

Twitter has revolutionized my photography business. I find assistants through it. I find locations through it. I source feedback on my photos through it. I hear about bugs on my website through it. It's a 24/7 support system. But you only get out of social media what you put into them, and I've invested a lot of time in Twitter. In the end, I think of Twitter as the client that will never disappear. That is, the people following my work on Twitter will always be there (unless I do something really stupid). They'll support my work, my books, my fine art shows, my workshops, my DVDs.

—Jeremy Cowart

At first I didn't understand Twitter and how it could help my business, but shortly after I started using it I received a message from a celebrity asking me to work on a project with him. It was all through Twitter and he has a million and a half people who follow him. Twitter is now part of my daily business routine and a very big part of how I stay in contact with my audience and clients. If you're not using social media in your business, you're being left behind.

—Matthew Jordan Smith

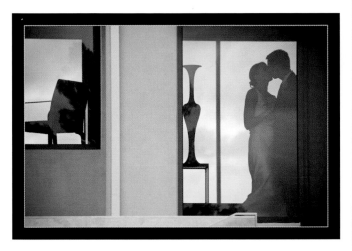

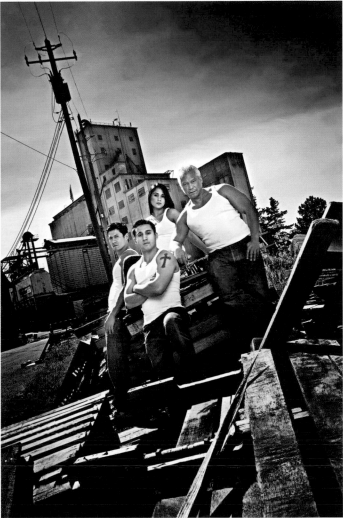

Twitter is essential, just like websites, for getting the message out about your business and the work you do. Twitter seems to appeal to the "need it now" generation and is a great way to entice people who may not take the time to visit your blog regularly. It always surprises me to find out who actually reads my tweets—sometimes it's the most unlikely people, and they could be my next customers!

—Kevin Kubota

Twitter allows me to connect instantly with followers and non-followers alike and helps me build my photography and workshop businesses. I use Twitter to drive traffic to new and existing blog content, promote sales messages, market my photography and workshop businesses, build relationships, create a personal brand, and find leads.

—Michael Corsentino

Use Twitter Search to Find Clients

Prospecting for new clients is a lifetime job for professional photographers, and Twitter Search (http://search.twitter.com) is a powerful tool that can help you find clients and generate business. First, you should know Twitter's search operators. These are the rules that the search engine uses to structure queries to the database. They combine key words to make your searches more specific and effective. You can type search operators such as these directly into the search box.

OPERATOR	FINDS TWEETS
color film	containing both "color" and "film."
"national park"	containing the exact phrase "national park."
Pets OR kids	containing either "pets" or "kids" (or both).
-root	containing "beer" but not "root."
#photo	containing the hashtag "photo."
From:skipc	sent from person "skipc."
to:scottb	sent to person "scottb."
@naturephotog	referencing person "naturephotog."
"wedding" near:"san francisco"	containing the exact phrase "wedding" and sent near "san francisco."
near:NYC within:15mi	sent within 15 miles of "NYC."
bride since:2010-07-22	containing "bride" and sent since date "2010-07-22" (year-month-day).
bride until:2010-07-22	containing "bride" and sent up to date "2010-07-22."
video -scary :)	containing "video," but not "scary," and with a positive attitude.
flight :(containing "flight" and with a negative attitude.
camera?	containing "camera" and asking a question.
Wedding planner filter:links	containing "wedding planner" and linking to URLs.
news source:twitterfeed	containing "news" and entered via TwitterFeed.

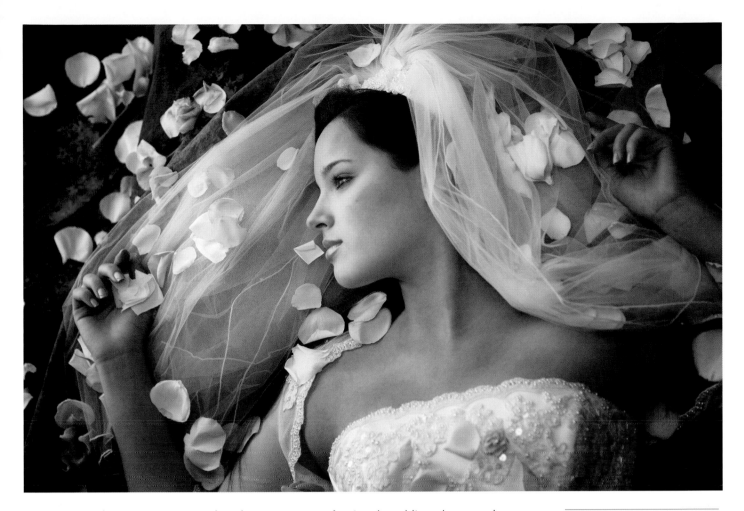

Once you become accustomed to these search operators, you can use Twitter to get photography jobs. Don't expect jobs to come easily, but these search operators can be part of your long-term strategy to prospect for serious business.

Let's say you're a wedding photographer in Tacoma, Washington. Go to http://search.twitter.com/ and type in "Wedding near:98401 within:100km." (Note: The operators that define the search must be typed in exactly as shown, without a space before or after the two colons.) The first response may come from someone who has a question about wedding announcements, which, as

a professional wedding photographer, you should be able to answer. Simply tweet back a reply and you're done. No need to say, "Oh, and by the way I'm a wedding photographer if you need one." Instead, rely on the link in your profile or your well-chosen Twitter handle—e.g., TacomaWeddingShooter—to get that message across. If your answer to their question is a good one, you will have earned a click on your profile, and if they still need a wedding photographer, you'll get your portfolio looked at. You have a prospect.

See how simple that was? You can apply this technique to many kinds of photography all over North America. Simply type in the

Twitter has become a powerful tool for prospecting for new business in all genres of photography.
PHOTO BY CLAY BLACKMORE

Your searches for new business on Twitter should be as imaginative as your approach to photography.
PHOTOS BY NICOLE WOLF

"soccer near:98401 within:20km." You'll get all sorts of real-time results. Mine those results and see if there isn't a way you can find out how to connect with some of the folks on Twitter who are talking about little-league soccer in your area. These are your prospects. And you found them for free. Now find a creative way to reach out to them and you should be able to generate some interest for your soccer photo business. You might build a free newsletter or blog of interest to local soccer players—populated with your soccer photos, of course.

Here's another Twitter search tip: In the upper right corner of the search results page there is an option to create an RSS feed directly from the search results. Add that feed to your favorite feed reader, such as Bloglines (www.bloglines.com) or Newsgator (www. newsgator.com), and you'll end up with a constant stream of potential leads—all of it free, all of it automatic.

You also have the opportunity to search for tweets in a specific language. Let's say you specialize in weddings performed in the Hispanic community. Switch to "Tweets written in: Spanish." Now you'll only see Spanish language tweets.

Don't get too caught up in the specifics. Think about the concept. Learn to use Twitter's search feature well. Remember, the sky is the limit on what you can search for. Use your imagination. See what you can come up with—it very well may lead to new business. Twitter's search tool is amazing and powerful.

subject you find relevant to the type of photography you do and the postal or zip code along with a geographic limit, such as 100km.

As another example, say you want to photograph an event such as Little League Soccer. Find out the name of the league (or a local team, if you really want to drill down) and make that the subject of your search; narrow the geographic area to 20km and type

Learn to Use Hashtags

A hashtag is a term you create to find tweets related to a specific topic. You can learn about hashtags in detail at http://twitter.pbworks.com/Hashtags, but the executive summary is simple: Hashtags help organize and manage searchable groups. Click on a hashtag—a topic preceded by a hash symbol (#)—and every tweet that is tied to that hashtag will show up in your Twitter stream.

You can also add hashtags to your own tweets to make them easier to track down. To tag tweets that relate to photography, use the hashtags #photo, #photography, and #photog. Because a hashtag is limited to 140 characters, some Twitter users decided to shorten these tags further to #tog or #togs, but we think this is a bad idea, for reasons stated below.

There is a caveat to using hashtags. Engineers who work at two of the three largest search engines alerted us to the fact that while the hashtag system makes content easier to find on Twitter, it may harm the ability of the major search engines to find and index that content. A hashtag can throw off the search engine, causing it to decide that the tweet is spam or porn or something else. The hashtags #tog and #togs further complicate matters because they are nonsensical to search engines. While in context it's easy to see where #tog fits nicely into #photography, the search engines aren't as good as humans at deciphering context.

Twitter Dos and Don'ts

Used properly, Twitter can be one of a photographer's most valuable business tools.

Do

- *Tweet using your real name or studio name.*

- *Follow industry leaders, vendors, and clients.*

- *Tweet every day. The time of day matters (see page 145 for more on scheduling issues). In our tests, noon EST is a safe time to reach the largest audience. Save your most important tweet of the week for Fridays between 2 p.m. and 4 p.m.—the most popular time for reading tweets, according to research.*

- *Be generous in your tweets; give away valuable information.*

- *Put your audience's needs ahead of your own.*

- *Use words like "you," "please," "free," "help," "great," "how-to," and "check out" in your tweets for the best results.*

- *Keep your tweets succinct. Every character matters.*

- *Develop a social media policy for your employees, train them on it, and make them sign it.*

- *Tweet about company milestones, history, vision, mission, and employees.*

- *Respond promptly to all replies and direct messages.*

- *Ask your followers what they'd like to see more of from you.*

- *Keep it clean. Family-friendly is a hard-and-fast rule for companies using Twitter. No off-color content.*

- *Link to and re-tweet others.*

- *Inform, educate, and inspire.*

- *Stay focused and on-message.*

- *Ignore trolls (tweeters who deliberately post provocative comments).*

¤ *Measure your progress on Twitter by tracking followers, re-tweets, and your WeFollow.com rank. Wefollow.com is a service that tracks the number of followers you have and the influence that you have over them in a specific category.*

DON'T

¤ *Tell other people how to tweet. Leave that to someone else.*

¤ *Say why you decide to un-follow someone. This information isn't useful to anyone.*

¤ *Ask people why they un-followed you. If your tweets aren't working for them, better to let them go so you can concentrate on the folks who do like what you do.*

¤ *Tweet about your socks, your coffee, or other mundane details of your life. Have a business purpose for your tweets.*

¤ *Use a tiny avatar. Use your logo or a real photo of a person as your avatar. Make sure it is at least 400 x 300 pixels. Twitter allows followers to see a full-size image if they click on it.*

¤ *Auto-follow everyone who follows you. Follow every client or potential client manually.*

¤ *Use too many or unconventional hashtags (see page 153).*

¤ *Type in ALL CAPS.*

¤ *Use long links. Shorten URLs via www.bit.ly.*

¤ *Use any automated Twitter program without testing it first.*

¤ *Give out your Twitter password to a third party.*

¤ *Tweet in anger. Your tweets never go away.*

¤ *Tweet anything you don't want the whole world to know about.*

¤ *Forget to ignore the trolls. (Depending on your circumstances, we often recommend blocking them.)*

¤ *Use Twitter as a stand-alone marketing tool. Make sure to combine it with blogs, podcasts, websites, etc.*

Tools to Improve the Power of Twitter

We've compiled a list of resources that will make it a little bit easier to move your photo business onto Twitter.

Bit.ly. Enables you to use an abbreviated URL and keeps track of how many clicks are generated, thus providing useful feedback on what is working. One of the big selling points of Twitter is brevity, with each tweet limited to 140 characters. Since traditional URLs take up lots of space, Bit.ly is an invaluable tool.

Twellow.com. Serves as the "Yellow Pages" directory for Twitter, enabling you to find people who live nearby or share your interests so that you can conveniently follow them if you choose.

Killertweets.com and Twitbacks.com. Helps you create a personal brand, with a Twitter background that suits the image you want to project. Killertweets charges a fee but provides many striking backgrounds from which to choose. Twitbacks is free but nowhere near as impressive visually.

Twi5. Allows you to "unfollow" your "nonfollowers." This is important because, to check on spamming, Twitter allows you to follow only a certain number of nonfollowers. This tool allows you to quickly eliminate those who do not follow you back so you can start to follow other, more promising prospects.

Tweetdeck.com. Allows you to see all of the action in your account within one single application.

TwitterCounter.com. Helps you count followers over a period of time and offers projections and all sorts of important data.

Klout.com. Measures Twitter influence and informs you about reach, demand, engagement, velocity, and activity. You can use it to search for topics and find the influencers relative to that topic.

TwitterGrader.com. Grades your influence based on number of followers, power of those followers, updates, and followers/following ratios. Also provides rankings.

Twitpic.com. Lets you use Twitter to post photos.

Ad.ly. Measures audience engagement.

JEREMY COWART

If I were a photographer starting out, I would focus on one thing and one thing only: Create. Amazing. Work. I've always subscribed to the idea that if your work is incredible, word will spread. It's easier than ever to tell people about good work through social media. People are always looking for the next cool video on YouTube or the next cool image to tweet about or blog about. And those people are art directors, future brides, bands, designers, and magazine editors. They are your potential clients. In addition to creating good work, it's also mandatory that you find your vision. What is it that makes you different from the thousands of other photographers? How are you going to stand out? What are you passionate about? What story are you trying to tell? If you can combine talent with unique vision, you're going to be just fine.

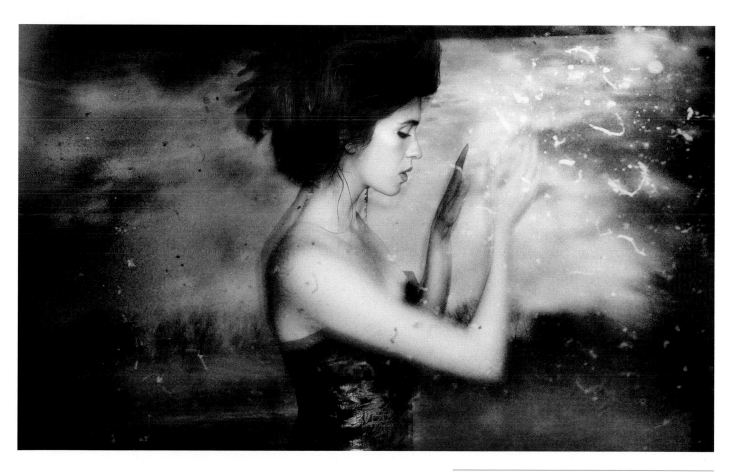

The pleasure of being a photographer is applying your talent and vision to a diversity of images.
PHOTO BY JEREMY COWART

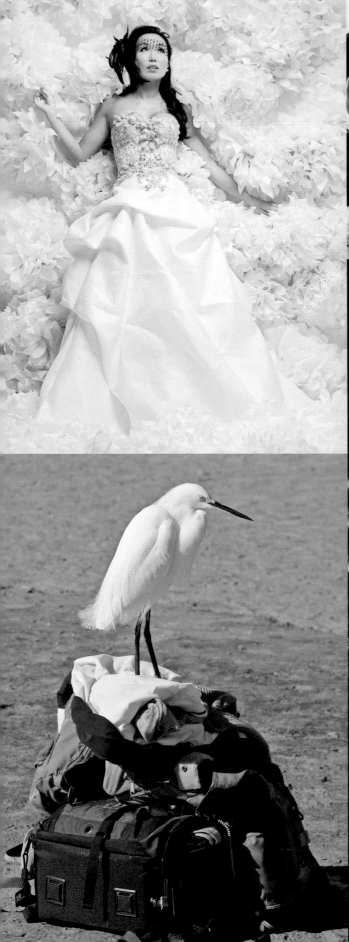

> The image is just a part of this process. It's the story around the images that you shoot and what you do with them that makes the experience memorable. —ALLISON RODGERS

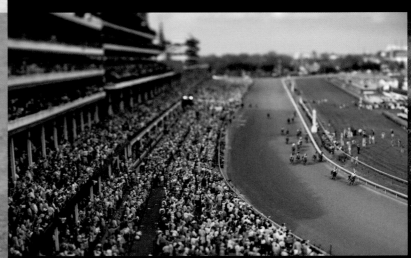

Blogging: Your Online Presence

IF YOU'RE A photographer and you want to earn a living from your photography, you should strive to have a strong Internet presence. The Internet *is* the vehicle virtually anybody interested in hiring you is probably going to use first. For businesses, blogs work as well as or better than static websites in our experience.

Entire books are written about blogging. We're not going to go too deep here, but will instead give you some concepts that you can take forward and apply to your business. Put your own brand, your own spin, and your true, genuine personality into your blog and we bet you'll see tremendous benefits as you turn pro.

PHOTOS BY (CLOCKWISE FROM TOP CENTER): JULES BIANCHI; ALLISON RODGERS; JEREMY COWART; JIM GARNER; VINCENT LAFORET, SCOTT BOURNE; NICOLE WOLF

Why a Blog Can Work for You

Here are just some reasons why blogging can help you build a professional photography business. There are obviously lots of other reasons for building a blog over a website. If you don't agree, we challenge you to try using one in addition to your website. Watch how the blog evolves compared to the website. We think you'll see for yourself the advantage of blogs.

¤ You can build a blog at no cost, and you can do it all by yourself. (There are free website hosts, but they rarely have simple back ends you can navigate without some programming knowledge.)

¤ Search engines love blogs. Google tends to pull from the first hundred words of any page. If you can write good content related to your target audience's needs, blogs will get you more Google traffic than the average website.

¤ Blogs offer RSS feeds. People can subscribe for free to your blog and receive automatic updates every time you post a new blog article or picture (see page 165 for more about RSS).

¤ When you need to change and update your blog site, you can use industry-standard tools and work at your leisure. Blogging tools like WordPress and Google Blogger let you handle your own updates free of charge. (With websites, you often have to pay a web administrator to update the content.)

¤ If you use WordPress your blog is automatically formatted for iPhone use. WP detects when someone comes to the blog via iPhone and serves up a mobile version automatically.

The images on your blog can be powerful tools in building your photography business.
PHOTO BY CHASE JARVIS

Choose a Host

You will need to decide where to host your blog. There are many options. The good news is that several of the best options are free, or nearly so.

The two largest free blog hosting services are Google Blogger (www.blogger.com) and WordPress (www.wordpress.com). We use WordPress because it has become somewhat of a standard in the industry, and that means it has very wide community support. Other popular alternatives include Tumblr (www.tumblr.com), Squarespace (www.squarespace.com), Posterous (www.posterous.com), and MovableType (www.movabletype.com). Some of these are free, while others charge a small monthly fee.

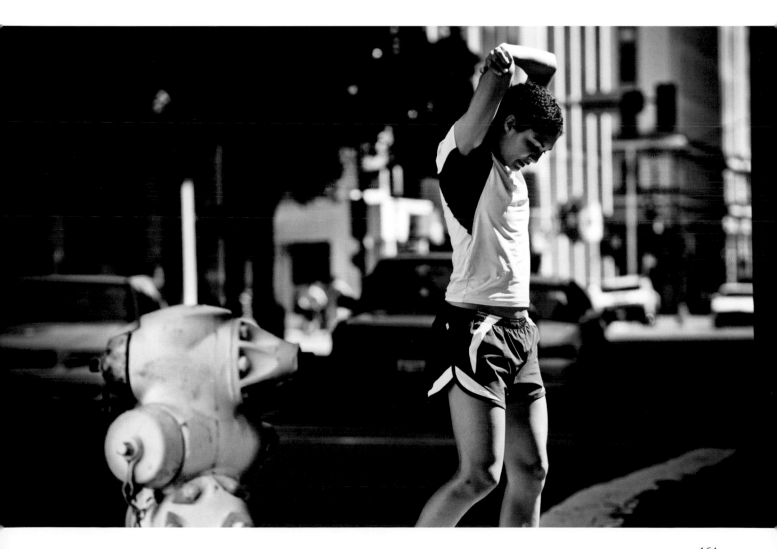

Understand What You Are Selling

Your online site typically has two simple goals. The first goal is to show the work. This is the single best thing any photographer can do to sell or publish photographs. Showing the work should become a mantra that you never let go of. Toss out anything that impedes this goal. The second goal is to set up contact. Sell an appointment. Sell the visitor on the idea of getting in touch.

Here's a great question to ask about your blog: Are the images and the information on your site so strong that people can't walk away from it? Make yourself and your website habit-forming! Give it so much impact that people share your URL and your images and talk about your work. You're the only one who can truly build your brand, and your website is one of the key vehicles to keep you at the top.

Make sure the images you post on your blog are
interesting and exciting. Never compromise.
LEFT: PHOTO BY VINCENT LAFORET
ABOVE: PHOTO BY KEVIN KUBOTA

Blogging Terminology

If you're new to blogging, you may want to understand what some of the basic terms of blogs, bloggers, and blogging are all about. Here is a brief primer of terms you will be encountering.

- **ARCHIVE.** *A collection of all your posts on one page. Can be categorized by week, month, etc.*

- **BLOGOSPHERE.** *The online community of people who blog and their writing.*

- **DASHBOARD.** *The first screen you come to when you log in to your blogging account, with all the controls, tools, and functions.*

- **PERMALINK.** *A permanent identifier used to point to a specific blog post someone wants to archive or access later. Blogs change frequently and older posts do not stay on the front page; the permalink helps readers keep track of their favorite posts for posterity.*

- **PING.** *Short for Packet Internet Grouper; notifies other blog tracking tools of updates, changes, and trackbacks.*

- **RSS.** *Short for Really Simple Syndication. (See opposite page.)*

- **TAG.** *Labeling/attaching a keyword or words to categorize similar posts.*

- **TRACKBACK.** *A system by which a Ping is sent by one blogger to another. When one blogger references another blogger's post in a blog, the second blogger usually sends a trackback.*

- **WEBLOG, OR BLOG.** *Similar to a website but usually a diary-style journal that is updated regularly and read via syndication.*

- **WEB FEED.** *Provides web content or summaries of web content together with links to the full versions of the content and other metadata.*

RSS

RSS (for Really Simple Syndication) allows people who regularly use the Internet to stay informed by retrieving summaries of the latest content from the sites they like without having to visit each site individually. News websites, weblogs, and podcasts, among others, use RSS to provide web content or summaries of web content together with links to the full versions of the content.

If you've never tried RSS or an aggregator, now is the perfect time. We prefer Bloglines (www.bloglines.com). Unlike e-mail subscriptions, you don't have to give up any identifying information to subscribe to an RSS feed. Accordingly, many people are more comfortable using RSS. If you decide that the content in your RSS feed is no longer to your liking, you simply click a button to get rid of it and it never shows up again.

Unfortunately, spammers love RSS just as much as we honest folk do, and they want to use it to send their spam-ridden messages. More and more web filtering schemes are popping up, and some RSS readers are employing filters as well. That's why it's important to follow some of the Don'ts on page 171 (such as avoiding words like "sex" and "guarantee," and not writing in all caps). Doing so should help you make sure your blog posts don't get confused with spam.

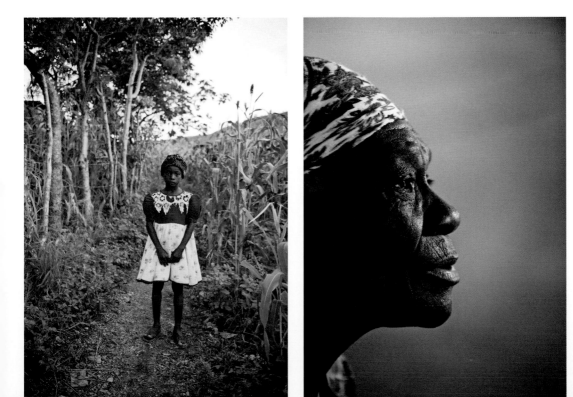

Update images on your blog frequently to show followers where you are, what you're shooting, and what's capturing your interest.
PHOTOS BY NICOLE WOLF

Design an Effective Blog

Once you pick a blog host, you'll need to decide how your blog should look. It won't do you any good to create the greatest images of your life if people can't find them on your site, they take too long to load, or the quality of your presentation lacks excitement.

As a general rule, think Google when designing your page. It's clean, simple, and un-fancy, but very effective. Google's simple design has led to hundreds of millions of dollars of net profits for its owners. Adopting those same design standards may not put millions of dollars in your pocket, but it will help you get closer to your goals.

The real key is to know your audience. Think of your approach from your prospect's point of view, not your own. If you're photographing food for a living, learn what the beliefs, feelings, and desires of foodies are. If you're photographing people for use in stock photography, learn what editors are thinking about and looking for.

If you're artistic and capable with CSS language, you can build your own template. You can also hire someone to build a template for you. For now, we suggest a free or low-cost template that allows you to customize a look by changing background colors, using your own logo, etc. WordPress and Google Blogger offer many free templates. See also the list of resources for photo-specific templates at the end of this chapter.

The primary rule in building a template is to keep your design simple and your blog easy to read and navigate. Make sure it shows off your work. Avoid using anything that takes away from readers being able to quickly, easily, and painlessly see the images. Keep your text brief and clearly written. Even though it's "cool," don't put text against a hard-to-read black background. Use serif fonts, such as Times New Roman, rather than hard-to-read sans serifs, such as Helvetica.

We prefer to visit sites that do not use Adobe Flash since they are often slow to load and harder to navigate, and because they present security issues for some computers. We also prefer sites

Be consistent when choosing work to post on your blog—show images that accurately represent your style and the genres in which you specialize.

PHOTO BY JEREMY COWART

that avoid launching with music. If you want to give your visitors the option of hearing music while looking at your images, feel free, but don't force it on them.

The biggest problem with most photo blogs is that they are too busy and cluttered and contain too much information. Your blog or website should be focused and deliberate. You should be able to articulate with specificity why each and every word and image on the site is there, much as you would with a good photo composition. This is especially true in regard to your landing page, the first page people see when they come to your site.

In our opinion, your landing page (and perhaps even your entire site) should highlight a single genre of photography. If you do weddings and pet photography, for example, imagine the potential confusion if images from both genres were to overlap. Brides rarely enjoy being compared to dogs.

Make sure your site gives an immediate sense of what you do and what products and services you offer. The main thrust of your page should be to show your work, ask for contact, and provide a clear presentation and a simple way to respond.

As you build your site, always start with a quick but succinct general overview (e.g., "I am a wedding photographer"), and get more specific as you go (e.g., "I am a wedding photographer who specializes in photojournalism"). General information should always be first—the big picture stuff (if you'll excuse the pun), followed by more detailed information. Make sure the most important details, such as your call to action, are bold, visible, and easy to access; they should also

PHOTO BY NICOLE YOUNG

PHOTO BY NICOLE YOUNG

be the largest items on the page. The largest should be one of your photographs. Nothing else should be as prominent.

Make sure that valuable content is immediately available. Making people click to enter your site (on what's called a "splash" page) isn't a good idea. Neither are proprietary browser tags or sites that use old-fashioned HTML frames. Your landing page should be a reliable index of the content of your site, as well as a source of top-level content. Consider both the interests of your audience and the search engines and give up the good stuff (that is, your best images) right away.

Finally, make sure you back up your template and all the graphics that go with it in the event of a problem. Also make sure that you have complete access to your blog at all times. It will be a lifeline for your business, and you can't afford to be offline.

Give up your "good stuff" on your blog—that is, the images you really like.
PHOTO BY SKIP COHEN

MAKE AN IMPRESSION WITH YOUR BLOG

You can (and perhaps should) use a blog to host your online portfolio. The Search Engine Optimization (SEO) benefits are tremendous (see chapter 8). It's also very easy to populate and update photos that reside inside blogs.

While it's all a matter of taste, we've decided to list (in no particular order) ten of our favorite blogs, ones we think do a great job for their photographer authors. Most of these blogs take different approaches. Study them. See what they have in common. Ask which of their features or benefits might appeal to you.

- ¤ **THE PIONEER WOMAN:** http://thepioneerwoman.com/photography

- ¤ **RICH LEGG:** http://leggnet.com

- ¤ **TREY RATCLIFF:** http://www.stuckincustoms.com

- ¤ **SCOTT KELBY:** http://www.scottkelby.com

- ¤ **CHASE JARVIS:** http://blog.chasejarvis.com/blog

- ¤ **NICOLE YOUNG:** http://nicolesyblog.com

- ¤ **SHUTTER SISTERS:** http://shuttersisters.com

- ¤ **THE ANSEL ADAMS GALLERY BLOG:**
 http://theanseladamsgallery.blogspot.com

- ¤ **VINCENT LAFORET:** http://blog.vincentlaforet.com

- ¤ **DAVID DUCHEMIN:** http://www.pixelatedimage.com/blog

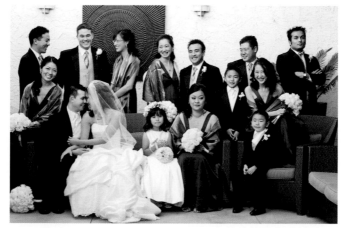

Jules Bianchi posts images like this on her blog, julesbianchi. com/blog, which she has been maintaining since June 2005.
PHOTO BY JULES BIANCHI

BLOGGING DOS AND DON'TS

Most professional communicators will tell you that everything starts with the audience. To blog effectively, be sure you know whom you're writing for and serve their interests, not yours, and consider the following guidelines.

Do

- *Be human and humane. Identify with the individual who reads your words, not with the masses.*

- *Keep your writing tight and to the point. Stay on topic. Posts of 100 to 500 words work best.*

- *Pay attention to the words you use. Words matter.*

- *Provide valuable content. The more solid information your blog offers, the more readers you will attract.*

- *Write tight sentences. Use proper grammar. Pick a style and stick with it. No amount of search engine or RSS trickery can replace good writing.*

- *Include at least one image per post when possible.*

- *Caption and tag your images to improve search results.*

- *Offer new, insightful, pithy, valuable information.*

- *Be absolutely honest and genuine. The Internet is full of people who have BS detectors.*

- *Tell the truth if you're responding to criticism of your business. The truth always comes out anyway, so be the one to tell it and avoid the drama.*

- *Update your blog frequently. The more often you update, the more traffic you will receive.*

- *Post on a schedule. Will you post daily, weekly, or monthly? Let people know what to expect.*

Don't

- *Allow someone to blog on behalf of your business if they're just a hired hand. Make sure they believe in, understand, and can passionately articulate your mission.*

- *Blog unless you have something worthwhile to say.*

- *Overuse words like "free," "guarantee," "sex," etc.*

- *Use red text.*

- *Write in all-capital letters.*

- *Use excessive punctuation.*

- *Use multiple dollar signs or symbols (use descriptive words instead).*

- *Repeatedly use the phrase "click here."*

- *Hold back. Give generously of yourself. Gurus who don't share are not loved.*

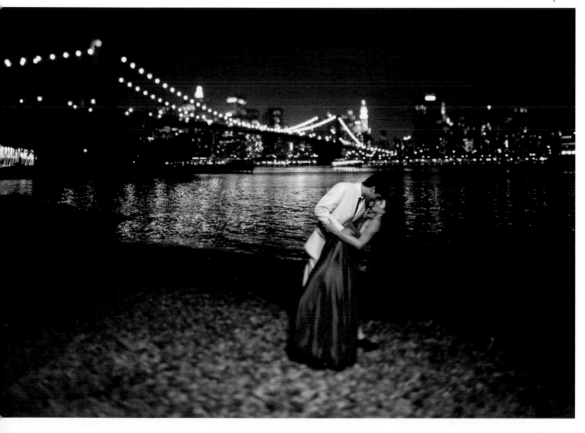

You want to create a good impression with every image you post online—in this case, what could be more alluring than a bit of romance and the Manhattan skyline?
PHOTO BY VINCENT LAFORET

Build a Community through Your Blog

Community has to do with building a relationship with your audience. When blogs were first launched, community usually came in the form of comments: People read what you wrote and then commented on your post. This brought the audience back for more because they liked to see their names in lights. Nowadays, there are other ways to establish community—polls, trackbacks, pingbacks, contests, e-mail feedback, and toll-free numbers, to name a few.

For many, comments are still top-of-mind when it comes to blogging, but there is a downside to allowing comments on your blog. Taking a page from marketing guru Seth Godin, we have decided not to allow comments on some (although not all) of our blog posts. Reading, moderating, and potentially responding to comments is time-consuming. It takes away from the time we have to research and write new posts. Like Seth, if we allow comments, we feel compelled to clarify or to answer every objection or to point out every flaw in reasoning. Also, we hate fighting comment spam. Finally, and most important for our audience, comments change the way we write. Instead of writing for everyone, we find ourselves writing in anticipation of those who will parse every word to infinity. That robs us of our voices and it robs our audience of our true opinions and feelings.

If you do allow comments, monitor them to make sure nothing spam-related, defamatory, or offensive appears on your site. Tread lightly here. The comments question is an open one, and you will no doubt offend someone no matter what you decide. So do what you think is right and move on.

Forums

User forums give readers a place to post feedback and ask questions. They create a level of interaction that goes beyond accepting comments or trackbacks. Forums need to be monitored for spam and offensive posters, but many bloggers feel this is a worthwhile tradeoff given the service forums offer their readers and the increased traffic they generate to their site. Unfortunately, the investment in time and money required to build a web forum from the ground up keeps most bloggers from using them. Consider these alternatives to building your own: ForumUp.org, Yuku.com, and http://phpbb.com.

Be Positive

With the emergence of online forums and blogs, photography can become very negative. Trolls (people who deliberately post

provocative comments) can't or won't do what's necessary to succeed and really, really don't want you to either. It would force them to come face-to-face with their failures. So ignore them. Stay upbeat. Stay positive. Stay focused on your goals, not your detractors. Excise the people, places, and things that are a negative influence on your life.

My blog, PhotoFocus.com, has more than 2.5 million page views per month. Even when I'm in the field I never miss writing a weekday post!
PHOTO BY SCOTT BOURNE

Promote Your Blog

Here are some things you can do from the start that will increase your chances of getting noticed.

- ¤ Write with keywords in mind. (See chapter 8 for more on keywords.)

- ¤ Use the name of your blog in your posts and post titles.

- ¤ Make it easy for your blog readers to subscribe, and include RSS feed subscription buttons (or "chicklets") in your sidebar.

- ¤ Submit your blog to RSS and blog directories, as well as to regular directories.

- ¤ Ping the major RSS feed and blog search engines each time you post. This can be configured with blog software. Or, if you're using Blogger.com, you can do it manually with Pingomatic or Pingoat. Use only one Ping service, however. Otherwise you could get blacklisted.

- ¤ Be sure your blog software is configured to send a trackback ping to blogs you cite within your posts. Pay attention to press releases distributed by PRWeb. If you cite a release and ping the trackback link, the press release will in turn link to your blog. This is great for increasing traffic.

- ¤ Comment on other blogs. Your name will be linked to the blog URL that you enter. Do not make off-topic comments and do not use keywords in the field for your name. Use your name or your blog name.

If you really want to attract readers, tell a story, and build interest in your blog; one of the best things you can do is interview interesting people. Some bloggers regularly feature interviews as a way to engage their audience and increase traffic all at once. We've seen this tactic work time and again. If you interview the right person—that is, someone who is genuine and helpful and who is of keen interest to your audience—your interview will drive quite a bit of traffic. You don't have to interview someone famous, just someone interesting. Whoever you interview, you can count on one thing: People in the interviewee's circle of interest will find out about your blog and perhaps visit it for themselves.

Another excellent way to build traffic is to write a series. A series can be daily, weekly, or monthly. It can be about any topic that's relevant for your blog. Now here's the kicker: Make sure the series is interlinked. In other

words, link each part of the series to the other. If you hook your readers, they'll visit all the pages in the series. This will drive up your page views and get the audience to read something in addition to the front page.

Link!

There are lots of reasons to include hyperlinks in your blog posts: They improve readability, comprehension, and search engine placement. But it's not enough to just use links—you need to use descriptive links. Consider this sentence: "To learn more about computers, go here." Now here's the same wording with a descriptive link: "To learn more about computers, go to the Apple website." As another example, if you have a post with a list of library resources, you could describe the link as "Resources" or you could say "Search Our Collections: Databases you can search for books, journals, e-journals, and more." The more descriptive link is easier to understand, and, as a side benefit, gets much better search engine response. Your readers' time and energy is too limited to click on an unknown link. Link well and you will build traffic.

TWO SECRETS OF A SUCCESSFUL BLOG

You can't be in business without a website, but how about the message you're presenting? The key to a successful blog is in two parts.

First, you need good content—topics that people really want to read about and comment on. Not everybody has the humor or the skill set to create a following like Jim Garner, with his video spoofs (jgarnerphoto.bigfolioblog.com). Jim gets leads from these videos mainly because they make brides laugh. The videos are a testimonial to Jim and how much fun he and his staff are to work with. Jim is, of course, one of the best photographers in the country, but this extra exposure just adds to the excitement he creates for his clients. Second, if you're not updating your blog at least once or twice a week, don't bother to have one. Blogs feed the search engines. Constantly updating your material is the only way to ensure that the search engines recognize your blog and drive traffic to your site.

Blog Tools, Plug-Ins, and Other Resources

Software makes it easy for photographers to create and maintain their blogs. Even if you turn the programming over to someone else, you might want to check out the following resources to see the many features available to photographers who want to increase their business through blogging.

WORDPRESS.COM: A great place to create a free blog.

BLOGGER.COM: Our second choice to create a free blog.

FEEDBURNER.COM: A great source for a free RSS feed for your blog.

NEXTGEN GALLERY (http://wordpress.org/extend/plugins/nextgen-gallery): Creates photo galleries in WordPress; has the ability to handle multiple photos, galleries, albums, and Flash slide shows.

GRAPH PAPER PRESS (http://graphpaperpress.com) and Sensor Theme WordPress (http://www.wpzoom.com/demo/sensor): Nice WordPress themes for photographers.

WRECKLESS ELEMENTS (http://www.wrecklesselements.com/search/label/templates): Blogger themes for photographers.

NEXTGEN GALLERY (http://wordpress.org/extend/plugins/nextgen-gallery): Integrates images into WordPress, with a Flash slide show option.

WORDPRESS FLICKR MANAGER (http://wordpress.org/extend/plugins/wordpress-flickr-manager): Handles uploading, modifying images on Flickr, and inserting images into posts.

VIPER'S VIDEO QUICKTAGS (http://wordpress.org/extend/plugins/vipers-video-quicktags): Copies and pastes embedded HTML from sites like YouTube.

ALL-IN-ONE SEO PACK (http://wordpress.org/extend/plugins/all-in-one-seo-pack): Optimizes your WordPress blog for search engines (Search Engine Optimization).

GOOGLE XML SITEMAPS (http://wordpress.org/extend/plugins/google-sitemap-generator): Helps search engines index your blog and notifies all major search engines about the new content every time you create a post.

KEYWORD STATISTICS (http://wordpress.org/extend/plugins/keyword-statistics): Optimizes your WordPress blog for search engines; automatically generates meta information (for example, keywords and description) needed for the search engine optimization (SEO) of your blog.

TWITTER TOOLS (http://wordpress.org/extend/plugins/twitter-tools/): Creates a complete integration between your WordPress blog and your Twitter account.

TWEETMEME BUTTON (http://wordpress.org/extend/plugins/tweetmeme): The de facto standard in re-tweeting, installed on more than 100,000 websites around the globe, allows you to transmit content of websites and blogs you find interesting quickly and easily using Twitter.

WP SUPER CACHE (http://wordpress.org/extend/plugins/wp-super-cache): Simplifies files you create in WordPress so they are easier to load.

BLOG CHECKLIST

Want to make sure your blog is operating at peak performance? Check the following:

¤ *Is your URL correct?*

¤ *Does your blog load quickly?*

¤ *Do you have a working RSS feed?*

¤ *Do you regularly update your blog?*

¤ *Is your blog easy to read?*

¤ *Is your blog easy to navigate?*

¤ *Do blog visitors have an easy and apparent way to contact you?*

¤ *Does your blog show your very best work?*

¤ *Does your blog show up in searches?*

¤ *Does your blog link to your other social media efforts?*

Study every photograph and photographer you can so that you know what's been done before and can build a vast visual database. In order to make a photograph that is unique, when you look through your camera you need to know, to recognize, when it's been done before and then find a way to "see" it differently.

HOWARD SCHATZ

In every Howard Schatz image creativity matches passion and a unique vision.
PHOTO BY HOWARD SCHATZ

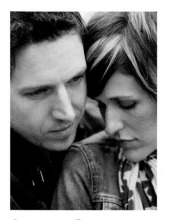

ALLISON RODGERS

Understand that this business is about so much more than just taking a pretty picture. Yes, we all enter this crazy world of photography because of the love we have for stopping time, but your dream will die quickly if you're not prepared before and after the shutter snaps. You have to understand how to take your clients from the beginning to the end of their journeys with you: From the consultation, where you plan what you are going to shoot, to the session, where you capture what you spoke about, all the way to the ordering appointment, where you help them figure out what they are going to do with the beautiful images you've created for them.

The image is just a part of this process. It's the story around the images that you shoot and what you do with them that makes the experience memorable. I am so thankful this is true, because it's one of the most wonderful parts about being able to say I'm a photographer.

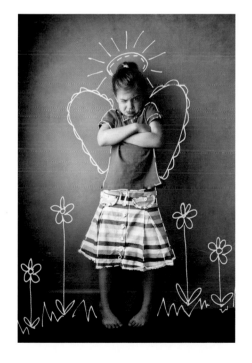

A truly successful image makes the viewing experience memorable.
PHOTO BY ALLISON RODGERS

Thinking of your photos in terms of concepts is . . . a very good way to open up their usefulness. Try to implement conceptual words into the essence of your photographs. —NICOLE YOUNG

The World of Search

GETTING FOUND, GETTING SEEN and getting heard is crucial for any emerging professional photographer. If your audience can't find you, they can't see your work. If they can't see your work, they can't buy your work. Solution? Get found.

In this chapter we'll discuss the world of "search" and how it can impact the emerging professional photographer. Be forewarned: This stuff can seem intimidating. But if you want to use the Internet to sell your photos, stick with us. Before we get too deep into this topic, we want to point out that Search Engine Optimization (SEO) and Search Engine Marketing (SEM) can be as simple as tagging your photos with the appropriate keywords. You are probably already doing that on some level, so congratulations: You're into SEO!

PHOTOS BY (CLOCKWISE FROM TOP CENTER): JOE FARACE; VINCENT LAFORET; SCOTT BOURNE; MICHAEL CORSENTINO; EDDIE TAPP; VINCENT LAFORET; NICOLE YOUNG

How Search Engines Work

Everything, everybody, every place is online. Your prospects and customers are online. Your competitors are online. Your bankers, vendors, and employees are online. How your photo business fits into that world will have a huge impact on how successful it becomes. People look to the Internet either to get information about products or to buy them. But if they can't find you, they can't buy from you.

Let's break down in simple terms how searching works on the Internet. Large, generic search engines like Google and Bing scour the Internet for everything and try to organize all the information in a way that generic users can access. There are also more specialized search engines (go to Pandia, www.pandia.com/powersearch, for a list of these) that help you search for more topical information.

Most consumers search in the most basic way: typing in the name of a product, service, or business and clicking through the results. To improve your chances of showing up in those results, it helps to know the mechanics behind the process. When you search, you're searching through an index, not actual web pages. Think of it in terms of a book's index, which helps you identify the page that contains the content you're looking for. An index of the Internet connects all the links from one page to another; it is billions of pages hosted on thousands of servers owned by the search engines.

The search engines typically return results based on a series of hundreds of variables, including number of keywords, location of keywords, number of inbound links to each site, quality of the website, and age of the website.

Make Your Site More Search Friendly

If you want to really tackle SEO, you need a plan. The plan doesn't have to be complex to be worthwhile. It could take as little as five minutes to create. Make a list of your goals and expectations. What do you hope to gain from making your photos or site more search-friendly? What sorts of things can you and will you implement to achieve those goals? How will you monitor your progress? Such questions force you to think rather than take a more random approach.

You can instantly improve your chances to rank well with search engines by building a blog (see chapter 7). Search engines love the natural elements of a blog. If you run a clean blog with lots of pictures and great organic content and regularly update it, you'll move miles ahead of many people who don't blog. Since we began building blogs, our traffic has gone through the roof on all our projects.

Blogs increase your odds of success because the entire indexing process used by the search engines is set to work well with blogs. If you can write as well as photograph, you dramatically increase the odds of ranking well in the search engines, particularly if your content uses keywords that tie in well to your photographs. (See the section on keywords, next page.)

You'll get the full benefit of a blog's ability to rank high in search engines by creating a site map. A site map is merely an outline of the content on your website. It makes it easier for people to look at everything you're presenting online and, more importantly, makes it much easier for search engines to index your content. This in turn makes it easier for people to find you using search engines. Every page on your website should be included in the site map. Find out more information on site maps from Google, and register your site map with them at www.google.com/webmasters. You should also fill out the categories and tag fields for every blog post. Depending on your blogging platform (WordPress, Google Blogger, etc.), you'll accomplish this in different ways; refer to your host's FAQ for specific information.

SEO Tools and Resources

To help familiarize yourself with SEO, take a look at these:

GOOGLE PLACES (http://www.google.com/local/add) helps you add a business listing, pinpointed on a map, to Google.

WEBSITE GRADER (http://websitegrader.com) shows you what you can do to improve your site's search results.

SEO LOGS (http://www.seologs.com) offers tips on keyword analysis and optimization.

A Word About Flash

Many photographers rely on Adobe Flash—driven websites to show off their work.

However . . . we suggest you avoid Flash as your only method of displaying images for several reasons, not least of which is the inability of many mobile devices such as iPhones and iPads to see Flash content. Beyond that, using Flash means you give up some of the most valuable real estate in the SEO landscape. Google can read a Flash site, but as of this writing, it cannot parse certain tags.

Add Keywords that Sell Your Work

Properly adding keywords to your photographs is the single best thing you can do to get them seen on the Internet. In previous chapters, we talk about showing the work to sell the work. Well, you're not showing it if folks can't find it, and this is why keywords are important.

The two most common keyword mistakes photographers make are to include too many keywords and to use the wrong keywords. For photographers, good keywording for searching includes identifying at least these three components: place, detail, and relevance.

Accordingly, here are three simple tips to keep in mind:

- ¤ Use descriptive keywords.

- ¤ Use the words you think people will use to search for content like yours.

- ¤ Pay attention to your content. Keywords are very important, but valuable content is more important; chances are, your well-researched, well-thought-out, well-written content will already contain the important keywords.

Let's look at the photo on the opposite page, identifying where it was taken (that is, the location) is important in order for it to be found in a search. People who may find your image helpful won't find it without help. The keywords for this image should include "Lower Antelope Corkscrew Slot Canyon on the Navajo Indian Reservation near Page, Arizona."

Notice how we listed lots of details about the place? That's the second tier—details. I could just say "Slot Canyon, Page, Arizona," but that would not be as descriptive or helpful. As it happens, there are two prominent canyons in the Page area and other less prominent canyons. The more detailed "Lower Antelope Corkscrew Slot" is important because there is also an Upper Antelope Corkscrew Slot. (The upper is better known, the lower is better to photograph.) When I add "Navajo Indian Reservation" I am giving even more detailed and, yes, relevant information.

If you create a template that includes place, detail, and relevance, your keywords will stand out above the crowd.

No matter how effective your keywords are, it's the quality of your images that will sell your work.
PHOTO BY SCOTT BOURNE

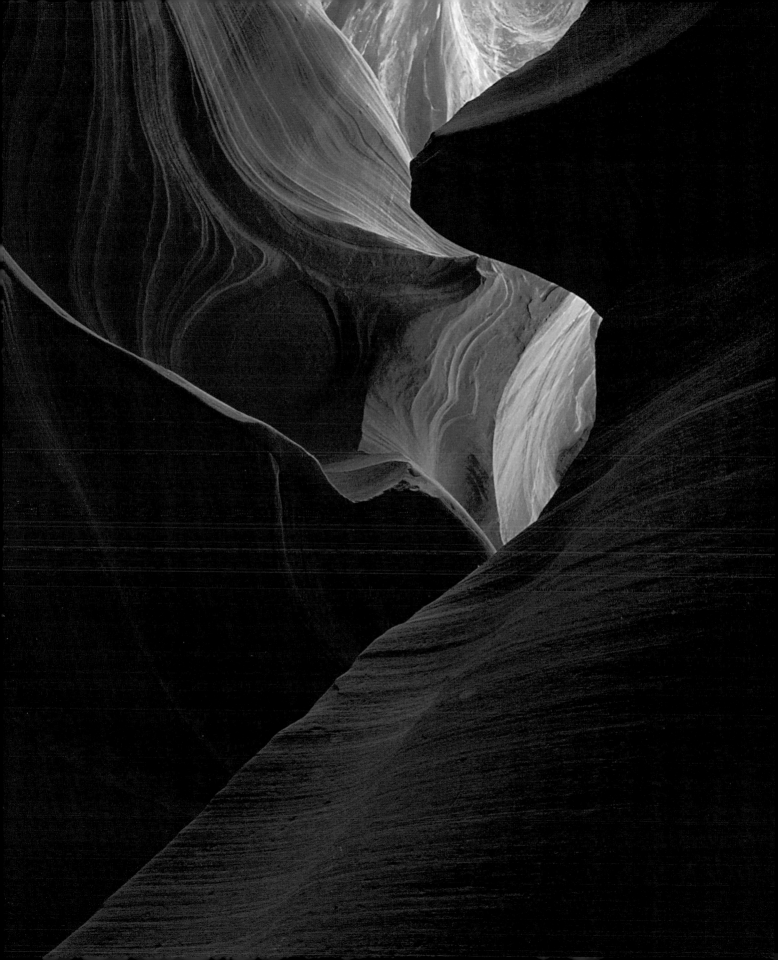

Narrow Down to Your Best Keywords

Start with fifty possible keywords and narrow these down to a dozen. A short list is easier to manage. As you narrow down the list, take into account things like competition. If you are a New York–based photographer and there are already 10,000 photographers in New York using the keyword "photographer," it might be difficult for you to break into that market realistically. You'll probably do better if you say "wedding photographer" and better still if you say "wedding photographer specializing in black-and-white wedding coverage." Don't trust only your opinion, seek help. Ask your customers what keywords they typed into their search engines to find you. Start there. Then use Google's free Adwords keyword finder at https://adwords.google.com.

Place Keywords for the Greatest Impact

It's not enough to know what keywords to use; you also need to know the places to use them. In our experience, the best place for your target keywords is in the title of your image, blog, podcast, or website post, or in the appropriate EXIF (Exchangeable Image File Format) fields found in programs like iPhoto, Lightroom, Photoshop, and Aperture. Captions are another effective place for keywords.

Let's talk about EXIF. While it is a bit more labor intensive to fill out your EXIF data when you catalog your photos, the payoff later can be fantastic. You can embed copyright information, contact information, and descriptions along with keywords so that all this valuable information travels with your image as it makes its trek across the good old information highway. The best practice, in our opinion, is to fill out this information on import as a matter of course. If you have 300 images you made at the same place at the same time on the same day, chances are that the images will have a lot in common. Accordingly, simply filling out the data as you import the images (something most modern-day image cataloging programs support) gets most of the hard work done for you automatically. You can go in later and clean up the bits that need editing. This is much easier than going into your photo library later and trying to add all of this information one image at a time.

Dare to be different in your composition—and choose image titles that ensure your images stand out in the vast universe of the Internet.

PHOTO BY JIM GARNER

Create Image Titles

When you place images into your library, you likely have some sort of naming convention that helps you find them later. If this naming convention isn't search-friendly, you are wasting a huge opportunity to have your work found.

People who are looking for pictures of the Grand Canyon aren't going to type"_NEF18323.273_Bourne_2010" ("_NEF18323" being the image label that comes right out of your camera; ".273" the job number; "_Bourne" your name; and "_2010" the date). In the real world, someone searching for images of the Grand Canyon will type "Grand Canyon photos" or "Grand Canyon pictures" or "Grand Canyon photographs" or "images of Grand Canyon" or "Arizona national park photos."

If you want search-friendly image titles, you need a naming convention that favors a description of a location, person, or place. When deciding on an image title, keep in mind that for best results, the file name should be no longer than seventy-two characters (you'll need at least four characters for the file extension, such as ".tif," so you actually have only sixty-eight characters to work with). Google and other search engines prefer dashes (-), not underscores (_). Don't repeat keywords in a title, as that may signal spam to many search engines.

When you include an image on your blog or website, it is assigned its own URL (this pinpoints the physical location of the image on the web server). Properly naming this URL can bring more traffic to your site. It's best to use keywords in this URL. These keywords should

be descriptive, not general.

Here's a bit of secret sauce: You should occasionally change the default location for your images. If you always upload images to your website via a path such as YOURBLOGNAME/PICS/FILENAME, change it up and try a new directory, such as YOURBLOGNAME/PHOTOS/FILENAME. This helps prevent search engines from thinking there's no new content there.

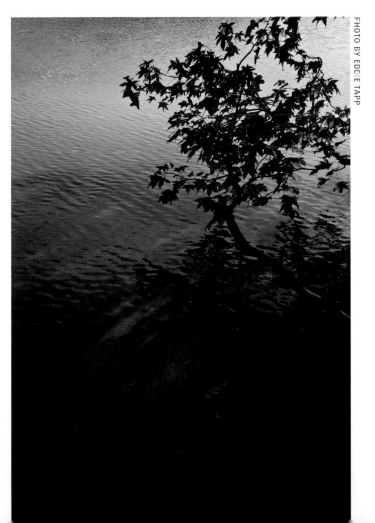

Keywording Dos and Don'ts

Using keywords properly can mean the difference between your photos being noticed or lost in the vast reaches of the Internet.

Do

- *Make sure keywords appear in the title or caption; whenever possible, a keyword should be the first word of a title or caption.*

- *Include as many relevant keywords as possible within the first 100 words of a description of an image that appears on a blog, website, or even Flickr.*

- *Keep keywords in mind when blogging.*

- *Show your more recent images most often. Your legacy images will sometimes attract less attention from a strictly SEO point of view.*

- *Opt for relevancy over frequency.*

- *Use a site that's established and trustworthy to host your images.*

- *Get other people to link to one of your images; this generally increases the image's page rank at Google.*

- *Use geo-tagging (words that give location) with your images; this will eventually matter quite a lot due to increased interest in localization of the web.*

- *Always err on the side of being honest, open, transparent, organic, helpful, valuable, generous, and relevant. These traits trump the fanciest SEO techniques every time.*

- *Append your site name to the end of all page titles. The HTML code on every web page includes a title, and by attaching your name to the end of this title you'll show up more often in search engines. A page titled "My Wedding Photography — Jones Wedding Service" will get more hits than a page titled "My Wedding Photography."*

- *Be careful about buying links or allowing reciprocal links from sites of ill repute or sites that are not tightly, topically associated with your content.*

Don't

- Use SEO tactics improperly; this can hurt your chances of being discovered via searching as much as proper tactics can help.

- Excessively repeat keywords.

- Misuse keywords. If you deliberately mislabel a post with such keywords as "naked" to lure people looking for porn into your site you'll only alienate them and you won't gain followers.

- Duplicate content just to get more keywords.

- Allow your website to go down for long periods of time.

- List titles and meta descriptions only on your home page—use every page.

- Avoid SEO just because it's hard work. It's worth the effort.

- Use your name at the front of your page titles.

- Use the same page title for every page on your site.

- Engage in too many tricks. Don't manipulate or game the system by using deliberately misleading keywords.

- Forget to put some text on every page of your blog or website. All pictures and no text makes for poor search results.

- Caption similar images with the same caption. Use different captions for each image.

Build in Links

Whatever host you use for your images, blog, or website, you need to build in page links near your photos in order to get the most search-friendly results. Linking to other pages (particularly if those pages contain competing photos) may seem counterintuitive, but every study we've seen and every SEO expert we've interviewed agrees that pages with good, tight, relevant links to authoritative sources score better in search results than pages that do not.

Link early and link often, and don't forget to link to other pages on your blog or website. It's the story around the images that you shoot and what you do with them that makes the experience memorable for viewers. For the best results, link to valid, authoritative, and helpful content.

While you can't force people to link to you, you can certainly encourage them to.

First, make sure to put your URL on everything and show it everywhere. The more often people see your Internet address, the more likely they are to visit your site. If they like what you do, they may link to you, and there you have it—another inbound link.

You can generate inbound links most easily by providing amazing content on a regular basis. This organic approach may

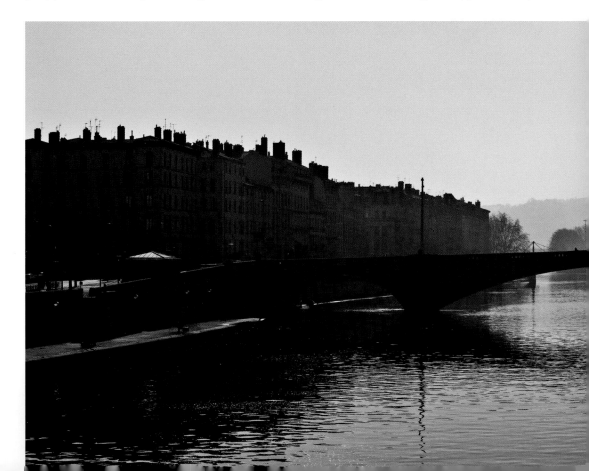

cause you to groan, because it means more work, but it's the very best way to build inbound links. Some other ways to build inbound links include:

- Engaging in link swapping and trading with like-minded people.

- Receiving links from sites in return for use of your images or an article you wrote.

- Asking your customers to link to you if they like your work.

- Filling out profiles on sites like Flickr, Twitter, or Facebook, and including your URL in your profile.

Remember that the quality of the inbound link matters. If you are a racecar driver and the folks at NASCAR link to your site, then that link has greater authority and will cause the search engines to stand up and take notice of you. Don't stop searching for inbound links. Links from ten years ago matter less to the search engines than recent ones

The surest way to ensure others will want to link to your work is to provide superior content.
PHOTO BY EDDIE TAPP

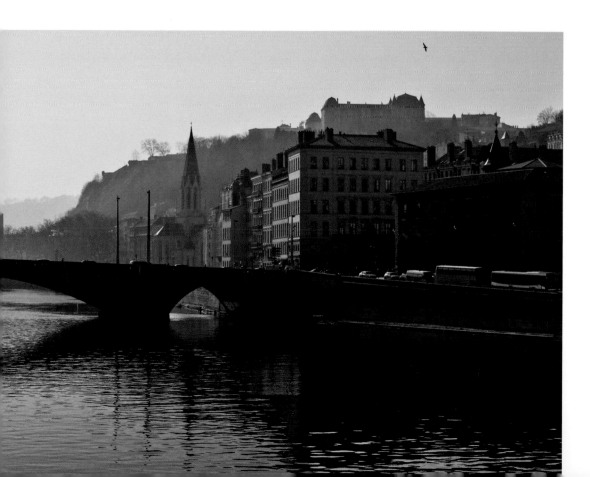

When creating stock imagery you want to be able to think of and visualize how your photos could be used. You don't always know who will be licensing your images, so you can't pre-visualize the final product, but thinking about what a designer might want will increase the marketability of your photos. When I'm organizing a shoot or setting the scene of an image, I try to consider their usability—a photograph or series of images that has several potential uses is more likely to be licensed and will have a much larger audience of buyers.

Thinking of your photos in terms of concepts is also a very good way to open up their usefulness. Try to implement conceptual words into the essence of your photographs. Creating images that use ideas such as "teamwork," "success," or even "sadness" will have greater impact and are likely to find you more buyers.

NICOLE YOUNG

Taking what a designer might want into consideration will increase the marketability of your images.

PHOTO BY NICOLE YOUNG

JOE FARACE

Always be prepared to make a sale. As an aspiring pro, you never know where your next assignment or sale is going to come from. That's why you should never leave the house, even to go to the supermarket, without a few business cards or postcards in your pocket or purse. Even better, make sure these postcards show samples of your work. Moo (www.moo.com) is an inexpensive online source that prints business cards using your photographs. Moo lets you print up to fifty different photos on fifty different cards, so you can hand a potential client a wedding, portrait, or event photograph that shows a real-world example of your work. These mini-billboards are the perfect answer to the question, "What kind of photography do you do?" Don't be afraid to let a client take several cards with different photographs on them. Unlike traditional business cards, people are less likely to throw away cards that have photographs, especially those with pictures of people on them, and those extra cards can get passed on to another potential client, making them a silent sales force for your photography business. Be sure your cards include all your relevant contact data, especially your Twitter and Facebook page addresses. Never miss the opportunity to make a sale.

Joe Farace lives by his creativity and diversity.
PHOTO BY JOE FARACE

Get off your computer. Join a local photographer's group. Attend at least one major conference a year. Experiment together with off-camera lighting. Working together, we make this industry better than we ever could alone. —JULES BIANCHI

Old-Fashioned Networking

WE'VE ALREADY TALKED about social networking. Now we're going to discuss good old-fashioned, hand-shaking, look-people-in-the-eye networking.

A great network is about people who are not only willing to work together but also complement one another's strengths. They share common threads of integrity, professionalism, trust, and friendship. Networking is not about collecting business cards but about developing relationships.

Building any new business, not just one in photography, is in part about having a great network. It's critical to have people whom you can call on when you need help. Trust us—nobody has all the answers, and the stronger your network the faster you'll travel up the road to growth and success.

PHOTOS BY (CLOCKWISE FROM TOP CENTER): MICHAEL CORSENTINO; BAMBI CANTRELL; JERRY GHIONIS; BAMBI CANTRELL; CHASE JARVIS; MICHAEL CORSENTINO

Attend Events . . . and Be Sociable!

The fastest way to grow a healthy network is to attend every workshop, class, convention, and trade show you can. These events give you a chance to meet other photographers and talk about the challenges of everything from technology to customer service. This is about communication, on the most basic level. Most people have a very hard time getting a conversation going with someone they don't know. So, this is probably a good time to expand on a few pointers. As basic as they may sound, you'd be surprised at how some people just need a little direction to get things going.

Be prepared. We mean really prepared. Bring business cards. (We know it's basic, but even we've forgotten them a few times!) Make sure you're properly groomed. Bugs in your teeth won't win you many friends. Dress appropriately. People really do judge you by the way you're groomed and attired.

Don't be shy. If you want to network, you can't do it from the back of the room. You have to be willing to put yourself out there. Go for it.

Put away the cell phone. Tweet later. Update Facebook later.

Don't interrupt. If someone you want to meet is talking with someone else, you won't make a very good impression if you bulldog your way to the front of the line. Wait your turn.

When you shake hands with someone, look them in the eye. Repeat his or her name—twice, if possible. This shows you're engaged and helps you remember the person. If you're comfortable doing it, lean in to the person when you shake hands. This is a sign of acceptance and warmth. Don't look over his or her shoulder to see if someone more important is nearby.

Don't talk too much about yourself. Don't brag. Don't strut. Be humble. Listen to what other people think. Let them finish their thoughts and ask lots of open-ended questions. Ask follow-up questions to show that you are interested and listening.

Don't monopolize your new friend's time. Networking is simple: You introduce yourself. You listen to what your new friend has to say.

You exchange cards. You figure out if there's anything you can do to help your new friend. You make a plan to follow up with each other, and you move on. Everyone at a networking event is looking for a chance to make new contacts. Let them.

Introduce your new friend to at least two of your old friends. This way you're not just walking away, but you're doing something that might turn out to be super helpful. Be sincere. Ask what one big problem or challenge your new friend faces and if you have a possible solution, offer it. Don't sell, just offer to help. Don't make promises you can't keep. If you're not truly interested in someone, spend enough time to be polite but move on. No sense in building false expectations.

Stacy Pearsall is the only woman ever to twice be named by the Associated Press as Military Photographer of the Year.
PHOTO BY KENNY KIM

How to Maintain a Network

Maintaining a network requires care, feeding, and some unselfish acts (a hard concept to grasp in today's "me, me, me" world). It's a complete waste of time to build a network, collecting people the way kids collect trading cards, and then not maintain it. Building a network is about quality, not quantity. Just take your time and you'll be amazed at how it can grow into something incredibly valuable! The best part of all: Your time is the only investment you need to make to maintain a network.

Communicate. A good network is all about staying in touch. So many people claim to have a good network but really have done nothing more than collect business cards! Once you've met somebody you want in your network, you've got to keep in touch if you want to be able to count on that person when you need help. In the same respect, you've got to be there when he or she needs help.

Strive for diversity. A network is a support system. Your goal is to have diversity in your network with people who complement your weaknesses. Friends are at the core your network, especially when you're just starting out, but it's the diversity in the skill set of the other members in your network who will provide the greatest support when you need it the most. Work to bring people into your network from different backgrounds and with skills and specialties that are different from your own.

Grow constantly. One of the most important reasons to attend a workshop, convention, or trade show or participate in online forums is to expand your network. Don't get us wrong: Attending great workshops and developing your own skill set is critical, but so is getting to know the person sitting next to you. You've got to keep meeting new people, which leads to sharing new ideas and concepts.

Make the most of social opportunities. Never have lunch or dinner alone! The greatest opportunity to get to know another photographer is over lunch. It's completely neutral territory and the social experience will help build your understanding of another member of your network. Learn to believe in the creativity that comes out of talking about business in a lunch or dinner environment.

Lighting guru Bobbi Lane (on right) during a demonstration at Skip's Summer School.
PHOTO BY KENNY KIM

Contribute. Building a great network is a two-way street; you can't just collect people and then sit on the sidelines as an observer. Don't be afraid to keep in contact. Participate in discussions on various topics. Share your opinions, but also listen to the opinions of others. You might just be surprised at someone else's point of view.

No photographer that we know of has built a stronger networking base than Illinois photographer Kenny Kim. Throughout the year you'll find him at various conventions and workshops, where he spends his time talking with other photographers. He gives back to the community through his involvement with Thirst Relief International, an organization that helps provide safe water. And, at virtually every event he attends, he simply does what he does best without being asked—he captures great images.

Kenny Kim captures Jerry Weiner of PWD during his business presentation at a session of Skip's Summer School. Kenny is an amazingly generous photographer. He wasn't asked to shoot for the event; he simply did it and later handed the management team a jump drive with dozens of images for future use.
PHOTO BY KENNY KIM

Conventions and Trade Shows

Photographers constantly need to stay on top of changes in technology, trends in marketing, and issues within the photographic community. The very best photographers in the industry never stop learning. You'll often find many of the most successful contemporary icons attending workshops and programs on new products and watching demonstrations of new applications. It's all about education and never resting on your laurels. Conventions provide a way to keep up and are also prime networking opportunities. Some of the major conventions you should try to attend include:

American Photographic Artists (APA, formerly Advertising Photographers of America), dedicated to advertising photographers and other media professionals. Find local chapter meetings across North America at www.apanational.com.

American Society of Media Photographers (ASMP), professional organization for stock and assignment photographers. Find regional meetings across the United States at www.asmp.org.

Digital Wedding Forum (DWF), convenes in February or March annually in Las Vegas; www.digitalweddingforum.com.

Imaging USA, owned by Professional Photographers of America (PPA), takes place annually in early January; www.imagingusa.com.

North American Nature Photography Association (NANPA), takes place annually each spring in different locations; www.nanpa.org.

PhotoPlusExpo, owned by PDN (Photo District News), convenes annually in late October or early November in New York City; www.photoplusexpo.com.

Photoshop World, operated by Kelby Media Group, convenes twice per year: in Las Vegas in the fall, and in a rotating list of East Coast locations in the spring; http://photoshopworld.com.

Pictage, part of the **PartnerCon series,** usually convenes in the fall and hosts other events throughout the year; www.pictage.com.

Wedding and Portrait Photographers International (WPPI), convenes in February or March annually in Las Vegas; www.wppionline.com.

Get the Most Out of Every Convention You Attend

Since attending a convention and/or trade show is so important in helping you stay on top of photography trends, you need to get the very most out of each convention. "Working the trade show" is no easy endeavor, but once you're there, do it right. Stop by every booth, one aisle at a time, and do your best to meet as many exhibitors and attendees as you can. Here are some useful tips:

Think about what you need most in terms of help with your business. Do you need more education in marketing and business, a better understanding of photography, or more frames and other products for providing added value to your customers? Maybe you need a few new focal lengths in your camera bag. Maybe you need a new camera bag! The purpose here is to establish your priorities. A few hundred exhibitors have booths at national conventions and it sure helps to walk in the door focused on where you need the most help. Otherwise, a convention can simply overwhelm you with too many choices.

Go to the print competition judging. Many of the professional photographic conventions offer some kind of print competition and judging is often open to the public. Sitting in and listening to the comments may well be the best bang for your buck out there! Comments from the judges are in effect

classes in composition, exposure, and printing given by dozens of industry icons.

Plan your days in advance. PhotoPlus Expo, Imaging USA, and WPPI all publish their speaker schedule well in advance. These programs expose you to another photographer's work, technique, and concepts. Think about which classes you want to attend and be there at least fifteen to twenty minutes early, as programs often fill up fast and you don't want to be closed out. Select your programs based on your priorities and what you need the most help with for your business, not on the popularity of the speakers.

Network, network, network. There's a reason we started this chapter talking about the importance of building a strong network. The friendships you can make just talking to people will become an important part of the foundation of your new business and your experiences at the show. Remember, everyone is dealing with the same challenges you are: the economy, creativity, growing a business, marketing, etc.

Diversify. We've talked about the importance of staying diverse. A convention offers great opportunities to start learning a new skill set. Find at least one program to attend that's completely out of your experience. In fact, choose a topic that scares you the most!

Bring some of your own images. We just don't understand photographers who come to a convention offering access to every icon in the industry, as well as every manufacturer, and leave all their work at home. You don't need to carry around a 16 x 20 portfolio case, just a book of approximately a dozen of your favorite images, or your promotional piece, or even a few images stored in your iPhone. We're big fans of paper prints at a convention. If you're trying to share some images at a particular booth and the person you need to talk to is unavailable, leave behind some 5 x 7s in a folder with a business card and more information about your business. You can then follow up after the convention.

Take a camera with you. We're not talking about the gear you shoot with for your business, but a decent point-and-shoot. Get a few shots of yourself at the show interacting with vendors and other photographers. Create a press release when you get home and submit it to the local newspaper and the chamber of commerce, and post it on your blog or Facebook page. See page 116 for a sample press release and some ideas on how to make the best use of it.

Don't be afraid to talk to your favorite speakers. Everyone at a convention is approachable. We're all there because we believe in education and sharing. Just remember to always show courtesy.

Last but not least, have fun. Seriously, "fun" is one of those words that's too often lost in business practices today. You're going to make new friends and connect with old ones. It's okay to work hard and party hard!

At Skip's Summer School, Tony Corbell (above) discusses lighting techniques and Kevin Kubota (right) encourages photographers to be more creative and test the waters outside their comfort zones.
PHOTOS BY KENNY KIM

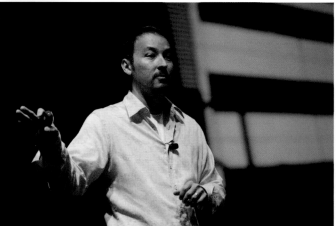

Look for workshops that not only strengthen your skill set but also give you the opportunity to network with other photographers.
PHOTO BY KENNY KIM

WANT TO BE GOOD AT NETWORKING? REMEMBER NAMES!

Nobody likes to have his or her name forgotten. Here some techniques we use to get better at remembering names; try one or a few of them next time you attend a convention.

¤ *When you meet someone new, say his or her name at least twice. As in, "Hello, Jayna Wilson. Is that Jayna with a 'Y' or just an 'A'?" Combined with the person's own introduction you will have heard the name three times in a few seconds.*

¤ *If someone hands you a business card, read it and focus on it. Read his or her name aloud from the business card.*

¤ *Write the new name down on a notepad. Speaking it, hearing it, and writing it will increase name retention.*

¤ *Ask where your new friend is from. Then repeat the location in association with his or her name. "Hi, Jayna Wilson from Lexington, Kentucky."*

JULES BIANCHI

I left a career in the film industry to start my photography business at the beginning of 2001. Where once I had been accustomed to being surrounded by people daily in an office or on the set, I was suddenly working by myself and figuring everything out on my own. There were no conversations around the water cooler about the latest trend; there was no one to brainstorm with. I was either at home alone with my computer or out shooting weddings. It made for a pretty lonely life. Back then, Facebook, Twitter, blogs, and photography forums didn't exist. Getting information and finding colleagues wasn't easy.

Today, you can find blogs to inspire, forums to read, Facebook updates of fellow photographers, and Twitter trends—all with a quick Google search. Twitter is like the biggest virtual water cooler in the world. But my advice is to use these tools only as a starting point. Get off your computer for long stretches of time. Join a local photography group. It's a great way to keep up with what is happening in the industry and to connect to others who are struggling with similar issues. Attend at least one major conference a year. It's worth the price of admission even if you only go to network.

Cultivate relationships with local photographers. One of the very best things about this is the ability to learn and grow together. I strongly encourage you to go out on assignment and shoot together. The more often you shoot, the more skilled you become. Borrow new lenses, share with one another. Experiment with off-camera lighting. You'll be pleasantly surprised by how shooting with a new lens will suddenly allow you to see in a new way. Working together, we make this industry better than we ever could on our own.

Images by Jules Bianchi often seem to reflect a certain level of happiness. Is it the situations she captures or her ability to bring out the best in her subjects?
PHOTO BY JULES BIANCHI

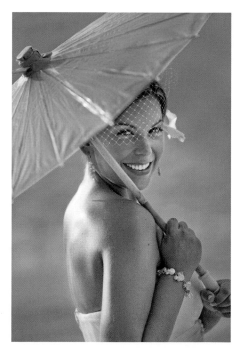

JERRY GHIONIS

Success in wedding photography, especially in performing on the wedding day, is largely about communication and listening skills and knowing how to read people. That, rather than focusing on how technically brilliant you are, will go a long way toward making you a great photographer. An endearing and attractive personality and an ability to work under pressure while staying technically proficient are especially important. You almost need to be like a chameleon: relaxed and down to earth at a casual wedding, yet able to carry yourself professionally at a high-society wedding.

I encourage new photographers to be as passionate about their businesses as they are about their photography. Consider yourself a businessperson who happens to be a photographer.

As a business owner, ask yourself, "Am I working in *my business or* on *my business?" Surround yourself with great people—your studio is only four walls without good staff. Stop being a control freak and get some help. Educate yourself. Seminars and workshops can literally change your life. After all, knowledge is power. Don't be too precious about the work.*

When it comes to marketing your new business, work first on marketing that costs you nothing. Ask your clients and vendors for referrals and maximize relationships with people who can help you. Also, wedding photographers should try creating a same-day slideshow to present at the reception. It's the best direct marketing you will ever do, and you can also charge good money for it. If you are going to invest in advertising, don't think about the advertising dollars you are parting with. Think instead about the return. Whenever an advertising opportunity arises, ask yourself, "Is there a better way I can spend this money?" And finally, don't forget to consider yourself a brand. Build it and they will come.

One of my favorite mantras has always been, "Don't focus on being the best." I just focus on being better than last week. I believe this is the key to being successful and consistently creating beautiful images. By doing that, you become the best you can be—you realize your own potential.

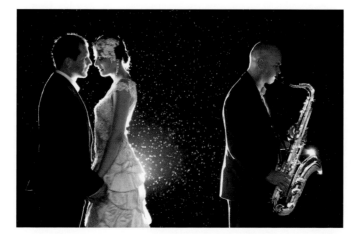

Jerry Ghionis has made it a point never to compromise on creativity, quality, or passion.
PHOTO BY JERRY GHIONIS

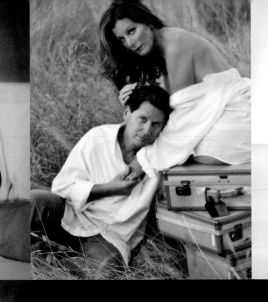

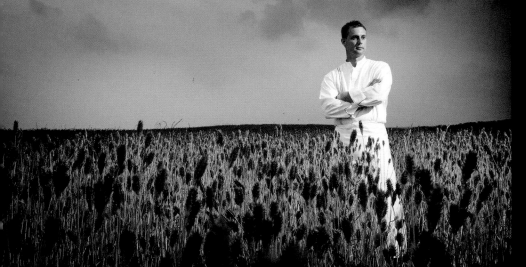

To be successful in anything creative, one has to love what one does. —KAYCE BAKER

Expand Your Business

WHEN YOU'RE JUST starting out, your first order of business is to understand photography and make sure your skill set is the very best it can be. Second is to develop your business flow. Third is to develop a marketing plan that includes publicity, advertising, and direct mail—everything it takes to get the word out. Fourth is to handle the business that starts to come in. Just a short step away, in last place by only a hair, is to diversify your skill set so you can expand your business. The goal is to make sure you can provide your growing list of clients with the services they request. But you need to expand carefully and wisely. Let's clarify the process a little.

PHOTOS BY (CLOCKWISE FROM TOP CENTER): BAMBI CANTRELL; NICK VEDROS;
TAMARA LACKEY; KAYCE BAKER; NICOLE WOLF; TAMARA LACKEY

Make the Most of Your Specialty

If you're a children's photographer, then all your efforts should be in marketing yourself to the right target audience for photographing kids. However, if a client loved the work you did photographing her children and asks you if you could do some food photography for her restaurant, wouldn't it be great to be able to say, "No problem!" and to direct her to your site showcasing your food photography?

Moving from photographing children to shooting food or Harley Davidsons is the extreme. But there's a more logical form of diversification we believe everyone should work to develop.

Consider, for example, diversifying within the category of people photography. How's this for a logical scenario? If you did a great job photographing a wedding and the bride and groom loved your work, then why wouldn't you want to be there to do the first portrait of the new baby when they start a family? Here's where stepping outside your specialty really comes into play, provided you have the skill set to do so. As the babies grow, doesn't it make sense to be there to do family portraits, family gatherings, anniversaries, and birthdays? Possibly Mom and Dad are developing their own imaging needs. Maybe they've got a business that requires product photography and they need help. Suddenly the kids are graduating and they need senior portraits and maybe a portfolio. Then they're getting married and the entire cycle starts all over again.

Why shouldn't photographers work with a family to fulfill all their photographic needs? With today's technology, you even have the ability to offer your clients their own holiday cards. The same goes for frames, canvas prints, additional albums, and more. You've got the ability to offer them one-stop shopping for all of their photographic needs.

Remember, though, you can only implement this scenario if you have the skills and have developed a solid support network. You never want to turn work away, but you should also recognize that in some cases it might to best to refer work to another photographer whose skill set is better suited to the assignment—and has the same sense of customer service, quality, and integrity that you do.

SURVIVAL OF THE FITTEST

What's the key to surviving as a profes-sional photographer in a tough economy? There is no secret. Survival is all about marketing, promotion, hard work, and utilizing every aspect of new technology.

Are you hitting the same old target or developing new markets? If you're a wedding photographer, how many of your brides in the last few years have had children? If they loved the wedding album you created, how about photographing their young families?

What are you doing to promote yourself? Are you involved in the community? Are you advertising in local papers? Do people recognize your presence? Larry Peters, a leading high-school seniors portrait photographer, used to photograph half a dozen seniors each year at no charge. They in turn became his ambassadors and helped spread the word among the various high schools in his area. Well-known pro David Ziser tracks anniversary dates for the couples whose weddings he shoots and does a first-anniversary sitting at no charge.

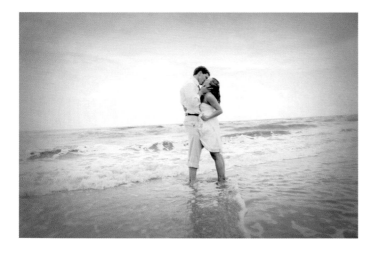

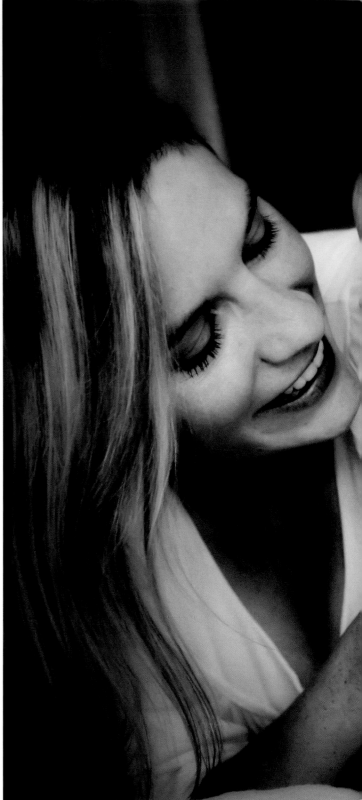

Tamara Lackey has built her business on diversifying within "people" photography. From engagement sessions to children, babies, and even maternity, she's made it a point to always meet the needs of her clients.

PHOTOS BY TAMARA LACKEY

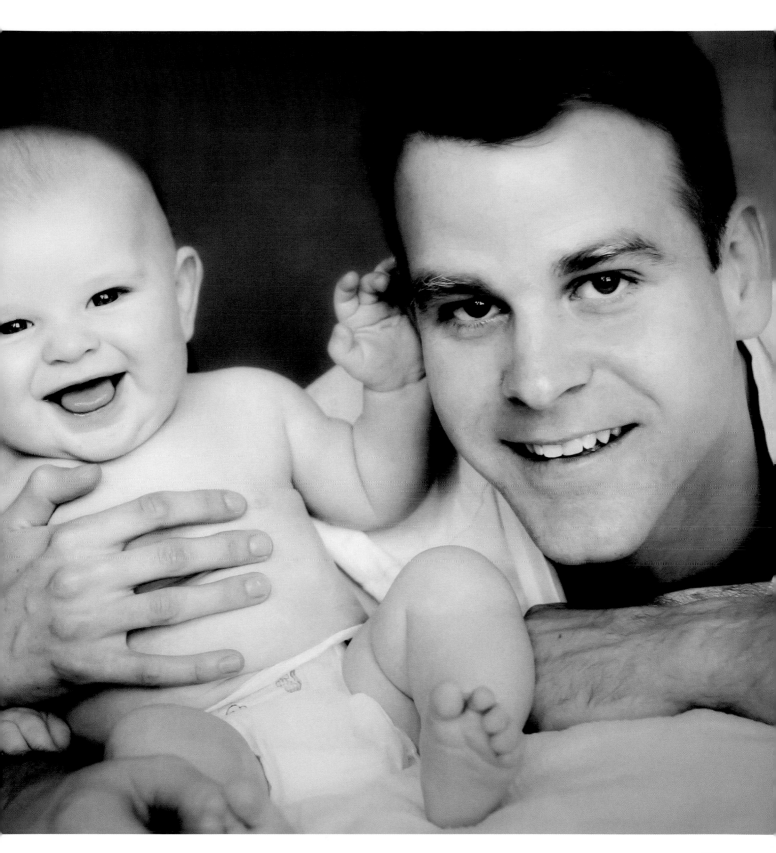

Make the most of whatever photographic specialty you choose—
whether it's weddings or birds.
PHOTOS BY SCOTT BOURNE

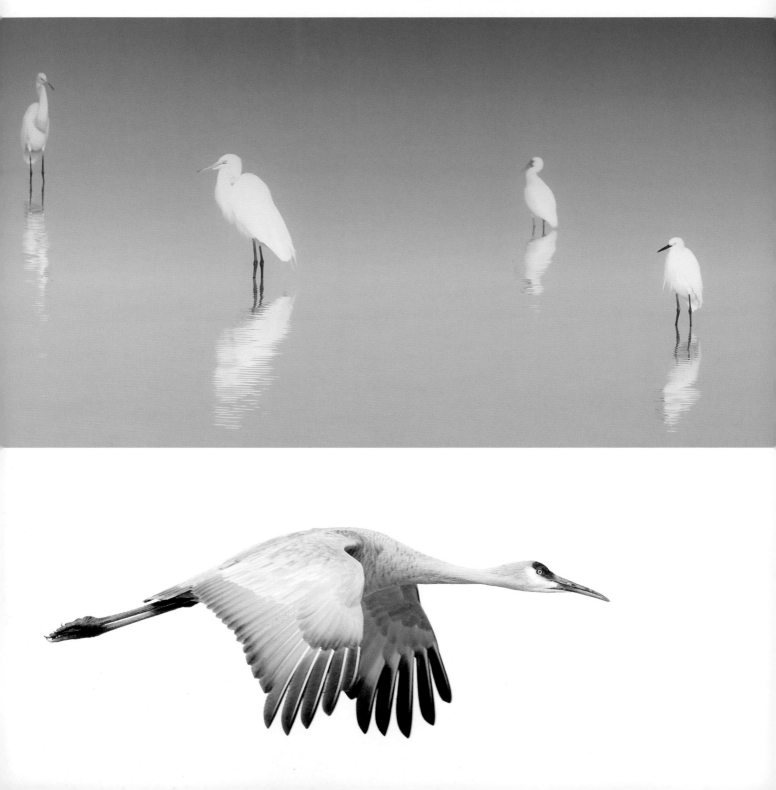

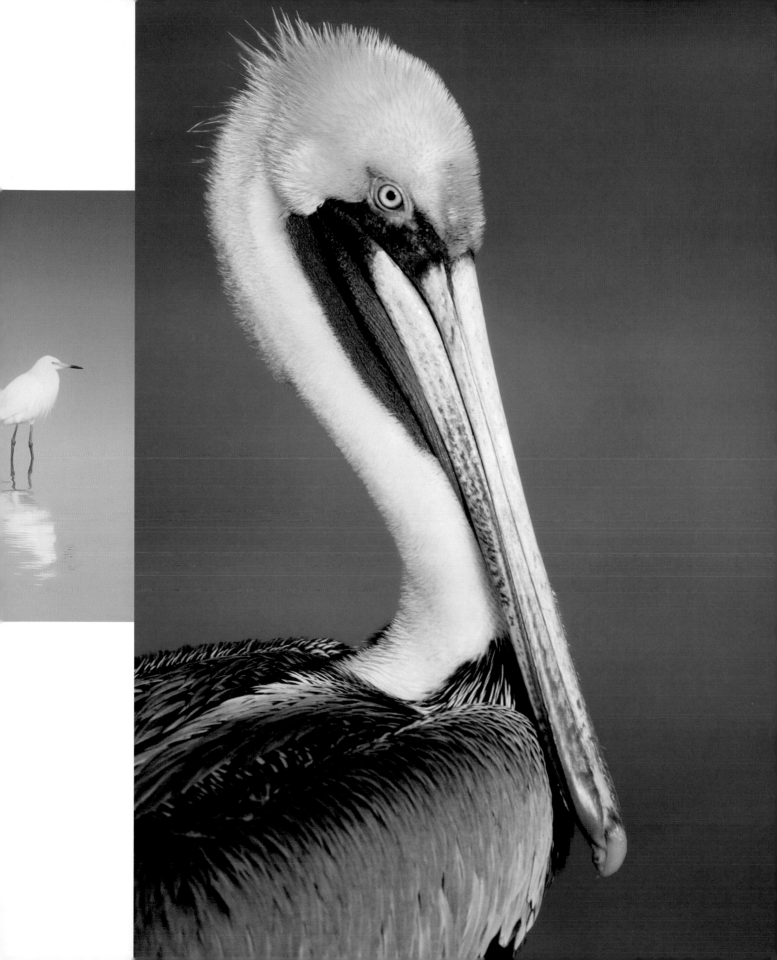

Make a Plan for Diversification

While your first venture into a specialty outside of your core experience might be accidental or random, you're going to be much stronger if you're proactive instead of reactive and lay out a plan for diversification.

Expand Your Skill Set

Practice specialties outside of but somehow connected to your main skill set. For example, if you're a children's photographer, learn to photograph families and pets. If you're a commercial or corporate photographer, learn how to do a great business head shot. If your main work is on annual reports or company brochures, learn about architectural photography.

Design a Publicity Campaign

This will include e-mailings and direct mailings to help you spread the word about your various specialties, as well as press releases. For more on these and other components of publicity, see chapter 4.

Establish a Clear Message on Your Website

We've talked about the importance creating an effective website that reveals your photographic mission, but your website is not necessarily the place to proclaim the diversification of your skill set. If you are a wedding photographer who also loves to photograph motorcycles or food, position that work on a different site and develop branding on each that's suitable for that specialty. In brief: Don't mix messages!

YOUR PHOTOGRAPHIC VISION

As you consider diversification, keep in mind that your greatest asset is your unique photographic vision.

Your vision is about the emotions or feelings you are able to evoke, not the facts behind the image or even the subject matter. It's about your single-minded desire to protect a memory and tell a powerful story without words. Whatever the subject matter, you should be able to express yourself with a camera in a way that moves others. So, before you decide to expand beyond the niche in which you have established yourself and take up a new specialty, make sure you can continue to make images that will move people with your vision.

ABOVE: Bambi Cantrell makes it a point to set up her galleries by photographic specialty, showing wedding galleries, family, fine art, and commercial.
PHOTO BY BAMBI CANTRELL

LEFT: As you strive for diversity, make every image outstanding.
PHOTO BY JULES BIANCHI

KEEP AN EYE ON THE TRENDS

Trends in style, culture, and products change all the time. Hemlines go up and down, this year's fall colors from the fashion world are different from last year's, and the list goes on. As you diversity and expand your niche, it's important to stay on top of these trends so you can bring a fresh approach to your new ventures.

If you are a commercial food photographer considering moving into wedding and event photography, perhaps seeing how your most successful colleagues handle the lighting on a salad and a glass of wine will give you new ideas on how to photograph the cake or champagne glasses at a wedding.

A great way to get on top of trends and stay in touch with what's hot and what's not is to visit www.blackbook.com or www.workbook.com. Make a brief trip through a few pages of either source and you'll see hundreds of images and different styles of portraits, fashion, product shots, and more from photographers all over the world.

Nick Vedros and other commercial photographers—along with the companies they shoot for—set many of the imaging trends that influence the public.
PHOTO BY NICK VEDROS

The one piece of advice I would give to all photographers starting out is to understand business and, more importantly, to understand their own business. To be successful in anything creative, one has to love what one does. Either diversify or specialize, but don't do both. Running a business is tough enough; running various ones with differing needs and being good at all of them is practically impossible. When you build a business on what you love to do, it shows in your work and it's apparent to your clients. That is how you build a business that succeeds.

KAYCE BAKER

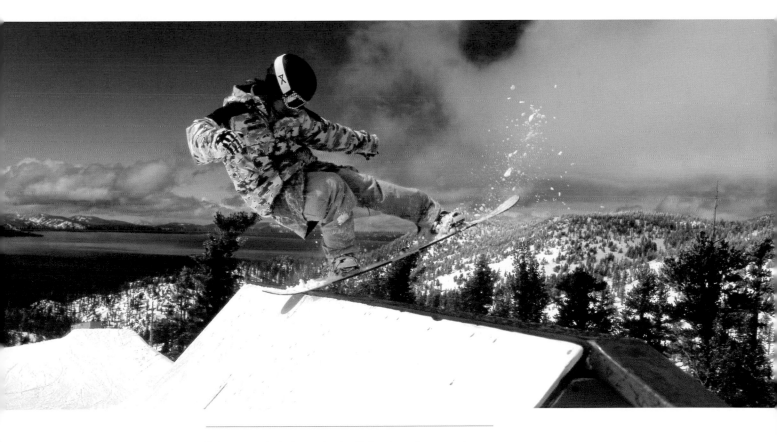

Being a great photographer is all about passion—your's as well as your subjects'.
PHOTO BY KAYCE BAKER

Outsourcing will help you accomplish more in less time, so you can spend more time doing what you love, photography.

—MATTHEW JORDAN SMITH

Outsourcing

ONE OF THE most daunting things about "going pro" is the harsh reality that there is a whole lot of work to do. Unless you're lucky enough to go pro with a large cash stash with which to hire help, like most emerging professional photographers you'll probably be a solo operation. It's you, you, and you.

You're responsible for creating a product, marketing it, shooting it, editing it, selling it, delivering it, and doing all the administrative stuff, such as bookkeeping and dealing with legal issues and taxes. But you don't have to do it alone. When you're first starting out, outsourcing—hiring contractors to help with these tasks—is a great way to reduce stress and allows you to do what you love most: take pictures.

PHOTOS BY (CLOCKWISE FROM TOP CENTER): JEREMY COWART; MICHAEL CORSENTINO; NICOLE WOLF; CHASE JARVIS; VINCENT LAFORET; CHASE JARVIS

Make a Plan for Outsourcing

Many resources are available to you. Just about every aspect of the photography business has a network of resources. The first thing you need to do is come up with a plan that outlines what parts of your business you *can* do, then ask which of these tasks you really *want* to do. Make a list of all these tasks. First, here's a short list of the work you'll be doing:

Administration. All of the back-end details and processes that make your photo business work: taking care of the money, licenses, clerical work, taxes, legal issues, etc.

Marketing. Creating product lines, brands, pricing structures, advertising, publicity, and more.

Selling. Getting customers in the door and getting them to say yes to what you have to offer.

Shooting. Creating the product.

Editing. Turning the raw images into finished products by selecting the best shots and retouching/refineing them so they look great.

Delivery. Packaging and presenting the finished product to the client, making sure everything meets the client's expectations.

Customer Service. Making sure your clients remain happy. If they have a question or a problem, or if you make an error, it's up to you to fix it.

Your first outsourcing task is to go find someone who knows more about these functions than you do. The great news is that there is a fantastic resource few new business owners seem to know about: SCORE is a government program engaging more than 12,000 counselors in more than 350 cities across the United States. The organization is made up of retired business executives who provide help online and in person at one of their offices; contact them at www. score.org. Other resources include the U.S. Small Business Administration (www.sba.gov) and Business.gov (www.business.gov).

Working with Vendors

Working with vendors and subcontractors can save you time, money, and stress. It can also help you improve the quality of your product. If you're not good at photo printing, hiring a great lab will no doubt improve your work. Not all the outsourcing is going to cost you a great deal of money. You learn to build enough money into your pricing structure to cover any costs that might be associated with hiring contractors.

If you think you can't afford to outsource,

then you are really saying you can't afford to be in business. It's a simple equation: You have only so many hours a week; if you're truly serious about being a professional photographer, then you simply have more tasks to complete than you do hours. That's why you need to consider outsourcing, even if your skill set is such that you can do each of these jobs yourself.

As you consider utilizing the services or products of the companies we suggest in the Resources section at the end of this book, it's also important to remember there are some potential disadvantages to outsourcing. If not handled correctly, outsourcing can complicate direct communication between you and your clients. You give up some control to vendors and are at their mercy in the event of a failure to perform (another reason to carefully pick the right vendor). Security can be an issue if you're giving up client data to a third party, so make sure you know the privacy and security policies of any vendor you choose.

It is better not to outsource some jobs, in our opinion. If you can automate some part of your process (using computer software, for instance), then there's no reason to outsource it. If you have business workflow steps that aren't really necessary or that could be streamlined, eliminate these steps rather than outsourcing them. Don't outsource anything that would require your personal touch or involves anything relating to personal interaction with your clients.

Despite the potential problems, we believe that the decision to outsource to the right company will almost always produce a result that's better than the average one-person photo studio can provide on their own.

AVOID TIME STEALERS

Wasting time is one of the biggest mistakes emerging pros make. Don't spend time doing things you don't do well.

If you're not a trained accountant, don't do your own accounting. Hire a part-time bookkeeper. It will take him less time than it will take you, and he'll do a better job. Instead, spend time making photographs and marketing your services. Resist the urge to meet with pals for a coffee every morning. Meet them after work. Spend your work time working and your play time playing. Don't let anyone steal your time. Once it's gone, it's gone, and you can't get it back. Think about what you could have accomplished during that half hour if you'd spent it on the phone contacting editors to discuss your latest photo expedition and the images you made.

PHOTOGRAPHERS ON EXPANDING THEIR BUSINESSES AND OUTSOURCING

Here's what the pro's have to say about how to get more work and how outsourcing helps them excel at the work they have.

I think it's dangerous to sit back and rely on just taking pictures these days. So in response, I'm launching as many side projects as I can to smooth out the ups and downs of being a freelance photographer. I rent out gear, my gear truck, and studio space. I've released an instructional DVD, joined the speaking/ workshop circuit, and do some creative consulting with ad agencies. I try not to overdo it, though. I always want to be a photographer and an artist first. But if you're signing up to be a freelance photographer, you'd better be ready for war. This business is a battle every day. It's a battle of talent, marketing, innovation, the list goes on and on. But I love what I do. I wouldn't trade it for anything. I honestly believe we have the best job in the world.

—Jeremy Cowart

Outsourcing is the new resourcing. When you outsource, you can provide quality service and products while focusing your time and attention on the creative side of your photography business. Outsourcing simplifies your business and mobilizes you while keeping overhead low. For many photographers this makes a lot of sense, especially now, when making investments in equipment, personnel, and training can be difficult and even questionable.

—Kevin Kubota

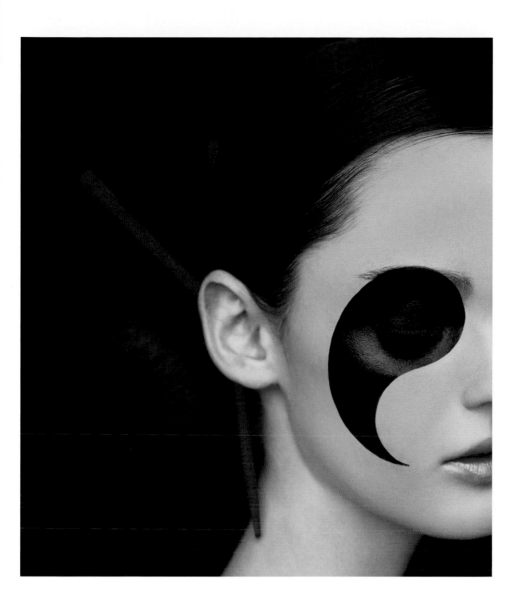

A long time ago a friend, the Olympic gymnast Dominique Dawes, shared something with me and I've borrowed it ever since. She told me, "You can't do it by yourself, you need a team. Team stands for Together, Each, Achieves, More." The same is true in photography. Not only can you not do it alone, but you'll be less profitable if you don't outsource as much as possible. Outsourcing will help you accomplish more in less time so you can spend more time doing what you love, photography
—Matthew Jordan Smith

KEVIN KUBOTA

The list of specific "things" I could tell people to do would go on and on. However, it's these core concepts that really make a long-term difference.

1. Have a desire to please. I don't mean kissing arse here, but a genuine desire to do the right thing and make your customers glow with happiness.

2. Acquire an attitude of shared success. I always try to find ways to help others be successful—vendors I work with, other photographers in my area, or clients.

3. Balance optimism with a healthy dose of humility. My optimism has always been tempered by a nagging feeling of self-doubt, just enough to keep me constantly striving to improve and able to appreciate what I can learn from others.

4. Practice Kaizen. This is a Japanese term for constant improvement. I never seem to be happy with anything if I think there could be a better way to do it. That's what led me to create software and training workshops. I like to find the best solution and share it with others.

5. Be real, be pleasant, be present. I never want to appear one way in public and another way in private. If you do this, you aren't being real, and eventually people will see right through you. Being pleasant can have a profound impact on the energy and mood of a meeting or shoot. Your clients want you there, have more fun, and remember—and refer—you. Being present means being a good, active listener. Everybody wants to feel heard and understood. When you do that, you gain your clients' trust and long-term patronage.

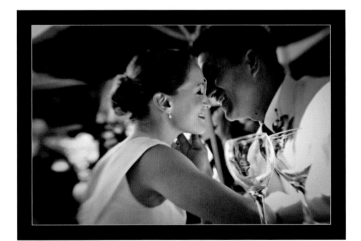

Kevin Kubota never does anything half way—from his image capture to his involvement in the industry to his commitment to giving back.
PHOTO BY KEVIN KUBOTA

MICHAEL CORSENTINO

For anyone starting out, I would recommend outsourcing. I can't say enough good things about taking this step. Outsourcing my proof editing and album design has revolutionized the way I do business and become key to my growth. I wish I'd done this much earlier in my photography career. It's a question of how your time and energy is best spent. For me that's creating images, marketing, and making sales, and it's probably that way for most other photographers, too.

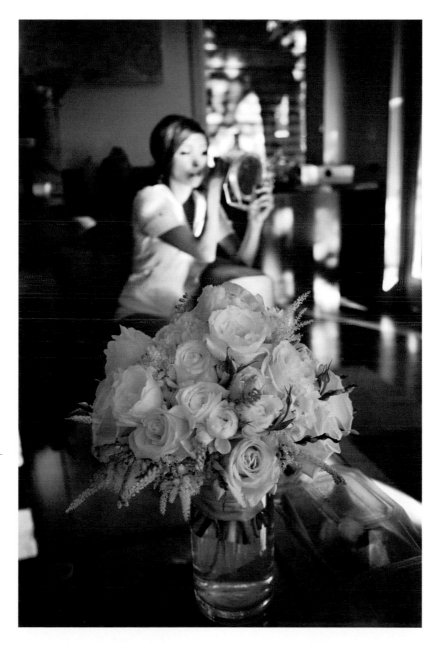

Every image tells a different story, and the photographer is in the driver's seat as the storyteller.
PHOTO BY MICHAEL CORSENTINO

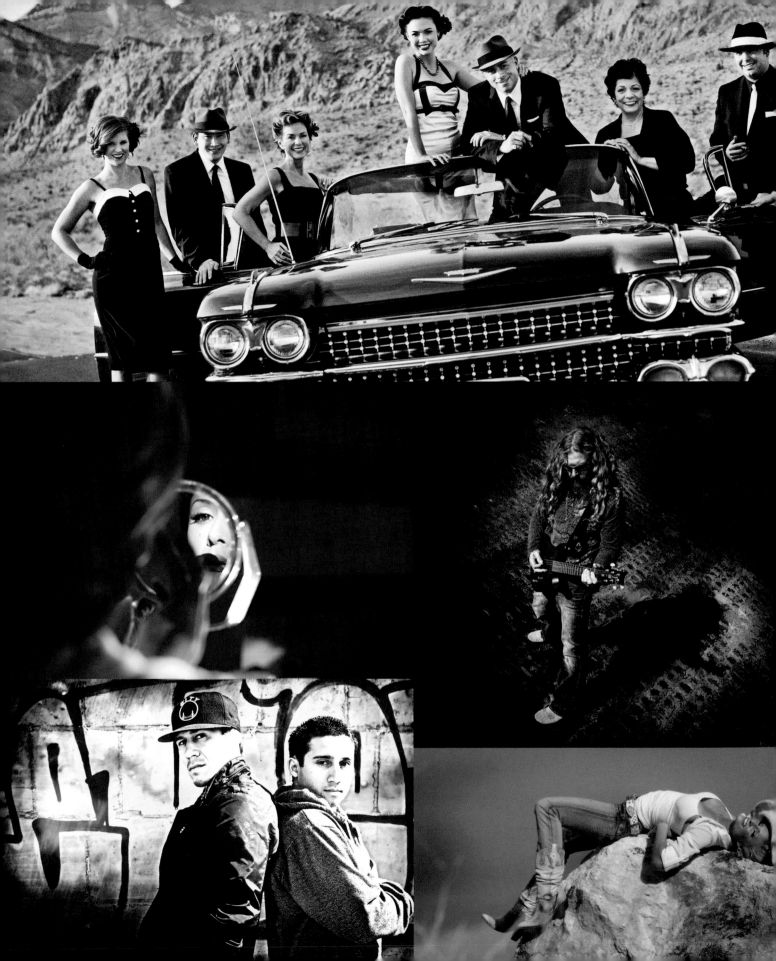

Resources

ONCE YOU HAVE a good idea of the parts of your business
with which you need the most help, it's time to start thinking
about execution. The first step is to select the right vendors.
Be careful here. You are literally about to build your business
on the backs of these vendors, so if they screw up, as far as
your client is concerned, you screw up. So select wisely. We
spent considerable time interviewing and talking with friends
in the industry to select some of the very best companies to
recommend in this book.

PHOTOS BY (CLOCKWISE FROM TOP): MICHAEL CORSENTINO; MATTHEW JORDAN
SMITH; EDDIE TAPP; EDDIE TAPP; MICHAEL CORSENTINO; MICHAEL CORSENTINO

Choose the Right Vendors

Please be aware that you must still use your own expertise to decide if these companies and their services and products are right for you. You're responsible for your own due diligence. And ultimately, any business relationship you build with these vendors is between you and them. Our recommendations are just that: recommendations. You bear the responsibility for making the relationship work.

Some things to look at before selecting one of the vendors we recommend, or any other vendor, include:

- ¤ Expertise: Are the vendors truly good at what they do?

- ¤ Reputation: Are the vendors established and do other photographers trust them?

- ¤ Price: Are the vendors' pricing structures within your budget?

- ¤ Contract or commitment: Is the contract or the commitment the vendors offer fair to both sides?

As you take the time to review some of the companies and products on our list, remember that we've chosen these companies because we admire their contribution to our industry. They not only provide products or a service but are also staffed with people who understand the challenges of a photography business. Many of these companies are operated by photographers and, at some point in their lives, they've been faced with the same challenges you face. You'll find that the staff at many of these companies will contribute to helping you solve many of the day-to-day challenges.

Here are some of the companies that we think are worthy of your consideration. Mind you, these aren't the only companies we trust, but this is a good starting point. As you develop your business, you will need to have relationships with some or all of these types of vendors. So take the time to get to know them. We'll update our vendor recommendations on our blog at www.goingpro2011.com as circumstances warrant.

Bags and Cases

TENBA
Your choice of camera bag is often about personal taste, but think about how much money you've spent on your gear! You want bags and cases that look good, but they've got to be functional and protect your equipment as well. Producers of gear from backpacks to shippable cases, Tenba has been around for years, and this experience shows in every product the company makes.
www.tenba.com
914-347-3300

Color Calibration

X-RITE

We're always amazed by photographers who strive to create the very best images but don't bother to calibrate their monitors for accurate color. It's like buying the finest stereo system and then pumping the music through a pair of $79 speakers! X-Rite makes it easy to calibrate your computer with products that will reduce the amount of gray in your life (and in your hair).

www.xrite.com
800-248-9748

Filters and Other Software

NIK SOFTWARE

In the same way that a NASCAR driver knows his car will perform better on a special mixture of fuel, Nik Software knows that their filters and other plug-ins will help you realize the full potential of every image.

www.niksoftware.com
619-725-3150

Lab

WHCC

This long-standing giant firm provides prints, albums, gallery wraps, frames, offset printing, boxes, press-printed cards, and books. The company is owned and operated by a Minnesota family who cares very much about photography and photographers. We've used their products and can attest that they are affordable and dependable, and of the highest quality.

www.whcc.com
800-252-5234

Lighting and Accessories

PROFOTO, POCKET WIZARD, AND SEKONIC

Long before the notion of the *Going Pro* project came to mind, I was using Profoto, Pocket Wizard, and Sekonic products as an important part of the Scott Bourne photography business.

One of the key ingredients in creating great images on location or in the studio is the quality of light, and that's why I count on Profoto gear. Reliability is also critical to great images. You don't have time to chase down a problem in the middle of a shoot; you want gear that works the way it's supposed to, time after time after time, and during decades of use, no Profoto flash has ever failed me. My first studio lights were made by Profoto and I've never looked back.

Sekonic meters have set the industry standard for accuracy, ease, reliability, and affordability for years. I've relied on Sekonic for years, and to this day, if I'm working with studio flash, I'm using a Sekonic meter.

PocketWizard gives you the ability to fire multiple strobes remotely again and again. Sekonic flash meters now have PocketWizard technology built in, making it super easy to meter and trigger the perfect shot remotely.

www.profoto.com
www.sekonic.com
www.pocketwizard.com
914-347-3300

Marketing and Printing Services

MARATHON PRESS

Whether you need a website, self-promotion post cards, or full-fledged marketing services, Marathon Press has something for you. Marathon can help you with e-mail marketing, direct-mail marketing, and logo and identity packages as well as printed products that you'll use for everyday promotions. Marathon's planning experts help you develop everything from your strategy to your marketing workflow. What we especially like about Marathon's programs is that they are designed to take you from the first day on the job all the way to the finish line. The company's emphasis on educating photographers to market themselves falls right in line with the *Going Pro* approach.

www.marathonpress.com
800-228-0629

Online Ordering and Fulfillment

PICTAGE

Photographers who shoot events—weddings, portrait sessions, proms, sports, etc.—can sell and fulfill orders through Pictage. You put your images from a session online and clients select their favorites and order prints directly from Pictage. Many professional photographers use Pictage services to manage their post-event customer service as well.

www.pictage.com
877-742-8243

Photoshop and Lightroom Add-ons

KUBOTA IMAGE TOOLS

Whether you are new at post-processing or an old pro, Kevin Kubota's add-on solutions will help you get the most out of Photoshop and Lightroom. His Dashboard application and various tools such as actions, borders, and textures make it easy for you to create digital images that look like museum pieces without any advanced Photoshop or Lightroom knowledge. Kubota Image Tools are timesavers too, freeing you up to go out and shoot and sell.

www.kubotaimagetools.com

Presentation

ASUKABOOK

You can set yourself apart from your competitors with a unique presentation. Asukabook's quality is legendary, and distinctive formats help your work stand out in presentations that include hard- and softbound books as well as smaller booklets you can hand out to potential clients.

www.asukabook.com

Slide Shows

ANIMOTO

Animoto is super-fast and easy to use, just the right product for an emerging pro who might not have the time, interest, or skill to build his or her own slide shows. Upload your favorite pictures, pick a background and some music, go get a cup of coffee, and come back to a beautiful slide show that you can share online or copy onto a DVD for your clients; the service will pay for itself in one or two orders.

www.animoto.com

Tripods

BENRO AND INDURO

The carbon-fiber tripods from both companies are outstanding, as are their tripod heads. Benro is the entry-level line, sturdy and reliable but less expensive than many competing tripods. Induro is professional-class and has recently redesigned its products to meet or beat the exacting standards that most professionals prefer. Scott Bourne switched from Gitzo to Induro tripods because they are less expensive yet stand toe-to-toe quality-wise with much more expensive brands.

www.benro.com
914-347-3300
www.indurogear.com
914-347-3300

Video and Photo Sharing

SMUGMUG

We believe SmugMug is hands down the best place to host video. SmugMug doesn't compress the video, supports a multitude of formats, and best yet, doesn't try to steal copyrights to your videos like many video-sharing sites do. SmugMug also makes it easy to set up photo galleries you might want to share with clients. Photographers who opt for professional accounts with SmugMug can add custom watermarks and other protection to their images and sell prints and digital downloads of their photos, with their own custom pricing, through the SmugMug interface.

www.smugmug.com

White Balance and Light Modifiers

EXPODISC AND ROGUE FLASHBENDER

These professional digital white balance filters for stills and video provide white balance with exceptional accuracy.

If you use on-camera or small flashes, then you should also check out the Rogue FlashBender and the Ray Flash Adapter. Both modifiers give you the chance to get big studio results with small flashes. Both are perfect for emerging pros who don't have big budgets for fancy studio lights but still want to get studio-quality shots.

www.expoimaging.com (ExpoDisc and Rogue FlashBender)
800-446-5086
www.ray-flash.com

Photographers

Throughout *Going Pro* we've featured the work of some of the finest photographers in the market. Each one offers a unique perspective on imaging and working with clients. Most of these photographers have blogs filled with great content, and many are often on tour speaking at various conventions and trade shows. A few have their own DVDs and educational material. Check out their websites to take advantage of all they offer to help you refine your skills and build your business.

KAYCE BAKER:
http://cheshireimaging.net

JULES BIANCHI:
http://julesbianchi.comblog

CLAY BLACKMORE:
http://clayblackmore.com

PHIL BORGES:
http://philborges.com

BAMBI CANTRELL:
http://cantrellportrait.bigfolioblog.com

TERRY CLARK:
www.terryclark.com

TONY CORBELL:
http://corbellproductions.com

MICHAEL CORSENTINO:
www.corsentinophotography.com

JEREMY COWART:
http://jeremycowart.com

KAY ESKRIDGE: www.imagesbykay.com

JOE FARACE: www.joefarace.com

JIM GARNER: www.jgarnerphoto.com

JERRY GHIONIS: www.jerryghionis.com

GREGORY HEISLER:
www.gregoryheisler.com

ELEANOR HERNANDEZ:
www.eleanorhernandez.com

CHASE JARVIS:
http://blog.chasejarvis.com/blog

KENNY KIM: http://blog.kennykim.com

KEVIN KUBOTA:
http://actionhero.squarespace.com

TAMARA LACKEY:
www.tamaralackeyblog.com

VINCE LAFORET:
http://blog.vincentlaforet.com

BRIAN PALMER:
http://brianpalmerphotography.blogspot.com

RALPH ROMAGUERA:
www.romagueraphotography.org

RYAN ROMAGUERA:
www.romagueraphotography.org

ALLISON RODGERS:
www.allisonrodgers.com

HOWARD SCHATZ:
www.howardschatz.com

MATTHEW JORDAN SMITH:
http://matthewjordansmith.blogspot.com

EDDIE TAPP: http://eddietapp.com

NICK VEDROS: www.vedros.com

NICOLE WOLF:
http://nicolewolfphotography.com

HELEN YANCY:
www.helenyancystudio.com

NICOLE YOUNG:
http://nicoleyoung.com

DAVID ZISER:
http://digitalprotalk.blogspot.com

Going Pro Authors

SCOTT BOURNE: http://photofocus.com,
http://goingpro2011.com, www.pwspi.com
www.scottbourne.com

SKIP COHEN: http://skipsphotonetwork.com,
http://mei500.com, http://goingpro2011.com,
www.pwspi.com

OVERLEAF: Composition enhances a dynamic subject.
PHOTO BY CHASE JARVIS

ANY PROJECT WORTH DOING takes a lot of work and *Going Pro* has been no exception. We've done our best to get you started on many different aspects of the business of photography that many books leave out. We set out to help you through the challenges most photographers forget about, and sometimes even ignore.

It's important for you to remember that being a great photographer isn't just about your images. It's about your personality. It's about your marketing skills. It's about your willingness to give back to the community and the industry itself. Most important, being a great photographer is about education. If your goal is to be the best, then recognize now that you can never stop learning. You can never stop practicing and perfecting the craft as you literally search for the ultimate image.

The legendary portrait photographer Don Blair was once asked what was the greatest photograph he'd ever taken. He answered, "I don't know. I haven't taken it yet!" Even into his late seventies he was still attending every workshop and program he could, always picking up some new idea on how to pose or light his subjects.

As you grow as a photographer you'll find you have the ability to give back, and you might even have a desire to teach your own workshops and hit the speaking circuit. Be very cautious on your approach to teaching, however. We believe very strongly that to effectively lecture about photography, you've got to be a working photographer.

Keep your concentration on creating outstanding images and building your reputation in your community. Listen to your clients. Spend time with your competitors. Network with other members of the business community who share your target audience. Most important, stay focused on more than your subjects. Keep in touch with why you became a photographer in the first place—your passion for making images!

You've chosen what we believe is the most exciting profession in the world. It offers you a never-ending chance to share your visions, realize your dreams, and share your heart with hundreds, if not thousands, of people throughout your life. And in what other profession can you make a statement like that?

Index

Note: For photographs with captions on opposing page, index page numbers refer to captions.